MW00577543

Advance Praise for
Dwell Time: A Memoir of Art, Exile, and Repair

"*Dwell Time* is a multigenerational family memoir that reads like a panoramic, deeply moving *roman-fleuve*—taking the reader from Eastern Europe through Havana, Miami, Manhattan, and Los Angeles, amid revolution, war, upheaval, and exoduses. That it's written by a revered conservator of art makes perfect sense because Rosa Lowinger's profession has given her a complex understanding of the past, of the contingencies of history, of the differences between surface and interior. One of art conservation's creeds is 'You can't repair what you don't understand.' This beautiful book is an act of understanding as a work of art."

—RANDY KENNEDY,
bestselling author of *Presidio*

"After a lifetime of restoring works of art, Rosa Lowinger turns her good hands to examine a life rent by exile and loss. A lyrical and moving memoir of art, family, and the flawed material out of which we make and remake our lives. A gorgeously written tribute to an extraordinary family and a reminder that with patience and attention, we may yet repair—if not the world—at least the luminous fragment that belongs to us."

—ANA MENÉNDEZ,
author of *Loving Che* and *The Apartment*

"An insightful tale that reveals a kaleidoscope of worlds that Rosa Lowinger navigates to chart a life in colors and materials, joys and calamities, rendering lives that were forced into exile many times but always eager to build a sense of home and purpose. A moving account filled with the eccentricities of life, family, and the love of something (and its preservation) that is sometimes beyond words."

—HRAG VARTANIAN,
cofounder and editor-in-chief, *Hyperallergic*

ROSA LOWINGER

DWELL TIME

A Memoir of Art,
Exile, and Repair

Library of Congress Cataloging-in-Publication Data
Available Upon Request

ISBN 978-1-955905-27-5 (HC)
ISBN 978-1-955905-28-2 (eBook)

Printed in the United States
Distributed by Simon & Schuster

Book design by Aubrey Khan, Neuwirth & Associates, Inc.

First edition
10 9 8 7 6 5 4 3 2 1

*Understanding matter is necessary to
understanding the universe and ourselves . . .*

—PRIMO LEVI

*Buildings are like the words of the people . . .
A carved stone is a book.*

—JOSÉ MARTÍ

CONTENTS

*

Part One

*

Part Two

•

Part Three

•

Part Four

PART ONE

Chapter One

MARBLE

I n a Jewish orphanage on the edge of Old Havana, a little girl drags a soapy rag over a long, white marble tabletop. There are twenty of these tables, and twice a day this six-year-old's job is to scrub ten of them clean of chicken, rice, and black beans—the typical ingredients of a Cuban supper. Pork would never be served here, of course. Neither would beef, because it costs too much. On Friday nights, the orphans might eat soup with matzo balls or long egg noodles slathered with chicken schmaltz. The girl likes both these foods. But she won't eat kasha varnishkes, no matter how hungry she is, how much they spank her, or send her to bed hungry. She is maddeningly stubborn. Beatings don't subdue her, neither does making her scrub the marble tables, the hardest task given to any of the little ones.

This girl became my mother. She was born on September 8, 1932, a national holiday in Cuba celebrating la Virgen de la Caridad del Cobre, the island's patron saint. Most Catholic girls

born on this day are named some version of Caridad—*charity* in Spanish. They are typically dressed in yellow baby clothes, the color linked to Ochún, the powerful female Yoruba spirit deity syncretized with la Virgin de la Caridad. My mother's parents, Jewish immigrants, named her *Ita* in Yiddish and *Hilda* in Spanish.

Three weeks later, her mother died. "I was a ten-pound baby," my mother says, blaming herself. She also faults the system that required C-sections be authorized by a priest or rabbi. "By the time the rabbi arrived at the hospital, I had torn my mother up."

In Afro-Cuban Yoruba religions, each orisha, or spirit deity, manifests specific qualities of the Supreme Being. Ochún controls fresh waters, rivers, divinity, fertility, and love. The men and women born under her guardianship are gregarious and seductive, the life of the party. But cross them and watch out. This river orisha is vain, spiteful, and quick to anger. "I don't forgive, and I don't forget," my mother has said for as long as I can remember. Throughout my life, I have received this warning.

MY MOTHER'S FATHER WAS ALIVE when she was sent to the orphanage. Born in 1906 in Bessarabia, then part of eastern Romania, Samuel Peresechensky left Europe in the 1920s on a boat bound for America. Because the 1920s were a time of extreme xenophobia in the United States, with the first anti-European immigration quotas codified into law by the Emergency Quota Act of 1921 and the Immigration Act of 1924, Samuel was left off in Havana. This was not a bad choice for an

immigrant trying to reach Ellis Island. For one thing, Havana
was far closer than, say, Caracas or Buenos Aires. There was also
practically an open door between the United States and Cuba.
Within six months, immigrants were virtually guaranteed a visa
to enter the *goldene medinah*, the "golden land," as the United
States was called in Yiddish. In the meantime, there was plenty
of work in Cuba. The republic was barely more than twenty
years old, and the country's fifth president, Gerardo Machado—a
man elected by a landslide who would later usurp power and be
portrayed on the cover of *Time* magazine as "Cuba's Dictator"—
was in the middle of a robust public works project to complete
the country's trans-island railroad, and another to begin con-
struction on a highway crossing the 750-mile length of the island.
There was work for stevedores along the docks and for masons in
the construction of buildings like the grand headquarters of
Bacardí Rum, the Hotel Nacional de Cuba, and a new capitol
building that would bear an uncanny resemblance to the one in
Washington.

My grandfather Samuel quickly fell in love with his new
hometown. His favorite parts were the dance halls and backroom
gambling parlors, where you could play cards and bet on the
numbers game. And, of course, the city's many bars, where he
habitually overindulged. In 1928, Havana had about seven thou-
sand bars. They were in nightclubs, hotels, restaurants, even cor-
ner bodegas and cigar shops. This proliferation was in large part
due to Prohibition in the United States. No longer allowed to
legally drink at home, Americans were flocking south to water-
ing holes in Havana. Many American barkeeps moved their
operations there as well. Being a bustling port and tourist town,

Havana was also known for its burlesque theaters, red light district, and easily available women along the docks. My grandfather Samuel patronized those as well, even after marriage.

Then his wife died giving birth to his first child.

My mother has no memory of what happened next. She thinks her father left her in the care of her maternal grandmother, Chaya Felman, a woman who became paralyzed from the shock of losing her younger daughter. A few years later, my mother was back in Samuel's care, living in a room they rented from a couple who had come from the Galician region of Spain. When Samuel went to work, he left my mother in the care of their landlords, who owned a laundry downstairs. My mother lights up at the memory of those days. "Los Gallegos taught me to iron with one of those big hot presses that I had to push down with all my weight. I used a flatiron also, that you had to heat on a stove and pick up with a towel." At the end of the day, Samuel would come home from the docks with a bag of oysters in hand. "He had a special knife to open them," my mother recalls. "I would eat the whole bag."

This happy portrait of a green-eyed, olive-skinned, dark-haired four-year-old who eats oysters with her father and enjoys pressing shirts "beginning always with the collar, then moving down to the area around the buttons, then the buttonholes," didn't last. Samuel came down with gout. Unable to walk, he couldn't work or pay the rent. My mother was sent back to her grandmother, who was living with her other daughter's family. My mother helped bathe and dress her paralyzed grandmother. Her aunt gave her a bed and food, but nothing else. "I used to collect bottles on the street and turn them in at the bodega—ten centavos for five bottles—so I could buy myself a sweet from the peddler who came down the street. My aunt didn't like me because she thought

my grandmother loved me more than her own children. She took my mother's clothes, jewelry, and silverware, which were locked in a trunk, and gave them to my cousins."

Eventually, my mother's aunt called her father and said: "Hilda can't live here anymore. She is a bother." That is how my mother ended up living in an orphanage where she became adept at cleaning marble.

I, TOO, AM AN EXPERT cleaner of marble. I am an art conservator, specializing in sculpture, decorative objects, and historic architectural materials. To me, it seems a strange luxury to use marble for an orphanage's dining tables. Marble implies wealth and elegance. It's the material of ambitious architecture, like the Parthenon in Greece, the Taj Mahal in India, and the Washington Monument. An archaeologist I know who works on Roman sites in Israel says that marble columns "sound different, richer, when you scrape them with your trowel." The first Roman emperor, Augustus Caesar, famously declared his imprint on civilization with the words, "I found Rome a city of bricks and left one of marble."

Marble is a metamorphic stone, forged by the heat and pressure of the Earth's crust on another stone, in this case limestone. This geologic process squeezes the pores of calcite crystals over centuries to make a stone that takes well to polishing and intricate carving. There are marble quarries all over the world, including Cuba. The stone comes in dozens of colors and patterns, but by far the most prized is a translucent stone with a bluish cast from the Italian Tuscan hill region surrounding the

city of Carrara. *"The marble not yet carved can hold the form of every thought the greatest artist has,"* said Michelangelo Buonarroti, arguably the most famous marble sculptor of all time.

Diagonally across the street from the orphanage where my mother lived sits an odd Carrara marble sculpture from 1837. Carved by an Italian sculptor when Cuba was a Spanish colony, la Fuente de la India, "the Fountain of the Indian," depicts a Taíno woman, rendered absurdly with classical Greek features and clothing and wearing a feathered headdress festooned with Cuban pineapples. Over the many years I have traveled back to Cuba, I've seen this sculpture grow dingy with grime, then get scoured with sandblasters and power washers, then darken with dirt all over again. It's a vicious cycle that gets worse each time, because though cleaning by acid, bleach, and sandblasting are fast ways to remove pollutants, those methods erode marble and make it more porous. The resulting nooks and crannies become places for dirt to collect faster and deeper.

In art conservation, we avoid such harsh processes. We are the masters of the slow and steady, using only methods and materials that do their job without inflicting damage. This takes many different forms, but in cleaning, the measure of how long it takes for a product to work on a substrate is called its *dwell time.* Dwell time can also mean the total time a person spends in an airport, or looking at a web page, or the time a family lingers at a border, waiting to get into a country, or the time you live in a city before moving on. In conservation, dwell time references chemical activity. The stronger and more reactive a material, the shorter time it takes to do its job, and vice-versa. We wash our hands for twenty seconds because soap needs that much dwell time to kill viruses. If you washed your hands with bleach, the dwell time

would be shorter, but your skin would burn and peel, the remedy worse than any possible disease. The same is true for works of art.

THE ORPHANAGE WHERE MY MOTHER spent her youth was founded in the early 1920s as part of an Ashkenazi home for poor Jewish women that was originally called the Meydlheim. The Meydlheim's goal was to protect young women who had come to Cuba in search of economic opportunity or husbands with whom they had lost contact during World War I. In 1921, many of these were girls who had come from the war-torn regions of Grodno and Bialystok, in what is now Poland. Others were survivors of the Kiev pogroms, a campaign of violence that saw seventy thousand Jews slaughtered and thousands of Jewish women and girls raped by Cossacks and army officers. The Meydlheim provided a familiar place for these destitute, malnourished, and traumatized women. Eventually folded into another organization called the Froyen Farayn (a women's group), the home offered a place to speak Yiddish and eat matzo balls amid the suffocating heat and insects of this strange tropical land of endless sunshine. Many of the women were taught to read and to sew, using machines donated by US-based Jewish welfare agencies. Some were assigned the job of caring for the orphanage's younger children.

My mother's caretaker was a quiet, pale-faced teenager named Ana Mintz. Ana had been born in Paris to Polish immigrants. When the family immigrated to Cuba, they remained so poor that two of Ana's siblings—twins—starved to death. Though she was only ten years older than my mother, Ana doted on her little

charge, making her bed and helping keep her few items of clothing tidy. Each night, after supper, my grandfather would whistle at the gate for my mother. "Don't go," Ana would beg. "They'll beat you, Hildita. Please."

My mother went down anyway. Desperate to spend five minutes with the only person in the world who she felt truly loved her, she scampered down the back stairs, knowing that the Froyen Farayn's director would be waiting for her with a leather strap when she came back.

"You have to stop this," Ana cried. "I am going to tell your father what is happening!"

"Don't you dare," my mother warned. "Or he'll stop coming."

WHEN I WAS FIVE YEARS OLD, about the age my mother was when she arrived at the Froyen Farayn, my mother often hit me. We were living in Miami Beach then, newly arrived Cuban exiles. My parents had left everything behind: family, possessions, an apartment building that my grandparents owned. We lived in a tiny, rented, one-bedroom apartment, the windows of which looked out onto Washington Avenue in South Beach. It was to be temporary, as we waited for the United States to take action and get rid of the communists ninety miles from its shores. That's what my father said all the time.

My mother was not so sanguine. Life had kicked her too much to think otherwise. She cooked, cleaned, and did laundry. My uncles Felix and Enrique lived with us, and there were twenty-one men's shirts a week to iron. She did it all expertly.

But underneath her façade of exactitude was smoldering rage. How could this have happened to her? After the orphanage and years of poverty, after she had managed to marry into a good family, how could she again be pinching pennies, worrying about survival? My mother scrubbed and swept with pursed lips and a furrowed brow. All it took for the volcano to erupt were minor infractions, like my not being hungry at dinnertime, not putting my crayons away, not wanting to take a bath—anything and everything. I never knew when she would strike.

I managed by drawing. I filled notebooks and doodled in the margins of Little Golden Books. I drew flowers, houses, girls with bobs and ponytails like Betty and Veronica from Archie Comics, embellishing facial features and hairdos in a Wonder Books Easy Reader titled *Barbie Goes to a Party*. I adored Barbie, that classic American girl, with her ponytail and helpful, smiling mother. *"Would you like to wear this?" Mother asks.* I imagined all American mothers to be cheerful like Barbie's. *"Yes, Mother, I like this dress!"* Flouncy dresses, ribbons, pedal pushers, black flats, and a book bag slung across her shoulders. I drew pine trees, roses, houses with peaked roofs and casement windows like the ones I saw on *Father Knows Best* and *Lassie*. Smoke rising from chimneys, snowcapped mountains—never the beach or a palm tree or anything remotely tropical.

My future peregrinations were in those drawings. By the time I was a teenager, I could not wait to leave Miami. I wanted to get away from my parents, and also the cloying nostalgia of Cuban exiles. I couldn't stand the handwringing—*"Perdimos nuestro pais. We lost our country"*—that was the thrumming subtext to *El Exilio*, as Cubans refer to life outside the island.

We'd lost an island, but gained America. Refugees around the world were clamoring to get into this amazing country. We were welcomed, privileged immigrants. In 1972, a 6.3 magnitude earthquake devastated Nicaragua, leaving thousands dead and tens of thousands homeless. I dreamed about that earthquake for weeks. I worried about Nixon, napalm, Kent State, racial justice, not the spread of communism.

For reasons I didn't quite understand, my strict Cuban Jewish parents agreed to let me go away to college. They scraped together the tuition and did not even protest when I said I wanted to study art. (They only refused to let me study theater, because it "leads to too much sleeping around.") At Brandeis University, I enrolled in drawing and painting classes. Everything I produced felt forced and bland, the charcoals messy with fingerprints and blurry lines. Pencil drawings looked like scribbles, and not in a good Cy Twombly way. My paintings were even worse. I muddled the colors, unable to make sense of using lights and darks to juxtapose forms. In high school, I'd taken after-school classes with a woman who had us copy kitschy renderings of fruit bowls, scenes of boats and sunsets, and turbaned women weaving baskets. My college paintings were no more interesting.

I dropped painting and turned to sculpture. The professor, Peter Grippe, was an old-school abstract expressionist who was friends with Willem and Elaine de Kooning and had taught alongside them and Buckminster Fuller at Black Mountain College in the 1940s. Grippe was an apt name for this man. He'd strut around us students as we tried to build clay torsos around wire armatures, gripped with fervor for the creative process. "Sculpture is movement—these figures must contain within them every bit of air that touches them," he'd exclaim

breathlessly, quoting the Italian Futurist Umberto Boccioni. I could just hear my mother's reaction: "*¿Que le pasa a ese tipo? Está loco?*" ("What's wrong with that guy? Is he nuts?")

When I switched yet again, from sculpture to printmaking, I was finally read the riot act: "Make a decision or come home. You're wasting our money."

They had a point. Dabbling in art was rich girl stuff—maybe okay in families where generations had gone to college, but not families where you were the first to do so, where your mother worked as an optician for Sears and your father spent weeks on the road, selling eyeglasses. To my relief, printmaking stuck with me. In retrospect, I think it was the medium's technical requirements. All those plates to coat, scratch, and soak; the presses to calibrate; the paper to dampen. I was good at it. I even made a few nice etchings and monotypes.

Around this same time, I enrolled in an art history class titled "Early Medieval Art." It was my sophomore year and I had degree requirements to fill. The class was held at 8:30 a.m., a perfect time of day to roll in right before my work study job at the Rose Art Museum, or after pulling an all-nighter in the print studio. The subject didn't interest me, but I'd heard that the professor was a good lecturer.

The man who would shift my life's path arrived to class one brisk and golden autumn morning wearing a brown wool three-piece suit, a white shirt, and tweed tie. Almost a caricature of the prim, buttoned-up scholar, Dr. Joachim Gaehde stepped up to the lectern and pulled a set of notes and half-eye reading glasses from an old leather briefcase. He ran a hand through his ash-colored hair, and said, "Lights down, please," in softly German-accented English. The sparsely filled lecture hall

darkened. Images of wall paintings from the Roman catacombs appeared on the wall-sized screen.

"The earliest surviving Christian paintings were made at a time when adherence to the religion was punishable by death," he began. The origins of Western iconography unfolded behind him. Baptisms. Good Shepherds. Loaves and Fishes. Saints and Maji. Dr. Gaehde told a story of forbidden imagery, a religion in its infancy. Next up were the Junius Bassus and Dogmatic sarcophagi, fourth-century masterpieces carved in high relief out of Italian marble. These caskets, made when Christianity was already codified in most of Europe, portrayed biblical scenes in stirring, intimate detail: Eve at the Expulsion from Eden. Isaac sacrificed by Abraham. Moses striking the rock, the act that would keep him from the Promised Land. Dour Pontius Pilate making the Italian *cornu* gesture at the Son of Man.

Sleep-deprived as any college student, I bolted upright. Here was a world of works of art that people were willing to die for. Crosses and chalices, illuminated Books of Hours, miniature bejeweled caskets that held bits of martyrs' bones or blood. I was particularly taken with the glittering mosaics from Rome and Ravenna, with their images of angels, barnyard animals, and the glowering visages of saints and conquerors. The lecture room felt holy, precious, scented with the warmth of plastic slides, the soft accented voice of the professor. As a child, I'd gone to Jewish schools and practiced a moderate form of Conservative Judaism. Certainly, I was no Christian. Still, I was struck in the heart. My hands shook as I took notes.

During a weekly phone call to Miami, I told my parents, "I think I might want to study medieval art history."

When I described what the subject was all about, my mother hit the roof. "*Te volviste loca?* We've watched you wasting months, doing *nothing*, making 'prints,' whatever the fuck that is. *Te lo acceptamos*, because that's what you say you like. But everything has a limit, Rosita. You think we're going to pay for you to study the art of the goyim? *Tzelems?* Crucifixions? Churches where they slaughtered Jews for centuries? *Qué va!*"

Really, what was I thinking? I might as well have told them I was going to get tattooed from head to toe. "Fine, I'll change my topic. But it's going to be art history," I snapped petulantly. I kept taking Gaehde's classes anyway. Gothic Architecture, Ottonian Manuscripts. Really obscure stuff. After a while, I spent less time making works of art and more time studying them.

One steely November afternoon during my junior year, I was in Professor Gaehde's office for an advisory session.

He asked, "What is your plan after graduation?"

After all the seminars and classes I had taken with him, how could he not know I was headed to graduate school? I said as much. My mouth felt dry. He lit a cigarette. Smoke ribboned in front of the view of low-slung clouds. Outside, a wide New England lawn was dusted with frost. I waited and waited, sweat trickling under the collar of my turtleneck.

Finally, Professor Gaehde offered, "Have you ever thought about art conservation?"

"No, sir." I'd never heard of it, of course.

He nodded. "My wife is quite well known in the field of paper conservation. You might find it enjoyable, given your good hand skills."

TWO YEARS LATER, I found myself in the cavernous atrium that would soon be the Metropolitan Museum's new American Wing. I was one of five conservation graduate students hired to assist with readying the artworks for the opening. Most of us were assigned to the cleaning and reassembly of Louis Comfort Tiffany's ceramic and glass entrance loggia for Laurelton Hall, his Oyster Bay, Long Island, mansion. My fellow student Judith Levinson (who would become director of conservation at the American Museum of Natural History) and I were there to work on a nineteenth-century fireplace that had been originally designed by American artists John La Farge and Augustus Saint-Gaudens for the grand entryway of Cornelius Vanderbilt II's mansion on Fifth Avenue.

The Vanderbilt mantel is made of oak, mosaic, iron, and Numidian marble, a rare maroon-red stone with white veining and grey striations. Most prominent among the mantel's features are a pair of larger-than-life-size classical female caryatids, Amor (Love) and Pax (Peace), who hold up the entablature and mosaic on bowed heads and upraised arms. The five-panel mosaic depicts a woman, also classically draped, who holds a garland in each hand and is flanked by a Latin phrase that translates to: "The house at its threshold gives evidence of the master's goodwill. Welcome to the guest who arrives; farewell and helpfulness to him who departs."

In 1925, when Vanderbilt's mansion was demolished, the mantelpiece was donated to the Met by his widow, and later loaned to the new Whitney Museum. By the time it returned to the Met for installation in the American Wing, the caryatids

were missing. It is not clear at what point this happened, but they were eventually found lying in the ground of a garden belonging to Cornelius's daughter Gertrude, a sculptor in her own right.

The American Wing was still a construction site, humid with the scent of wet concrete, noisy with motors, hammering, workers shouting, the backup beeps of forklifts, and the clatter of gantry chains that were hoisting Tiffany's brightly glazed floral ceramic capitals onto fluted columns. Outside the floor-to-ceiling window-wall was Central Park, dappled with early autumn's blush. This was a far cry from Miami, where September is at the height of what is known as "snakebite season," a time of stifling heat, humidity, and hurricane warnings. The mantelpiece, however, was a mess. Judith and I were hunched on the floor in a corner of the atrium, where the portions of the mantelpiece were littered. The huge caryatids were broken in half, missing fingers and small chips from their hair and garments. Scoured by the salt air of Long Island, they did not even seem to be the same Numidian marble as the other mantel parts. Worst of all was the central mosaic I was assigned to. Made of half-inch marble stones, known as tesserae, set into plaster, it was fracturing and out of alignment. Marble tesserae were either loose, missing, or jammed above the surface.

As students, we were guided carefully by the Met's conservators, not left to our own devices. But still, this was like being thrown into the deep end of a pool. Hand skills? My fingers felt arthritic, frozen in the chilly atrium air. How could one even begin to deal with missing bits, a splintering mosaic, and the caryatids, whose marble was so eroded that the hard white veins of calcite stood proud on the russet-colored surface like sugared icing on a cake?

Those questions are answered in a published paper that Judith and I authored in 1980. But not included in that academic essay is the first essential principle I learned about my new chosen vocation: Conservation is a mix of art, science, and hand skills, but it is fundamentally the art of understanding damage. You can't repair what you don't comprehend. You need to know the chemical makeup of the Numidian marble to understand that the iron inclusions that give it that deep red color also make it susceptible to salt damage. Where the material comes from (North Africa), what it was intended to do (serve as an architectural showpiece), and what happened to it along the way (dismantled several times, backed with concrete, languishing along an ocean-front for twenty-two years) are the first things you need to know before you plan a conservation treatment.

Welcome to the guest who arrives, stated the mosaic panel. That autumn, I embraced conservation as a boat that would take me to new landscapes, ones filled with grand works of art that had nothing to do with the constant strife of my burdened and over-bearing parents. But little did I know that this odd profession I had lucked into, thanks to Dr. Gaehde, would be the pathway to a personal restoration, one that would soon take me around the world, then back to everything I had fled—Miami, Cuba, and my family.

A DECADE LATER, on a windy hilltop in the Cuban colonial town of Guanabacoa, I was struck by the idea that, on a molecular level, both marble and human bones are made primarily of calcium carbonate. This rumination occurred to me for no

particular reason while walking among the marble graves of
United Hebrew Congregation Centro Macabeo Beyt Hayim,
Cuba's largest Jewish cemetery. I was taken there by Luis Lapidus,
a lanky and mustachioed preservation architect I had just met at
a conference. A little younger than my parents, Lapidus—whose
name, coincidentally, translates to "made of stone"—was also the
son of Eastern European immigrants to Cuba; but he had sup-
ported the 1959 revolution and stayed when many others left the
country. On the afternoon that he drove around Havana Harbor
in his Soviet-made Lada, Lapidus explained that Guanabacoa is
a Taíno word that means "site of the waters." Although Cuba's
indigenous peoples were decimated by Spanish conquistadores,
their presence remains palpable in place names like Guantánamo,
which means "Land between the rivers," and Baracoa, a remote
eastern town, where Christopher Columbus is said to have first
landed, whose name translates to "the presence of the sea."
Guanabacoa, Lapidus also told me, was known as a center for
the practice of Afro-Cuban religions, and the cemetery's gate-
keeper was among a group of *santeros* who cared for the resting
place of Jews by pulling weeds, making sure that broken bits of
headstones were collected and cataloged, and cross-referencing
names and grave locations in a large ledger that was kept under
lock and key.

Those valiant efforts notwithstanding, the Jewish graveyard
was in dire condition. Many lids were caving in from their own
weight. Stars of David were missing points. Weeds sprouted
through hairline cracks and tombs were sugaring, a process that
exfoliates small crystals of calcium carbonate. Inscriptions were
so caked with fungus that many were hard to read. It looked like
a textbook's worth of marble damage.

Which was the reason Lapidus had brought me here.

"How would you like to teach a workshop on marble restoration here?" he asked.

I could already hear my parents' indignation. My coming to Cuba for a historic preservation conference had seemed risky and irresponsible to them. A long-term commitment to a place still run by Fidelistas, a place that was then in the throes of post-Soviet economic free fall, would have crossed all boundaries of sanity.

The idea, of course, intrigued me instantly. "We could get a lot done in a week," I said. "I could bring down all the tools and materials. Except, of course, the solvents."

Lapidus nodded and squinted toward the ocean, where thunderheads flashed with lightning. "If you want to look for any of your relatives, do it quickly."

We walked back to the gatekeeper, and I gave him my maternal grandmother's last name—Oxman. The man flipped the pages of his large book and shook his head. "*No está.*"

"What about Chaya Felman and Fanny Grunbaum?" I asked, naming my maternal great-grandmother and my father's aunt. Those he had.

As the clouds rolled in and the air grew humid and metallic tasting, we trotted toward a far end of the graveyard, navigating bulging tree roots, prickly weeds, and broken sidewalks. "Here's Chaya Felman!" exclaimed Lapidus.

As Jews do, I placed a pebble on the flat headstone of the great-grandmother whose favoritism, according to my mother, was the purported reason her aunt sent her to the orphanage. I said the Kaddish, and Lapidus responded with "amen." We then headed in the direction of my father's aunt Fanny's grave. Lapidus rushed ahead of me. As I hurried to catch up, the tip of

my sandal snagged the broken sidewalk. I fell onto a blue-grey tomb with dark striations. It was badly eroded, but the name was clearly visible:

Rosa Oxman Felman.

The grandmother I was named for, the woman whose untimely death framed my entire life, reached out from beyond her marble gravestone to remind me that my interest in repair, the reason I became an art conservator, began right there, with her, in Cuba.

Chapter Two

CONCRETE

My father, Leonardo Lowinger, known to all his friends and family as Lindy, was born in Santiago de Cuba on October 23, 1932. Santiago is a coastal port town, the fifth villa established by Spanish conquistador Diego Velásquez de Cuéllar in his circumnavigation of the island. The hilly eastern city served briefly as the capital of colonial Cuba in the sixteenth century. It is five hundred miles from Havana, half that distance from Haiti. Eastern European Jewish immigrants almost never went there. My paternal grandfather, from Cluj in northern Transylvania, was one of the few exceptions.

Known as *Bumi* to his friends, Avrom Lövinger was the polar opposite of my mother's nightlife-loving father. The son of a devout scholar-rabbi who made a meager living certifying the kosher status of slaughtered meats, Bumi was the hardworking eleventh child in a family of twelve children. The Lövingers were so poor that they subsisted, in part, on food donated by

neighbors. Most of the nine sons worked itinerant jobs, traveling as far away as Zagreb and Sofia.

When he was twenty years old, Bumi boarded a cargo ship in steerage class bound for America. No one remembers what city or even what country he left from. Like Samuel Persechensky, he had dreams of Ellis Island. And like Samuel, fifteen days later, he found himself standing on deck alongside a cadre of new Yiddish-speaking friends. As the boat pulled into port, they watched the Cuban flag wave atop Havana's Morro Castle. Upon disembarking, the Eastern Europeans made a beeline for the US embassy. Bumi was told it would take about six months to get his visa. Quickly picking up some Spanish, which sounded a lot like Romanian (he also spoke Hungarian, German, and Yiddish), Bumi learned that the government was hiring laborers for the cross-island railroad project. He'd have to relocate to far-off corners of the island, where he might not hear about his visa until long after it came, and where he would be doing hard labor among Chinese and African workers without another Jew in sight. But Bumi was used to peripatetic living, and this work paid one peso (on par with the US dollar at that time) per day. The government was also providing the laborers with transportation, food, and lodging.

I remember my grandfather as a dour man of few words, a man whose face was scrunched into a strange squint, his mouth a taut half smile. "That look was frozen on his face from years of laboring in the sun," my father explained. In a document he wrote in his later years, titled "My Father, Alberto, and My Mother, Blanca," my father described his father as a man who "suffered what we call today anxiety; in those times, it was called loneliness."

As the railroad line moved eastward into sugarcane country, Bumi began noticing Jews with pushcarts selling merchandise around the mills. He asked around in Yiddish, and learned that many of the peddlers had come east like him, to work on the central highway. Many of the laborers were from Haiti and the Dominican Republic. They preferred to spend their earnings with the Jews rather than at the company stores, which charged exorbitant prices.

Having saved enough to travel back to Havana, the peddlers bought staples like soap, razor blades, work shirts, and dungarees from the wholesale houses in the old city, which they sold on payday to the workers from the mills. The peddlers prospered, and many opened brick-and-mortar stores in rural places like Manzanillo, Agramonte, and Trinidad.

Soon Bumi had a pushcart of his own. He became a natural leader among his fellow peddlers. "They all wanted the same customers for the same goods," said my father. "In Yiddish, their only common language, my father got them to make an agreement with one another. One payday he would sell the razors, and another would sell the dungarees. Another day, he would sell the cologne, and another the toothbrushes. Then they would switch, and so on." When Bumi decided to open his own store, a Spaniard told him that the secret to getting credit was to "sign with an X so they think you can't read or write. That way they think you're not smart enough to cheat them."

My grandfather changed his name from Avrom to Alberto and opened a place in Santa Cruz del Sur, a coastal town founded in 1871 about fifty-five miles southeast of Camagüey, the capital of Camagüey Province. A born entrepreneur, Alberto set up shop next door to the largest store in town and sold the same dry

goods, clothing, household items, hardware, toys, and eyeglasses they did. He figured: "This is where people are going to buy. They already know the area. And I'll be happy enough with only the customers the big store cannot serve, or those that get angry at them. Being bigger, they also have more expenses. I can sell cheaper and still make a good profit."

He did well and, within a few years, opened a second store. But success only heightened his anxiety. "On purchasing trips to Havana, he kept to himself, hardly mingling with his old friends from the boat and never going out, except to eat in a kosher restaurant or attend synagogue," wrote my father.

In one of the letters he sent back to Cluj—letters in which he would send cash wrapped in carbon paper so no one could detect that there was money inside—my grandfather Alberto asked his mother to choose a bride for him and send her to Cuba. Four months later, Blankutza Grunbaum, the quiet daughter of a religious poultry farmer whose beneficence was often the Lövinger family's only sustenance, arrived in Havana.

I PICTURE THAT YOUNG WOMAN, my grandmother, arriving in the tropics to marry a man she didn't know. The ship is out at sea for weeks, the weather growing hotter every day. Finally, they see the coast, maybe in the amber morning light, muted by salt spray. Before her, on a high bluff, is the Hotel Nacional, a large cream-colored building topped by a Cuban flag. My future Abuela jostles for position on the deck as the ship slows through a narrow harbor channel flanked by fortresses and turrets. Strange birds hover overhead, their bills like sacks of flour. The

ship moors by a large, squat building. The steerage passengers wait while those in first and second class disembark. My future Abuela is twenty years old—nearly ancient for an unmarried Jewish girl. Short, curly haired, and "no beauty," as her new husband will later tell their firstborn son, she pines secretly for a Hungarian stage actor whose autographed sepia photo she has carried across the Atlantic.

Soon it is her turn to walk down the gangplank. The city stinks of fish and sweat. Blankutza waits to have her papers stamped, then she is released into the white light of the city. A "skinny, sour-faced man," as she will later tell her sons, approaches her, holding a sign with her name written in a shaky hand.

He greets her politely, aloofly, squinting. "Here, I am known as Alberto, but you can call me Bumi." He picks up her bag and strides ahead, as nervous as she is. They cross a plaza with a marble fountain sculpted with lions where pigeons hover, awaiting crumbs. The heat rises; she hears a glut of languages. Her future husband hurries past buildings made of a material that contains small fossils.

Despite the Great Depression, which had devastated the economy back home in Romania, Blankutza sees construction all around, winches grinding, giant birdlike cranes dangling I-beams that hover over half-built structures. Oolitic limestone, a calcium carbonate stone that contains small fossils of marine creatures, is the main material of the ancient colonial city. But practically everything my future Abuela saw being built, as she traversed Havana on her way to being married and then boarding a train for eastern Cuba, was made of concrete.

LOOK OUT YOUR WINDOW. Chances are that much of what you'll see is made of concrete. There's twice as much concrete on our planet as all other construction materials (wood, metals, plastics) put together. This versatile material is as old as civilization. Marble might be synonymous with Rome, but it was the empire's formidable concrete that allowed it to build the aqueducts and fortifications that defined its economic and military might.

Ancient concrete was made by heating limestone to the point where it disintegrates, then adding a blend of gravel, crushed rocks, or pebbles. The concrete that built early-twentieth-century Havana used Portland cement as its primary component. Made by adding gypsum to traditional lime mortar, Portland cement was patented by an English bricklayer in 1824 and improved in the 1850s, when a French gardener came up with the idea of adding steel reinforcements, typically mesh or rods, to add tensile strength to concrete's brute compression power. This transformed a material that was strong, but cracked easily when stretched or torqued, into one that could withstand forces in many directions. Buildings could be confidently built taller, faster, cheaper, and with elaborate ornamentation.

THOUGH ALBERTO AND BLANKUTZA, who quickly became known as Blanca, were initially disappointed, they soon found the good in each other. Alberto recognized in his new bride "the essence of kindness, humbleness [sic], and family orientation."

She was a gifted cook, especially of the Hungarian dishes—chicken paprikash, stuffed cabbage, and a dizzying array of complicated pastries—he had been craving since his arrival in the tropics. Blanca found Alberto faithful and hardworking, someone she could trust to provide a good living for her and their family. He had some strange habits, like banging his head against the wall when he was angry or frustrated. Having traveled halfway across the world to marry this man, she tended "to the torments of his soul" as part of her job as a wife.

However, when her first son, my father, was born, the tables turned. As soon as they returned from Santiago to Santa Cruz del Sur, Blanca's normally level demeanor unraveled.

"We are all going to die," she augured gloomily.

Alberto paid her no attention. There were no words then for postpartum depression, but he had been forewarned by his mother that some women become *meshuganeh* after giving birth. Blanca would not eat or sleep. Her hands shook, and she wept all day. "Please, let's go, let's go," she begged. Alberto, who was himself always on the verge of fraying, finally gave in. The family left for the inland city of Camagüey, where he was thinking of opening yet another dry-goods store. He had already decided to close the store in Santiago, which was floundering.

What neither of them knew was that a hurricane was tracking westward across the Caribbean, heading straight for Santa Cruz del Sur. Cuba's National Hurricane Center issued its first warning to residents on November 5, a day before the storm intensified to a Category 5, with 175 mile-per-hour winds. The news did not reach the coastal city. There was no evacuation, a fact that experts still wonder about, as it was clear that the event would be cataclysmic. The storm made landfall on November 9, seventeen days

after my father was born. A six-foot storm surge destroyed the town. Alberto lost his store and house. But Blanca's precognition had spared them the fate of 2,870 people—80 percent of the town's residents—who drowned in the tsunami.

And now Alberto knew he had married someone with "the vision," as their people in Transylvania called it. This sixth sense blanketed the family with a certain calm, an antidote to Alberto's fury. "He never hit us, but his anger scared us," explained my father. "When he banged his head, we would hide under the bed." "We" included his brother, Enrique, four years younger, a mischievous, happy-go-lucky child who, like many second sons, bore none of the weight of legacy placed on the firstborn.

"When you graduate, you will work for me and eventually take over the business," Alberto made clear to my father when he was in high school. By then the Lovingers (Alberto had dropped the umlaut) were living in Havana. Blanca insisted that they move there as my father approached bar mitzvah age, for it was clear that in hyper-Catholic Camagüey (the city's prosperity in the eighteenth century earned it the moniker "City of Churches"), there would be slim pickings of Jewish girls to date or marry. My grandfather kept the large store in Camagüey and opened one at 227 Calle Bernaza, a narrow street along the border of Old Havana, which had many other Jewish stores, the most prosperous of all owned by the Neiman family (no relation to Neiman Marcus), wholesalers who sold work clothes to the sugar factories. There were Jewish fabric stores on Muralla Street, Sephardic-owned leather goods stores on Teniente Rey, and Jewish diamond cutters on San Rafael Street near the glamorous department stores. The Lovingers had a successful *quincallería*, a store that sold hardware and dry goods—scissors, hammers,

lighters, costume jewelry, dolls and toys, sewing supplies, baby bottles, even condoms. Alberto was making a good deal of money, saving "ten cents for every dollar he made." The family lived above the store in a four-room, railroad-style apartment.

As my father neared his high school graduation, Alberto's closest friend, a fellow Hungarian speaker named Fabian Weiss, suggested he invest in property. Weiss had made a lot of money during World War II as the exclusive representative of all the fine European watch brands. My father was delighted. "I had graduated with a [high school] degree in accounting, but I wanted to become an architect."

IN 1949, the year my father graduated from high school, Havana was in the middle of an architectural revolution. Annual construction costs for registered projects had soared upward of forty-six million pesos, equivalent to approximately half a billion dollars today. And what was being built was like nothing ever seen before in Cuba. Gone were the ponderous colonial buildings, austere art deco towers, and even fancifully decorated art nouveau, neo-baroque, and eclectic houses, the latter a term that describes a mishmash early-twentieth-century style. Cuban modernism was spare, avant garde, and geometric. Liberally using thin shell vaults—a reinforced concrete technology that allowed for wide areas to be spanned without the use of internal supports—architects created sweeping, arched rooflines, some barely three inches thick. Designs were self-consciously exuberant and tropical. Some, like Max Borges Recio's Náutico Beach Club (1953) and his Arcos de Cristal nightclub for the Tropicana

cabaret (1952), showcased the outdoors by using glass windows set between thin concrete arches. Other buildings were decorated with brick, terrazzo, hardwoods, metal, mosaics, colored glass, and, of course, concrete that was raked, pocked, perforated, and treated to expose its aggregate. The resulting architecture was both very modern and very Cuban, for it deliberately made use of the porticoes, patios, and louvered windows that had been used for centuries to manage the torrid climate.

Modernism was not simply a way of building; for Cuban artists and intellectuals of the mid-twentieth century, it was the post-colonial, philosophical, and conceptual crux of what it meant to be *cubano*. In painting and sculpture, the movement was called *La Vanguardia*, or "Vanguard." Started in the 1920s by painters who had traveled to Paris, rejecting the classical nineteenth-century training offered by the Cuban National Art School, it used the styles of Cubism, Surrealism, and Fauvism to produce artworks that were distinctly Cuban in subject matter, and searingly critical of the era's corrupt politics, especially when it came to the treatment of *campesinos*. In music, the movement began first with the mambo, a jaunty, syncopated dance style that in the 1930s modernized traditional Cuban dance styles with big band sounds and jazz riffs, and continued in the 1940s with the development of Afro-Cuban jazz and cha-cha-cha. These styles took the world by storm.

Cuba's two main architectural magazines published the works and writings of international superstars Frank Lloyd Wright, Walter Gropius, and Le Corbusier in the 1920s. In 1938, both Gropius and Austrian American architect Richard Neutra visited the University of Havana's school of architecture. Cuban would-be architects also studied abroad, most notably at Harvard and the

Georgia Institute of Technology, where the world's greatest innovators with thin-shell concrete construction taught, among them
Pier Luigi Nervi from Italy, Eduardo Torroja from Spain, and
Félix Candela from Mexico. My father would have given anything to be among them. But Alberto was an immigrant who had
traveled across the world to build a business. Though his younger
son, Enrique, was encouraged to become an optometrist, the
eldest, my father, was expected to help run the family business.

"I'll tell you what," said my grandfather to my father. "How
about if I buy a plot of land, and you design a building for us. As
an architect, you'd only make a few thousand dollars working for
someone else. This way, you can own the building too."

Guiding himself with Brazilian architectural magazines that
included photographs of buildings he referred to as "futuristic,"
my father got down to work. He sketched a fourteen-unit structure with a grand, sweeping exterior, a thin-shell concrete entryway, and kidney-shaped balconies. The interior hallway had a
curved staircase with bronze banisters, marble-paneled hallways,
and two-bedroom apartments featuring geometric, wooden-
screen dividers between the living and dining rooms. My grandfather bought a plot of land in the swanky seaside neighborhood
called Vedado, and hired a licensed architect to turn his son's
drawing into plans and manage the construction and engineering. According to my father, the architect/contractor said of his
design, "Let me simplify some details, and I'll give you the cost
of both designs so you decide which one makes more sense."

Though this smacks of collusion between Alberto and the
architect, my father had no choice but to agree. "At least they left
the interior the way I wanted it."

MOST CONCRETE IS UTILITARIAN, austere, and ugly. It causes heat buildup in cities and prevents water absorption into soils. Production of Portland cement is an environmental disaster, responsible for a whopping 8 percent of global greenhouse gases. Concrete sculpture calls to mind austere, Soviet-era monoliths of proletariat war heroes and workers. Brutalist buildings (a term that itself erroneously infers contempt) seem to be all about soulless, cost-saving government megastructures—courthouses, city halls, and low-income housing. But in the hands of a true artist, concrete, like marble, can be the essence of sublimity. Artists like Donald Judd and Nancy Holt have used concrete to create sculptures that are velvety in texture, subtly varied: the essence of modernism. Postwar architects throughout the world have used unpainted, reinforced concrete to display wooden formwork, variegated aggregate, and pocked fissures known as "bug holes" that result in aesthetic masterpieces. Just fly into Dulles International Airport, designed by Finnish architect Eero Saarinen, or thumb through a book on Brutalism, and you will be astonished.

Though concrete repair is a vast modern industry (it has its own gargantuan trade show, *World of Concrete*, held annually at the Las Vegas Convention Center), repairing "aesthetically significant" concrete—especially when it is unpainted and on the scale of a building—is more difficult than doing the same with a traditional material, like marble. To restore it you are forced to go nose to nose with its essence; you cannot scumble your repairs with varnishes and coatings. You have to reverse engineer the

process, understand the mix, the aggregate, how it was poured, what type of wood was used for the mold, and whether retardants or release agents were introduced to alter the drying. It takes repeated testing, patience, craftsmanship, and the belief that it is possible to reach the goal, for owners and contractors frequently like to say it is not doable. Even then, you're working blind until the mix cures, which can be up to a year. Achieving this aesthetic, and making sure that the concrete is of the right strength, is a tricky high-wire act. Then again, who really thinks of concrete as a thing of beauty?

My father did. I know because he told me so, about ten years ago, when I was explaining the care that needed to be taken when removing graffiti from the concrete formwork of the Miami Marine Stadium. Built in 1963, when thousands of Cubans began pouring into Miami, fleeing Castroism, the Marine Stadium is a striking, sculptural grandstand that sits partially in an aquatic basin and boasts a folded concrete plate roof that was the longest expanse of cantilevered concrete at the time of its construction. It was designed by a newly arrived Cuban architect named Hilario Candela for the purpose of watching speedboat racing and concerts and left to molder by the city in 1994, after Hurricane Andrew. Before its closing, the stadium was a much-beloved and well-known site for concerts and performances by the likes of Cab Calloway, Duke Ellington, the Who, and Bonnie Raitt. Jimmy Buffett's most famous concert ever ended with him jumping into the aqua water of the basin.

In the late 1940s, when my father was coming to terms with the fact that his destiny was commerce, not architecture, Hilario Candela was studying at Georgia Tech, where he found himself "surrounded by the masters of using concrete as expression, not

just a tool of construction." In summers, while my father trekked across the island to check on the Camagüey store and sell whole-sale eyeglass frames, Hilario came home to Havana to intern at the architectural firm of fellow Georgia Tech graduate Max Borges Recio, the designer of Arcos de Cristal, a much-lauded cabaret for Havana's Tropicana Nightclub. The Tropicana was the island's most popular nightclub. Tourists and Cubans alike flocked to see extravagant shows featuring the likes of Celia Cruz and Nat King Cole. Young people who couldn't afford a table were allowed to watch the show from the kidney-shaped bar for the price of a drink.

Among them was my father. With its sensuously lit tropical gardens, the Tropicana was one of his favorite spots for courting a beautiful girl he met by chance at a dance party. They would arrive separately at the nightclub. Secrecy was vital to their rela-tionship, for if there was anything that Alberto tolerated less than his eldest son working anywhere but in the family busi-ness, it was his romance with Hilda Peresechensky. Though Hilda was quiet and polite around the Lovingers, Alberto objected to her the moment he noticed her and Lindy holding hands at a beach club. "It's because I was poor," my mother insists. "He only wanted rich girls for his son, and he also hated that my father was an alcoholic, even though those things were not my fault."

But maybe it was a deeper understanding—one damaged tem-perament spotting another. Though my mother claims she was demure around the Lovingers, I know how she seethes when she feels snubbed. Her eyes narrow and her lips pull together, her breath flowing from her nostrils, like a dragon. A person who bangs his head against the wall instead of spewing his anger onto

others is no match for someone who does the opposite. When my mother feels threatened or disrespected, victory at all costs is her only aim.

IN MARCH 1952, just days after my father's building was completed, Cuba went from being a fledgling and rather corrupt republic to a full-blown dictatorship. It happened right after midnight, with swift surgical precision. Three black Buick sedans packed with army officers sped out of a country villa on the outskirts of Havana. They converged at the headquarters of the Cuban army and were waved through by the officers on duty. Armed men stepped out of the first two cars. Fulgencio Batista, a charismatic career officer and former president of Cuba, stepped out of the third sedan. Batista had been running for president again, but he was predicted to lose. He decided, instead, to take power by force. Cuba has not had a free election since that time.

My parents thought little of it. "We were young, just going about our business," said my father.

"I was too busy to worry about politics," echoed my mother. Having left the orphanage at age fourteen, she finally had a stable home. Her father had married Ana, the French-born Polish girl who had cared for her at the orphanage. They lived together in a light-filled, spacious, fourth-floor walk-up on Muralla Street that had two bathrooms. She had a new half-brother, Felix, born when she was fifteen. My mother attended high school at the Centro Israelita, her tuition paid by donations. There she mingled with the city's other Jewish teenagers, attended socialist-Zionist summer camps, and many dance parties.

She was a great dancer, having learned when she was little from Los Dandys, an Afro-Cuban dance troupe that rehearsed across from where she'd lived with her aunt and grandmother, before being sent to the orphanage. Los Dandys performed each spring at carnival, and almost always took the first prize in the competition. They enjoyed watching the five-year-old *polaquita*, as Jews were known in Cuba, copying their moves, and they repeatedly invited her to join them in practice. Coupled with her sauciness, good looks, and an intelligence born of the streets, being a great dancer made my mother a killer party date.

In those days, parties were all about clearing the furniture in someone's living room, putting records on the phonograph, and dancing to the latest mambo and cha-cha-cha tunes. One night, she noticed a skinny, pimply boy who was cutting some seriously good moves of his own. "Who's that?" she asked the host.

"You don't know Lindy?" asked their mutual friend David Egozi. My mother did not.

At the party, Lindy danced with Hilda a few times. He was as good as she was, but she was repelled by his acne. A few weeks later, while walking home from her job after school, she ran into him on Prado, a wide promenade near Old Havana. She was with a friend. He was with his mother. "Later this afternoon I'm graduating from the high school. Won't you join us?" he said to the girls.

My mother liked the fact that he was nice and had a car. He took her to the movies and to the Casino Deportivo, a newly built social club with a community pool where young people went on weekends. Her father, Samuel, also liked her boyfriend. Lindy was gracious, friendly, and never acted superior because his family had money.

Was this love? "Not to me," my mother said.

He, on the other hand, was head over heels with the beauty from Old Havana. What a body, what a sensuous smile and attitude. She was practically the opposite of his docile homebody of a mother, but also Jewish. She was actually more like his father than he understood, but he did not know that at first.

Around the time my parents started dating, my maternal grandfather, Samuel, opened a fabric store in Cárdenas, a seaside rural outpost ninety miles east of Havana. Cárdenas had fewer stores than Havana and was fertile ground for an immigrant business. Samuel's store was successful. My mother could finally afford to buy the occasional new dress, rather than rely strictly on hand-me-downs. Samuel's wife, Ana, did not want to move to Cárdenas. She, my mother, and little Felix remained as a family on Muralla Street, awaiting Samuel's return on weekends.

Then, predictably, Samuel stopped coming home. He also sent less money. Ana was a gentle, unsuspicious person, but my mother knew her father's ways. She started snooping around within the Jewish network of shopkeepers and learned that her father had started drinking again and the rent on the store was in arrears. There were other women also—prostitutes, goyim. And he was gambling, on *la bolita*, the lottery, and "everything except his family," my mother said ruefully.

When he finally lost the store, and the family could no longer afford the airy apartment on Muralla, my mother flew into a violent rage. "I called him every name in the book, and threw him out of the house. It broke my heart, but he ruined us. Ana and I moved to a small, dark, one-room place on Sol Street."

Little Felix was four years old, Hilda nineteen. "Ana and I both worked full-time jobs at fabric stores. We left him home

alone, telling him, 'Fishele, please stay in bed; don't go near the stove.' I'd run home at my lunch hour to feed him. After work, Ana would care for him. I did the cooking and the cleaning."

Those dark, destitute days seeded a newfound terror that would consume my mother forever. "I felt cursed, like nothing would ever work out for me. I would see the rats scurrying outside my window; they ran along the balcony railings." Worried all the time about the four-year-old they left alone, about her father, who wandered the streets, suffering from gout and alcoholism, but whom she would not forgive for what he had done, and mostly about the ever-present shadow of penury that trailed her no matter how hard she worked to get out from under it, she hooked onto the one bright spot in her existence: Lindy Lovinger. The boy who, though not handsome, promised her a life away from tenements with rusty pipes, broken windows, cockroaches that flew in while she slept at night, and shared bathrooms that she had to scrub before she would even deign to squat over the toilet. Lindy was kind and tenderhearted. It was no small matter that he was willing to defy his father to have her.

"No one had ever loved me like that," my mother said.

"She was really, really beautiful," my father added.

MAXIMS ABOUT BEAUTY ARE as ancient as the written word. "Everything has beauty, but not everyone sees it," said Confucius around 500 BCE. "Beauty is in the eyes of the beholder," wrote Plato a hundred years later. Conservation is a form of beauty-keeping; it seeks to reverse conditions that befoul the appearance

and intrinsic value of works of art, what Aristotle claimed repre-
sented "not the outward appearance of things but their inward
significance."

Though not dealt a great hand at the start of life, my mother's
single best trump card was looks that included an oval face, high
cheekbones, deep-set dark-green eyes flecked with hazel, and
shapely curves that were as desirable in mid-century Havana as a
Vedado penthouse and a Cadillac with sweeping fins. Pictures of
her from the era reveal a teenager who looks more like a showgirl
than one who lived in a tenement where the concrete floor of the
communal shower was glazed with scum, and excrement over-
flowed from the outhouses. "Being as poor as I was, I had to do
my best to always look like I was not. I bathed every day. I only
had two dresses, but they were always clean and ironed."

Even at age ninety, my mother gets her hair and nails done
weekly. Her eyebrows are tattooed, and she is always getting age
spots cauterized from her face and hands. She nags me constantly
to "Get a pedicure and manicure! Your nails look awful," even
though I explain, ad nauseum, that one can't wear nail polish and
work on artworks with one's hands.

And yet I have become aware in recent years that my interest
in restoring beauty, in reversing damage, might have to do with
my mother's intolerance of ugliness, even if takes a different form
than her obsession, say, with keeping her house so spotless that
there is not a speck of dirt under the kitchen sink, no dust on the
crown of lampshades, and you can literally eat off the floor of any
room in her house, even the bathroom.

WHEN MY BELEAGUERED and besotted father told my mother that he was being sent to New York for a year, "so I'll forget you," she responded, "Will you write to me?"

"Every day," he promised.

"I'll do the same," she said.

Hundreds of postcards went back and forth between New York and Havana. When Alberto was satisfied that Lindy had forgotten Hilda, he called him back to Havana. My father boxed up Hilda's cards and mailed them home so they would always have this memory of their secret courtship. When Alberto found out what had been happening behind his back, it was too late to stop it.

My father informed him: "I'm twenty-one years old and I don't need your permission. I'm marrying her, whether you like it or not."

For all his wrathful head banging, Alberto was not about to lose his son. Back in Romania, the Lovingers had been decimated by Hitler's gas chambers. As much as Alberto detested Hilda, at least she was Jewish. She even spoke fluent Yiddish. He chose the lesser of two evils and granted a reluctant blessing. But he never stopped seething over Lindy's choice, never stopped telling him in Hungarian, even in front of her, that she was going to ruin him and was only after his money. Had he soft-pedaled his objection, as he did when my father said he wanted to study architecture, he might have kept the lovers apart. As my mother admitted years later: "I wasn't in love with your father when he left for New York. It was only your grandfather's objection that made me determined to marry him."

MY PARENTS WERE MARRIED ON March 12, 1955, almost three years to the day since Batista's coup d'état. A few days before the ceremony, my parents gave a tour of their newly furnished apartment to my grandmother Blanca. My mother was nervous. Her future mother-in-law always appeared kind and generous, but Alberto's loathing continued to color everything.

The apartment was by far the loveliest place my mother had ever lived. It was in the Lovingers' airy Vedado building, in the back hallway with a partial ocean view from the balcony. My father had bought all new furniture for the place at La Nacional, Havana's trendiest furniture store. My mother's favorite item was a modern floating dresser mounted to the bedroom wall. When they were showing off the room, my father leaned his weight against the dresser. It tore out of the wall and crashed onto the tile, smashing a lamp that had been sitting on top.

"What's wrong with you? How can you be so stupid?" my mother yelled.

Blanca looked stunned. But on and on my mother went, unable to rein in her fear and fury even in front of her future mother-in-law.

At one point, Blanca interrupted, trying to calm the situation. "Don't pay too much attention, Lindy. She was raised without a mother. She doesn't always know how to act."

"What did you say?" my mother demanded.

Blanca responded only to my father, in Hungarian.

My mother turned to her future husband. "Choose between us. Right now. It's either me or her."

"Please, Hilda, enough," begged my father.

"It doesn't matter that we've sent the invitations," added my grandmother Blanca, revealing her true feelings in Spanish. "You'll be fine. There's nothing she can do for you that I can't."

"*Ah, sí?*" asked my mother.

"Don't, Hilda," my father warned. But it was too late. The match had been lit.

"You really think there's nothing I can do for him that you can't?"

My mother loves to tell this story to me. She relishes the details of my grandmother shaking her head smugly, my father begging her to please not utter what he knew was on the tip of her tongue. It makes me cringe to hear her final coup de grâce: "*Me lo puedo templar!*" I can fuck him! "And I've been doing just that."

REINFORCED CONCRETE IS A perfect metaphor for marriage. The steel makes the concrete strong under tension. The alkalinity of Portland cement protects the steel from corroding. The two parts work to keep each other strong. But this relationship has built-in flaws. The first is a process called carbonation, by which carbon dioxide in polluted air permeates the surface of the concrete, making it continually more acidic and therefore no longer able to keep the steel from corroding. Hairline cracks, even microscopic ones, allow water and air to enter and further corrode the steel. Because rust takes up more space than metallic steel, small cracks soon turn into big ones, allowing more water

in and therefore more rust, a process that self-perpetuates until repairs are made. If salt is added to the mix—either through coastal air or by poorly washed sand or gravel—corrosion accelerates.

Walking in a neighborhood of seriously deteriorated concrete is as sobering an experience as watching a marriage fall apart. Cracks appear like jagged wounds, bleeding orange rust. The stains are cries of accusation at those who have failed to provide the regular maintenance that is as necessary for aging concrete as upkeep is for marriage.

In Centro Havana, an early-twentieth-century quarter dense with very damaged concrete buildings, people steer toward the middle of the street when they walk, to avoid what one friend calls "raining balconies." Tropical weather is especially punishing to poorly made concrete. Hard rains followed by baking sun exacerbate cracks, leading to further rust and bigger cracks, eventually resulting in collapses, what in Cuba is called *un desrumbe*.

Given that reinforced concrete is the main building material for so much infrastructure—roadways, bridges, airport runways, granaries, and nuclear reactor cooling towers—its performance and sustainability are a matter of life safety. In 2006, when I was sent to coastal Mississippi by the National Trust for Historic Preservation to evaluate needs and gather stories of resilience through preservation after Hurricane Katrina, it was impossible to miss the fact that the 1980s reinforced concrete buildings fared far worse than old ones built of stone and wood. Salt-driven corrosion also appears as a major contributing factor in the horrific 2021 collapse of the Champlain Tower South condominium in Surfside, Florida, a sudden event that killed ninety-eight people.

AT THE CEREMONY WHERE MY parents signed their marriage certificate, Alberto could not contain himself. He started screaming in Hungarian, pounding the table. "Don't do it! Save yourself from her!"

"He knew what she'd be like," my father once said ruefully.

Yes, but, like salt air, he also was part of the problem.

Chapter Three

CERAMIC

was born three months before Fidel Castro, his brother Raúl, Ernesto "Che" Guevara, and fifty-seven other would-be revolutionaries left the Yucatan bound for Cuba on a yacht that was designed to hold twenty people and whose name was *Granma*, a misspelling of the word *Grandma*. Recounted in books, newsreels, and magazines, the events of that period are the stuff of opera: A storm throws the *Granma* off course. The landing is ambushed by the dictator's army. The Cuban press deliberately misreports that the revolutionaries were all killed or captured. Then, finally, a clandestine visit by *New York Times* reporter Herb Matthews to the Sierra Maestra Mountains, where he reveals that the swaggering, cigar-smoking Fidel Castro is very much alive and in the throes of a full-scale guerrilla war.

Described as the best journalistic scoop of the twentieth century, Matthews's front-page story appeared on February 24, 1957. I was almost five months old then—the second generation

of my family to be born in Cuba. That I would be the last would have seemed as absurd a notion to my parents as a spaceship landing on the moon. What on earth could have wrenched us away from this prosperous, welcoming country? Though Cuba was ruled by the same white Catholic elite that had brought the world the Inquisition, Cuba's bigotry in the mid-twentieth century was reserved for its population of color, not Eastern European whites. Racism in prerevolutionary Cuba was so pernicious that even President Batista, of mixed race, was not allowed to join the Havana Country Club. This fact was, of course, lost on people like my family, who only noticed that our fellow Cubans, whether Black or white, took no issue with our religious beliefs.

Eastern European Jews—Ashkenazis—were generally referred to as "Polackos," or Poles. That was not viewed as a slur, just Cuban shorthand, a moniker like "Chino" for Asians, "Gallego" for Spaniards, and "Alemán" for anyone not Jewish from a German-speaking country. Violence toward Jewish people, as had been seen during the war and its horrific aftermath, when emaciated concentration-camp survivors returned to towns in Hungary, Ukraine, and Poland only to be met by murderous mobs, simply was not prevalent in the Caribbean.

There were exceptions. Most notable among them was the St. Louis affair, a devastating 1939 refusal by then-Cuban president Federico Laredo Brú to allow an ocean liner carrying nine hundred Jewish refugees with proper visas to disembark at Havana. The boat was also turned away by Canada and the United States, resulting in the death of a third of the passengers and harrowing escapes for those who managed to elude capture by the Nazis. My mother recalls marching on the presidential palace as a child with

all the island's Jewish students, the residents of the Froyen Farayn among them, waving Cuban flags to protest the decision.

By the mid-1950s, those days were ancient history. Jews were well-established members of Cuban society. Most were middle-class merchants—a group with whom Batista had no problem. One of his closest associates was Meyer Lansky, a Jewish "businessman" he brought to Cuba to sanitize gambling operations after a high-profile 1953 article in the *Saturday Evening Post* singled out the island's casinos for particular corruption. Most of Cuba's twenty thousand Jews lived in Havana, a city that boasted Jewish schools, kosher restaurants, and three synagogues, the most well-attended being Beth Shalom (better known as El Patronato), a Conservative, meaning non-Orthodox, congregation. Construction had been funded by the most prosperous of Havana's Jews, my grandfather Alberto among them.

IN LATE 1956, when I was born, Cuba quivered with revolutionary fervor. Acts of sabotage, including bombs exploding in neighborhood trash cans, were commonplace. Students would be found shot dead by military police. "We were used to political violence," my father said. "It was more or less the way regime change happened in Cuba."

Two months after my mother came home from the maternity hospital, revolutionaries opened fire on the Montmartre nightclub, a nightspot a few blocks from our house that had featured performances by Lena Horne, Édith Piaf, and Cab Calloway. The chief of the island's feared military intelligence service was

killed in the attack, and the international press reported that
bleeding women in evening gowns stumbled into bullet-riddled
mirrors as they tried to flee the horror.

Then on New Year's Eve, the busiest night for Havana's night-
clubs, a bomb detonated at the Tropicana. That one really shook
my family. One of their neighbors in the building was a radio
announcer who broadcast his shows from the glamorous open-air
nightclub, and regularly invited my parents to sit at his ringside
table. "We probably would have been there if you hadn't just been
born," recalled my father.

Still, the warfare that mattered most to our family was
in-house. My mother and grandfather were at it constantly. He,
who had "saved a dime out of every dollar he made," according to
my father, criticized her spending. The whole family worked at
the store on Calle Bernaza, the men arriving in the morning, and
the woman coming only for the afternoon shift, after lunch and
siesta. But while Abuela Blanca took the trolley from Vedado to
Old Havana, my mother would wait around until the last minute,
then treat herself to taxis. At home she had a cook and laundress.
When I was born, a nanny came along. My grandmother did all
her own cooking and housework.

"Your father wanted to give me everything I didn't have," my
mother explained defiantly. This included renting a summer
house in the beach town of Santa Maria del Mar, paying for her
brother Felix's schooling, and looking the other way as she filched
cash from the register to buy furniture and clothes for her father,
Ana, and Felix.

Poverty has a way of gouging out all sense of moderation. As
a friend who was raised in abject circumstances explains: "If

you've ever had to stare into an empty refrigerator, you will never again have one that is not packed full, even if you can't possibly finish what's inside."

My mother was also egged on by her father, the perpetual gambler, with whom she'd made up right before her wedding. "I once took him with me to El Encanto to buy a bathing suit. My father had never been inside the store before. When I tried on the suit and asked what color he thought I should get, he said, 'Get it in every color!'"

The clashes between my mother and paternal grandfather reached a breaking point just months before I was born. The store on Calle Bernaza was packed to the rafters with merchandise, some of which was on high shelves. One busy day, a customer came in, asking for a particular doll for his daughter's birthday. Six months pregnant, my mother asked another employee to climb the steep ladder to bring a box down. My grandfather Alberto barked, "Get it yourself and don't bother others with work you should be doing." Whether that is what he said or what my mother heard is lost to history. She started up the ladder, then missed a rung and fell to the ground.

Rushed to the hospital, she was terrified of losing not only the baby, but her own life, given what had happened to her mother. She was confined to bed rest for the next three months. Alberto was contrite and despondent. "He came to visit me, white as a sheet," recalled my mother. "He practically got onto his knees, begging for forgiveness. I told him: 'If I lose this child, I'll kill you. I'll go to jail, but I *will* kill you. Count on it.'"

In conservation there's a term for works of art that come with intrinsic defects: *inherent vice.* In paintings, such fabrication flaws appear when an artist uses impasto (the thick application of pigment to a painting) that is too heavy to be held by a canvas, or oil paint underneath acrylic, a condition that leads to cracking and flaking as the oil paint cures, releasing gases that get trapped beneath the plasticky acrylic. When bronzes leach the remnants of an inner mold, called the "investment," through tiny pores or casting imperfections, that is inherent vice. So is the galvanic corrosion caused by welding two disparate metals together.

Items made of fired clay, such as ceramics, tiles, and terracotta, can display inherent vice in many ways. My friend and colleague Amy Green, a conservator and trained ceramist, explains: "Clays can have imperfections and inclusions. The firing temperature can be too low or too high. The temperature can be correct, but the item can be sitting in a cool spot in a kiln, or there can be an incompatible coefficient of expansion and contraction between the glaze and the clay, which can cause lifting or 'shivering' of the glaze, eventually having it fall off."

A conservator can't reverse such damage; she can only manage it.

This language of inherent vice applies both to my mother's and my grandfather's personalities. That they were similar in makeup is apparent only to me. My father, who was subject to both of their mercurial temperaments, would not see this. My

mother would consider the statement "a slap in the face." Whether these flaws were baked into their personalities—like clay that has the wrong inclusions—or a product of the hardships of their lives, is for a trained psychotherapist to unravel. I have spent a lifetime trying to manage my mother's mood swings. It leaves me numb, the way inherent vice does if I don't see a way to treat it. Like a ceramic with too thin a handle, she is always on the verge of fracturing. Initially beloved by everyone she meets, she often ends up shattering friendships. Those of us who won't abandon her—my father, my brother, me—receive her most blistering attacks. Afterward, she behaves as if nothing at all has happened. Seeking help is out of the question. "I'm my own therapist!" she claims anytime I try to mention that her mood swings, loneliness, catastrophizing, and rages might be managed by a professional. "I am the way I am because of what happened to me in my childhood," she counters, dismissing me even as she makes the case for my argument.

I know almost nothing of my grandfather Alberto's boyhood. There appears to have been crushing poverty, but was that all that caused him to be lonely, anxious, so frustrated that he banged his head against the wall? What drives a person to travel across the ocean, leaving everyone he loves behind?

My father once told me a story that might explain a subsequent reason for Alberto's rigid desire to keep his oldest son bound to him. The story takes place in 1934, when my father was two years old. By then Alberto had made decent money with his store in Camagüey. He decided to leave the store in the hands of a sister and brother who had followed him to Cuba and move back to Cluj with his wife and son. According to the 1930 Romanian census, there were then about 13,504 Jews in Cluj—12.7 percent

of the population. Jews were major contributors to the economic, social, and cultural life of the city. There were forty Jewish periodicals in the city and dozens of theaters and synagogues.

Upon his return to Transylvania, Alberto saw impending danger. My father was not specific about what Alberto saw, but history records this as a time in which the ultranationalist, anticommunist, and virulently antisemitic Iron Guard had been assuming power in Transylvania, stepping up harassment of the Jewish community. The Cluj synagogue was bombed in 1927, and the Jewish periodicals were ordered to be shut down. In nearby Germany, Hitler had risen to power, establishing the first anti-Jewish laws of the Reich. He became the führer by August of 1934.

My father wrote the story that his father told him:

> One day [my father, Alberto] was in a place at the wrong time, and the secret police rounded up the entire block he was walking on, and everybody was transferred to a big hall in front of a table where three people were siting inspecting everybody's documents. Nobody knew what was going on, but he noticed that some were ordered to go through one door and others through another. Fearing that, being a Jew, he might be sent through the bad door, and noticing that one individual sitting at the table was wearing a Mason ring, he stood in a position making a sign visibly recognizable by anybody who was also a Mason. As it happened, he was called by such person and he made him go through the door which set him free to go back to his family. The others who went through the other door, they were never heard from again. He tried to warn our families about this, and beg them to leave, but, naturally and quite understandably, nobody

listened. They told him he was imagining this. Who on earth
would have believed the Holocaust? My father became a Mason
before my mother came to Cuba. When I became eighteen years
old, he asked me to become one, which I did, knowing this story.

CONSERVATORS ARE TRAINED TO use caution when attributing the cause of damage. Terms like *appear to* and *evidence of* are standard in our field. A glaze could be detaching because the clay body is not porous enough to hold the fine vitreous surface in place. It could have been subject to water, mold, aggressive cleaning, or because it was buried for centuries in soil that was thick with salts. Our diagnostics try to take everything possible into account—the way things were made, their history, use, and the chemistry of their condition and fabrication. To me the difference between good and sloppy conservation is a commitment to doubt.

We come to our work with a body of knowledge, but our goal is to look at every object without preconceptions. In my career I've conserved dozens of Chinese T'ang ceramic horse and camel sculptures. These objects typically break along the legs where the ceramic is too thin. When someone brings one to my studio, I don't have to think too hard to diagnose what caused the damage. But it's my job to take the trouble anyway, to look beyond the old adhesive and the fills and make sure I am not seeing a unique condition. To understand the root of damage, we have to question what we know, over and over, even when the result seems obvious.

That leads me to say, therefore, it *appears* that my mother shows many of the symptoms of a personality disorder wrought

by early childhood trauma. And there is *evidence* that my grand-father's anxiety, which might have similar roots, became exacer-bated by the fact that he was unable to save his family from Hitler's genocide. I can't say for sure. I'm not a psychologist.

WHEN IT COMES TO MENDING FRACTURES in a family, there is nothing like a newborn child. My arrival was like a glue that bound all the pieces together. My birth meant that my parents moved to an airy, light-filled apartment along the more desirable front stairwell of the building in Vedado, a floor below Alberto and Blanca. Samuel, Ana, and Felix came by every week. Everyone doted on me, and not long thereafter, Blanca's sister, Fanny, arrived in Cuba from Budapest, after having spent the war years hiding in a convent. For the first time in her life, my mother's life was stable and free of want. The losses of her child-hood were mended and patched. She was always going to be rough, the scars and former breaks apparent. But for that short while—1956 to 1961—she was appreciated by everyone around her. Even Alberto could not help but show his delight and grati-tude. For me, those memories are held in black-and-white pho-tographs: Me sitting on a large bed, flanked by my adoring parents. Me on the porch swing on the balcony, or in the water at the beach, or posing with my grandmothers, Ana and Blanca, or cleverly seated among a group of bisque porcelain dolls that I was not allowed to play with, as my mother once explained, because they were too fragile for a toddler.

Though all was well within the family, the political situation in Cuba was rapidly devolving into full-blown civil war. This was

a product of years of inequality and corruption—inherent vice baked into the Republic of Cuba from its onset. On March 13, 1957, two years nearly to the day since my parents were married, the Directorio Revolucionario Estudiantil, a university students' revolutionary group, attacked the presidential palace looking to assassinate Fulgencio Batista in his second-floor office. There was a snitch within the group, and Batista was actually hiding on the third floor of the 1916 neo-baroque palace. Twenty out of a hundred students were killed on the spot. Almost all the others were captured. Those who managed to escape fled into the countryside where they joined one of the other revolutionary groups working to overthrow the dictatorship. This led to heightened vigilance across the island, and summary extrajudicial killings of anyone even suspected of revolutionary activity.

As bombs went off and acts of sabotage became more commonplace, my father was regularly stopped at checkpoints as he traveled to sell eyeglass frames or check on the store in Camagüey. "It could happen two or three times in one trip," he explained. "When the soldiers didn't find any weapons, they would demand I give them merchandise. If I didn't, they could shoot me and say I was a revolutionary."

Tired of the violence and the shakedowns, my family, like many others, welcomed Batista's ousting. On New Year's Eve 1958, they watched it happen from the balcony of their apartment in Vedado. Normally they would have celebrated at the radio announcer's table at the Tropicana, but rumors were circulating of bombings at the clubs that night, so they stayed home instead and partied with their neighbors. For Cubans, New Year's Eve is a raucous, all-night affair that typically ends with breakfast. At approximately 3:00 a.m., my parents and their friends

were on the balcony when they saw a large military plane fly over the building. This was unusual, to say the least. Airplanes did not take off in the middle of the night. This one turned several slow circles, then it banked sharply to the east over the ocean and disappeared. An hour or so later, another one followed.

In the morning, jubilation in the streets confirmed that Batista had escaped on the first plane. The second one contained his ministers and other government officials who feared for their lives with the advance of Castro's army. Days of celebration followed. The streets swarmed with people waving Cuban flags, shouting *"Viva Fidel!"* Livid mobs fanned through the city, attacking the parking meters and casinos—symbols of Batista's corruption. My family stayed indoors, the stores closed, as the country awaited the arrival of Fidel Castro and Che Guevara.

Eight days later, on January 8, 1959, amid wildly cheering multitudes, Castro made his way across the crowded city of Havana to Campamento Columbia, the headquarters of the Cuban army. My family watched it on the television console in Alberto and Blanca's apartment. Castro delivered a three-hour, nine-thousand-word speech—his first public verbal marathon. At a key point in the spectacle, as he was assuring Cuban mothers that he would do everything in his power to solve all of the nation's problems without a drop of blood being shed, three white doves fluttered around the stage. One landed on his shoulder. The audience could be heard gasping. A quasi-religious aura descended on the crowd.

As my family watched in amazement, not sure whether to believe this was a rehearsed spectacle or divine providence, Blanca's sister, Fanny, stood up and pointed at the television: "They're communists!" she cried.

"What? That's crazy!" Alberto shouted.

"I'm telling you, they're communists. They did the same thing when they marched into Budapest!" she insisted.

I have queried many experts on the Soviet invasion of Hungary about this. They all insist that nothing of the sort happened in Budapest. But Tia Fanny swore she saw that same spectacle with the Soviet communists, and when she saw it a second time in Havana, she was adamant.

"We're going to have to leave the country."

"Sit down!" my grandfather barked. Turning to his sons, he said, "Just a spinster who doesn't know what she's talking about."

BEST PRACTICES IN CONSERVATION require us to know as much as possible before we take action. Most general situations demand careful, slow decision-making. (The exception is emergency work, where, like doctors in a field hospital, we make triage decisions for works pulled out of earthquake rubble or hurricane flooding.) Scientific diagnostics help inform our choices, but the value of a treatment is also a matter of circumstance. Typical ceramic repairs, for example, involve straightforward protocols. We fit fragments together, adhere them with a conservation-grade adhesive (which means it won't yellow or become brittle and insoluble over time), then fill losses with a number of reversible fill materials that mimic color and texture and, finally, use paints and varnishes to make the damage blend with the original surface.

But sometimes there's a reason to change the approach. The Japanese art of *kintsugi* is a process by which mends are highlighted

with gilded lacquer. The broken work of art becomes renewed and reinterpreted by damage. Archaeological ceramics are also not typically repaired invisibly. The shards, once dug up, are sorted at long tables. Matches are made by comparing texture, shape, and color. It makes no sense to hide these repairs. "With archaeological objects, we have to know the difference between wear and damage," explains Dr. Nancy Odegaard, a highly respected conservator and scholar who has authored several books on archaeological conservation. "The former contains information about use that must never be altered."

At the scale of architecture, the only thing that matters is the integrity of the material, its safety and long-term durability. The most gorgeous cladding is, first and foremost, there to shield the building from water intrusion. Unless a building is an ancient monument, no one wants to see a patchwork of repairs across its surface. When architectural ceramics fail, often you have to bite the bullet and replace. No one likes to do this. But conservators simply must make these hard choices. As Amy Green explains, "When a glaze is detached so badly that you can't see the surface anymore, or if the ceramic body is so crumbled that the remedy won't last, we just have no choice but to replace." The decision is imperfect, but we have to cut our losses or split the difference.

IN EARLY 1959, my parents weighed their own difficult decision. They did not act in haste. They stayed in Cuba for another two years, watching their country devolve from a freewheeling dictatorship into a frighteningly rigid totalitarian system. They brushed aside Tia Fanny's January outburst. They chalked up Che

Guevara's televised firing squads at La Cabaña fortress to the people's need to see their dead young men avenged. Agrarian reforms did not threaten their livelihood. Neither did the nationalization of the phone company. Having traveled regularly across the island, my father had seen the gaping economic inequalities between the rural landless poor and those whose ownership of vast sugarcane fields allowed them to build palaces filled with Carrara marble, furniture from Europe, and Lalique glass. He understood that some of what was happening was long overdue.

But when rumors began to circulate that there was going to be a moratorium on professionals leaving the country, my father's brother, Enrique, the optometrist, took off for Miami. My father continued working with his father at the Calle Bernaza store. Occasionally he traveled to Camagüey. Business remained healthy.

Fidel Castro declared himself head of the army, but not president. He appointed a moderate, respected judge to lead the nation and let him form a cabinet composed of liberals. Casino gambling was gone, but that was no big deal, unless you were in the Mafia. Cuba's wealthiest citizens had left in droves, but that was also understandable, given how closely they'd been associated with Batista.

Most important to my family was the fact that, radical as Castro appeared to be, his new government did not target Jews. He did not blame us for Batista's excesses, even though Batista was close pals with a Jewish member of the US Mafia. In the wake of World War II, in which Jews had been decimated, and Stalin's repeated purges and plots always targeted Jewish intellectuals and doctors, this was no small matter. Golda Meir of Israel sent Fidel a warm congratulatory message after his victory.

Like most Cubans, my family had no way of knowing that, since the earliest days of the revolution, Castro had been holding secret meetings with Soviet leaders and the Cuban Communist Party. The meetings took place in the fishing town of Cojímar, where Ernest Hemingway kept his boat, the *Pilar*, and where he set his Pulitzer Prize–winning novel, *The Old Man and the Sea*. By late 1959, the looming future became clear.

All summer long, key positions in the government had been assigned to members of Cuba's Communist Party. In response, Huber Matos, a hero of the revolution who had fought alongside Castro in the Sierra Maestra, resigned from his position on October 19, 1959. Two days later, Castro had him arrested. At a large outdoor rally, Castro whipped up support for his communist leanings by asking the assembled crowd whether Matos should be shot. News reports describe everyone shouting in unison "*Paredón! Paredón!*" (Firing squad! Firing squad!)

Matos was jailed, not shot, but my mother and father read the writing on the wall. "Let's go now," said my mother. My grandfather Alberto adamantly opposed the idea of abandoning his properties, which would be confiscated under new government laws. "The United States will never allow communism so close to its shores," he shouted. "If she wants to go so badly, let her take Rosita, and you can meet her later," he told my father.

"That is not going to happen," my mother told my father.

Through a New York eyeglass wholesaler whose merchandise my father sold across the island, my father obtained US-residency papers for the three of us. In the summer of 1960, as Cuba and the United States sparred over oil and the island's relationship to the Soviet Union, the US oil industry in Cuba was nationalized.

In October, all other US-owned businesses were expropriated. A break in United States–Cuban relations seemed imminent.

My grandfather's best friend, Herman Weiss, told him, "Bumi, mortgage all your properties and take your money to Miami!"

My grandfather dismissed him handily.

Not long thereafter, the Cuban government passed a law nullifying all property leases and giving rental units to their occupants through a rent-to-buy program that compensated owners at state-determined prices.

Now stripped of the building he had designed in Vedado, and another one my grandfather had purchased in an inland neighborhood called La Víbora, my father told his father, "It's time to get out with as much money as we can."

Herman Weiss again had a solution. "Send Lindy to Miami. Someone will meet him at the airport and take him to the bank to open an account for $300,000."

Back in Havana, my grandfather was to transfer the equivalent in Cuban pesos plus 20 percent to someone else's account.

But the very same Alberto who had had the prescience and will to traverse the ocean in the 1920s, then head east in Cuba to make his fortune, then flee Santa Cruz del Sur when his wife augured a tidal wave, and sense the rumblings of the Holocaust in 1934, could not accept what was about to happen to his beloved adopted country. When my father begged him to do the deal, he shouted: "I've worked too hard in life to give 20 percent of what I've earned to gangsters! The United States is not going to let this happen!"

Maybe it was not just about money. Cuba had welcomed my grandfather and given him the opportunity to prosper. Cuba had offered him the immigrant's dream of solace, prosperity, a place

to raise children and grandchildren without having to worry about being rounded up and sent to Auschwitz. At sixty years old, having left one country already, who would not cling to hope for an adopted home?

The final straws came in rapid succession. Just before Christmas, my father was called to the ministry responsible for nationalizing small business. "They asked me to go across the island and give them an inventory of all the stores. I knew them all because we were their wholesalers. This was going to mean showing up to my customers and taking away their businesses. I did not want to do it, but there was no way to say no to those people."

Finally, there was the time I purportedly came home from preschool and announced, "Today in school, I learned that Fidel is more powerful than God and Papa!"

"What's that?" my mother asked, alarmed.

I proceeded to explain to her how, at the Jewish preschool I attended, all the four-year-olds were told to close our eyes and ask Papa Dios, as God was referred to among small children, to deliver candy to them. When we opened our eyes, there was of course nothing in our hands. The exercise was then repeated with the request being made to "Papa Fidel." And, of course, upon opening our eyes, we had the candy.

"There's no more time to waste," my mother said to my father.

On January 3, 1961, the United States broke off diplomatic relations.

On January 6, Three Kings Day, we left Cuba. It would be the last time my parents would see their homeland.

Chapter Four

PLASTIC

Before the middle of the nineteenth century, every item that we wore, built, wrote with, ate upon, and saw came from plants or animals or the rocks and metals that form the Earth's crust. That changed in 1855, when an English scientist named Alexander Parkes mixed cotton with nitric acid to produce a gummy, clear material that hardened to a film for waterproofing fabrics. Parkes went bankrupt before his invention, called Parkesine, could go into production. An American who bought the patent used the mix to make synthetic substitutes for billiard balls (fascination with the game had begun endangering the world's elephant population) and, later, combs, men's collars, musical instrument parts, and, most important, photographic film that ushered in the age of movies. The resulting synthetic, called celluloid, was the world's first plastic.

Celluloid remained dependent on a natural product—cotton. But in 1907, a Belgian American named Leo Baekeland developed

a fully artificial formula for shellac, a coating used traditionally as a medium for mixing paint, a varnish for furniture, and as the material of choice for pressing gramophone records and insulating wires in the new electrical industry. Made by combining formaldehyde, a common laboratory chemical, and phenol, a waste product of coal extraction, Baekeland's formula, called Bakelite, marked the first time in human history that a substance was made entirely of material that did not exist in nature. Baekeland coined the term *plastics*, derived from the Greek *plastikos*, which means an item that can be shaped or poured into a mold.

By the 1930s—a mere two decades since Bakelite's discovery—manufacturers like Rohm and Haas, BASF, IG Farben, and E. I. du Pont de Nemours (today known chiefly as DuPont) had invented polymethylmethacrylate (acrylic), polystyrene, melamine, polyurethane, polyethylene, and nylon. Unlike celluloid and Bakelite, which were synthesized in response to specific needs, these new polymers were made for the heck of it. Scientists figured there'd be plenty of commercial uses for them. When Hitler began marching across Europe, commercial uses were scrapped in order to make airplane windows and submarine periscopes (acrylics), parachutes and airplane cords (nylon), and, as Susan Freinkel writes in *Plastics: A Toxic Love Story*, "mortar fuses . . . aircraft components, antenna housing, bazooka barrels, enclosures for gun turrets, helmet liners, and countless other applications. Plastics were even essential to the building of the atomic bomb." At home, people gathered around Bakelite-encased radios to listen to news of the war.

When the war ended in 1945, the plastics industry was producing 818 million pounds of material per year in the United

States alone. Manufacturers finally turned their efforts to household goods, like Tupperware, cling wrap, Formica, linoleum, melamine trays, dinnerware, place mats, and furniture. Plastics also ushered in the era of children's toys like Gumby, LEGO, Colorforms, Mr. Potato Head, Hula-Hoops, Fisher Price Corn Poppers, and Mattel's glamorous career girl, Barbie.

THREE KINGS DAY is the traditional gift-giving day in Latin American countries. Children wake up on January 6 to see what Los Reyes Magos brought them. Even Jewish children received gifts on the holiday. In 1961 Los Reyes brought me a teddy bear, a baby doll, and a small, plastic doctor's kit with a stethoscope, a tongue depressor, and a toy pillbox inside.

That morning, tension swirled in our apartment. Nobody told me what was happening, of course, but my mother had spent the previous days quietly packing our belongings in preparation for leaving the country. Stealth was necessary because José, our building's *encargado* (superintendent), was the block's representative of the Committee for the Defense of the Revolution, a network of neighbor-upon-neighbor spy groups that had been set up on September 28, 1960—my fourth birthday—in response to a mysterious explosion on a French freighter that had been unloading ammunition in Havana Harbor.

The day of the explosion, Castro decreed: "We're going to set up a system of revolutionary collective vigilance so that everybody will know everybody else on his block, what they do . . . what they believe in, what people they meet, what activities they participate in. Because if they [the counterrevolutionaries] think

they can stand up to the people, they're going to be tremendously disappointed. Because we'll confront them with a committee of revolutionary vigilance on every block."

My parents had residency papers that allowed them entry into the United States. The tricky part was getting out of the country without incident. The rules weren't totally clear, and even with appropriate exit papers, things could happen to delay or cancel your departure. The CDRs would rapidly mobilize to taunt people, screaming "*gusano!*" or "worms," the term for people who were abandoning the revolution. Once those mobs formed, anything could happen. The street could have been blocked. Neighbors could have pelted us with rotten eggs and tomatoes, which people were encouraged to keep on hand for just that purpose. My father had heard of instances where neighbors smashed bottles in the street to damage the tires of cars taking would-be emigrants to the airport. If someone had decided to rough my father up, or grab my mother, someone could have reported my father to the police for having started the fight. My great-uncle Bernardo, a diamond cutter, had been hauled off to the dreaded La Cabaña fortress on some trumped-up counterrevolutionary charge. There he was stripped of his clothes each morning and forced to run laps barefoot on the eighteenth-century pavement stones, then forced to watch his fellow prisoners face the firing squads. A few months after we left, my grandfather Alberto was jailed for two days, because officials found boxes of deteriorating World War II–era baby bottle nipples on his shelves, and he was accused of hoarding.

Around midnight on January 6, Uncle Enrique's pals drove over, parked outside the building, waited to be sure José the *encargado* was asleep, then quietly hauled our boxes down the

curved staircase and took them to their apartments. The next morning, my father and grandfather went to work as usual. Three Kings Day was still celebrated, and the weeks prior to the holiday were ones of nonstop work from 9:00 a.m. to midnight at the Lovinger store. On the holiday itself, my grandfather had a tradition of opening the store for half a day to accommodate last-minute shoppers. My mother stayed home. My grandmother made lunch. My maternal grandfather, Samuel, came over, making a rare appearance at Alberto's table. "We ate a hearty lunch of rice, beans, chicken, because we did not know when our next meal would be," said my mother. After the meal, Alberto went down for his afternoon siesta. My father, mother, Samuel, and I got into a taxi. "Rosita is sick, we're taking her to the doctor," my mother called loudly as she left her beautiful Vedado apartment for the last time.

At the airport, Enrique's friends waited with the duffel bags and cartons. I've regularly wondered how it was possible to leave with so many personal belongings, but my mother explained that if you had proper papers, and US residency, you had a chance of taking anything you wanted—as long as it wasn't a prohibited item like a college diploma or a deed to a property. At the airport, one had to stay composed, not draw attention. No one knew what excuse could be used to rescind your exit permit. My mother was wearing gloves. Underneath were diamond rings—hers and my grandmother's. I was carrying my doll and doctor's kit.

In my mother's mind, the story of that morning centers on a single set of incidents. So much was happening: a stew of anguish over leaving the house, making sure the bags arrived without incident, passing through checkpoints armed by soldiers carrying

machine guns. She was doing everything possible to remain calm. The boxes and duffel bags contained mainly household goods, but some held valuables, like crystal and expensive Saladmaster pots and pans. They braced themselves for hours of opening and searching. But then my father spotted a Masonic ring on the hand of one of the soldiers.

Among Cuban men, Masonry had been popular and respected for centuries. José Martí, the venerated poet who is the intellectual author of Cuban independence, and Generals Carlos Manuel de Céspedes and Antonio Maceo, who led the 1898 War (known in the United States as the Spanish–American War), were Masons. Like his father, who had flashed the sign that saved their lives in 1934, my father now flashed the secret Masonic sign to the soldier with the ring. The soldier nodded and pointed to a box. My father pointed to a different one that held only my clothes and toys. That box was opened; the others passed through uninspected.

At the last checkpoint, a soldier asked my mother to open her handbag. She did so, relieved that they did not ask her to remove her gloves. Then the soldier said to me, "Let's see what's in that doctor's kit."

I clutched it to my chest and shook my head.

The soldier smiled, thin tolerance straining his features. "*Por favor, niñita.*"

"No. It's mine."

"Give it to him," hissed my mother.

The soldier crouched and looked me in the eye. "Your family can't pass through unless we see what's inside your doctor's kit."

I did not move.

My mother pinched my upper arm. "Open it right now, or I'm taking it away!"

As the story goes, I threw the kit on the ground and scattered its contents. "Here, take it!" I yelled.

"YOU ALMOST COST US OUR DEPARTURE," my mother likes to tell me. That's a preposterous thing to say to a child. But I don't remember much about that day. I'm always slightly frantic when I travel through an airport, certain of calamity about to happen— not the plane crashing, but a lost passport, a bag left on the curb, a missed connection. I check and recheck what I've packed, get there hours earlier than I need to. I'm sure it was that day of sitting for eight hours in "*la pesera*" (fishbowl), the glass enclosure where would-be immigrants were held without food or water. Behind the glass, relatives peered in, most in tears. "You had to be escorted to the bathroom, so you could not accept a package from someone outside," my mother explains. "I was wearing gloves to conceal my rings, and every five minutes you said to me, 'Mama, comb my hair!'"

My mother brushes off any notion that I just needed to be soothed, that I was feeling their tension. "Nonsense. You were too little."

Not any younger than she was when she was taken from her aunt's house and sent to an orphanage, which she claims to remember perfectly.

WE ARRIVED IN MIAMI late at night. My uncle Enrique picked us up and took us straight to Burger King. My parents ordered Whoppers. I picked at a small hamburger. We had no place to live yet, so my father left with Enrique to spend the night at a studio apartment in Hialeah, and my mother and I bunked at the house of the sister of my former nanny, Pilar.

The following day we found a furnished, one-bedroom apartment on Miami Beach. That's where the Jews settled, as opposed to the neighborhood west of downtown Miami that soon became known as Little Havana. To save money, Enrique left his studio and moved in with us. He slept on the living room sofa. I had a single bed along the wall in my parents' bedroom.

Among our new neighbors were many of my parents' friends, including the Zacroiskys who had partied with them on that fateful New Year's Eve welcoming in 1959. They had left several months earlier and had brought enough money with them to start their wholesale jewelry business.

"Because of your grandfather, all we had was $100, a single bill that your father hid in his cigarette lighter," said my mother bitterly. They spent the entire amount on a deposit for the apartment, food, and cleaning supplies. Smack dab in the middle of what is now fashionable South Beach, the apartment was dark, cramped, and grimy. "I spent a week scrubbing that place," my mother recalled. "By the time I got finished, what I thought was a brown sofa had turned orange."

While my mother cleaned, my father looked for work. First, he sold women's shoes. "He lasted one day. He couldn't deal with the crouching and the smelly feet and bunions." Then, walking

along Washington Avenue, five blocks from our apartment, the twenty-eight-year-old who had never worked for anyone but his own father found an optical store.

"The place was called Barnes Optical Service," wrote my father, documenting his experiences. There was a sign on the door that there would be an opening within the next two weeks. My father walked in and, in the fairly decent English he had learned in school, told the owner that he had experience in the optical industry.

"Can you do benchwork, cut, and mount lenses?" Barnes asked.

My father wasn't sure what he was asking, so he replied, "My father owned the store. My specialty was running the office and selling wholesale."

"Sorry, that's not really what I need," said Barnes.

My father left. But he returned the following week, still without a job. "Is the position filled?"

Barnes shook his head.

My father said, "Look, today is Wednesday, and your helper is leaving on Saturday. I will work for you Thursday, Friday, and Saturday for free. Let's call it a trial period. By Saturday you'll know if I can do the work. You have nothing to lose."

What my father wasn't able to explain to his would-be boss was that his father had made him work from the ground up. Therefore, he knew all of the technical artistry of optician work. By Saturday, he was hired. He was paid minimum wage—$1.00 per hour. Three weeks later, his paycheck doubled. He pointed out the mistake to Jack Barnes.

Barnes said, "It's no mistake, young man. Now that I realize what you can do, I want to make it impossible for anybody to steal you away from me."

My father was happy. "I didn't care if it was wholesale or retail. It was only supposed to be temporary."

WHEN DOES TEMPORARY BECOME PERMANENT? For plastics, the question is complicated. Plastics are polymers—extremely long macromolecules made of repeating, identical, small molecules known as monomers. Our DNA is a natural polymer. So are silk, wool, rubber, and the building blocks of every other living thing on Earth. The "Plastics Age," which began in the late nineteenth century, marked the onset of limitless invention. Waste products from oil and coal production have since been transformed into race cars, space suits, heart valves, artificial limbs, and microchips that allow us to hold entire libraries in the palm of one's hand.

But though plastics have brought us previously unimaginable conveniences, they are noxious, wasteful products that are wreaking havoc on our rivers, oceans, and marine life. Because their polymers cannot be consumed by bacteria or insects, plastics can linger for centuries before they break down. This permanence suggests that plastics are excellent materials for making durable works of art. The exact opposite is true. Plastics don't decompose entirely, but they degrade badly when exposed to sunlight, heat, and humidity. What's more, because plastics tend to be copolymers of more than one material and can be mixed with plasticizers to improve their flexibility, stabilizers to slow deterioration, fillers to change their transparency and color, lubricants and flow promoters to allow for intricacies in molding, and all manner of thickeners, impact modifiers, and flame retardants, they are open to endless modification.

In the early days of plastic use, artists and their fabricators experimented wildly with formulas. "We tweaked the amount of catalyst, added more plasticizers than traditional recipes called for, to see what we could get done for an artist," says Jeff Sanders, a fabricator who made many of Claes Oldenburg's 1970s multiples in California, including the black, rubbery *Soft Screw* and translucent green *Chrysler Airflow*. I have worked on many *Airflows*. They come to me sticky with plasticizers that have migrated out of the formula, flocked with dust and dog hairs. I wipe off the stickiness with solvents, but it always recurs.

Soft Screw, a work whose name describes it perfectly, begins to liquefy at the tip, the polymer oozing down the threaded shaft like a lethal chemical. This process has no remedy except refabrication. This has only been possible because the fabricator who made it originally is alive and both the artist's foundation and the edition's publisher, Gemini GEL, worked together to make it happen. Plastic artworks that are this degraded can otherwise only be maintained by storing in refrigerator-cold conditions. The same is true for early film stock, whose cellulose nitrate can self-ignite at room temperature.

Once a throwaway material, a substitute for a more valuable material like ivory, plastics are now major components of heritage collections. We collect early computers and telephones, models of the first Pan Am 747, spacesuits used for the moon walk, and works by artists like Eva Hesse and Bruce Nauman that were once translucent, malleable, and ethereal-looking, but now "exhibit severe symptoms of degradation, such as discoloration, embrittlement, distortion, cracking, stickiness, or the reek of vinegar or vomit," according to Dr. Tom Learner, head of the Scientific Department at the Getty Conservation Institute, where

groundbreaking research is being done to try to figure out how to deal with these once temporary objects that are now part of our permanent historical canon. As Learner and Dr. Odile Madden write in the GCI's Conservation Perspectives:

> Why do plastics seem inherently less secure than other materials we encounter as artifacts? One reason is that their technology is relatively immature. For most traditional cultural heritage artifact materials, such as stone, wood, bone, ceramics, glass, metals, and oil paint, the technologies used to modify them developed over a long period of time. Generations of practitioners have worked by trial and error and weeded out the processes that resulted in inferior products. . . . Moreover, older artifacts fashioned from traditional materials seem to be durable because they are the ones that survived. In essence, time has selected the sound examples while the unsound have returned to the earth. We also have had plenty of time to observe these survivors under a range of stressors and have experienced how variations in their makeup can affect longevity. . . . Plastics are different. Our experience with them is much shorter, and the objects being nominated for cultural heritage status were made only recently. We have limited understanding of how they will behave.

MY PARENTS UNDERSTOOD THAT their move to Miami was permanent "when the United States made a mess of the invasion." The "invasion" my father refers to was the thwarted April 1961 attack known here as the Bay of Pigs and in Cuba as Playa Girón. Both terms refer to a swampy site in southern coastal Cuba,

where an army of CIA-trained Cuban-exile mercenaries landed with the hopes of taking Cuba back from Castro. The would-be liberators had been training in the Everglades since 1959. They had contacts on the island among other revolutionary groups who had fought Batista and split from Castro. Unfortunately, someone ratted out the group, and the commandos' surprise landing was ambushed. John F. Kennedy, who had inherited the plan from his predecessor, Dwight D. Eisenhower, was not inclined toward the invasion. For this or some other reason, US air power was not deployed. Most of the landing liberators were captured. Some were killed, others imprisoned and paraded on television. It was humiliating to the United States and a triumph for Castro. To my parents, this was the sign that all was lost.

I was too young to understand what was going on. I remember thinking that Miami Beach was lovely. It looked very similar to our neighborhood in Havana. In some ways it was even better, because the beach was in walking distance from our apartment. All of our friends were there also, including Raquelita Zacroisky, our next-door neighbor in Havana who now lived in our building, and Roselyn and Lito Schniadoski, whose mother was my mother's best friend. On weekends, all the families would go to the beach together. Armed with folding chairs, umbrellas, blow-up rafts, and Styrofoam coolers packed with drinks and sandwiches, we would spend the entire day eating, swimming, building sandcastles, lounging on the sandbar, and playing in the wavelets with my father, who would splay his arms out like a giant pinwheel so we kids could spin around the frothy surf as if on an amusement-park ride. "We went to the beach because we couldn't afford anything else," my mother explains. For a child, this was heaven.

Except that there was always danger lurking. And not just the Portuguese man o' wars that appeared on the sand, their swollen blue bodies keeping us out of the water. Within seconds, and for no apparent reason, my mother could shift into a creature that stung with equal venom. My uncle Enrique once splashed her playfully at the beach, wetting her beehive updo. "I didn't speak to him for a year," she claims proudly. That seems hardly possible, since we all shared the same apartment, but it's a measure of her swagger. Our days were marked by her moods. She could be joyous, funny, loving, but if the wrong thing splattered her, watch out.

I sensed boiling anger underneath her sticky sadness. It spilled out one evening when the two of us went to dinner at a cafeteria a few blocks from our apartment. My father must have been working late. The memory is blurry, but I remember her growing morose and jagged as she reached into her wallet for spare coins to pay our bill. Then, on our way home, she slapped me. I remember the shock of it, not knowing what I did. To this day I don't know. She does not remember the episode at all.

These sudden attacks soon became the norm. My arm pinched hard, my ponytail yanked so abruptly that I would lose my balance. She insisted that I wear my hair so tightly pulled back in that ponytail that even as a four-year-old I felt it was precisely for that purpose. Her rebukes were even more disturbing. "I gave you life, and I can take it away!" my mother hissed with seething anger, so close to my face that I recoiled from the scent of cigarettes on her breath. Typical kid misbehaviors—whining, fighting with another little girl, getting a bad report from preschool, or continuing to color or play with my toys when she said it was time to take a bath—would send her flying at me, belt in hand.

Each time she walked into the room, or when we sat to dinner, it felt like I was stepping off a cliff. If I did not finish what she put on my plate, she would dump my dinner onto my head, rice, beans, and eggs streaming over my tear-strewn face and clothes. I'd quake in my seat, unable to swallow or move, as she stormed around me, threatening and screaming.

Sometimes she snapped out of it quickly. Other times it escalated, but always when no one else was around. Then she'd yank me by the arm, throw me into the bathtub, railing at me for having to clean the slop of food that she herself had thrown over my head. At five years old, I was a veteran of her invectives. I braced for them, steeled myself against her wrath by telling myself it would not last long. Once she figured out my strategy, she upped the ante. "So, you think you know what's about to happen? Oh, no, you don't. What's coming is like nothing that's ever hit you before." I'd break down, sobbing. She did this only when we were alone, never in front of others. Her goal was terror and domination. And it worked.

Within months of our arrival, my parents got my uncle Felix out of Cuba. He was not quite thirteen years old, more of an older brother to me than a younger one to my mother. He slept on a cot in the living room and went to high school. Now there were five of us in the one-bedroom apartment. "I was responsible for everything at home!" my mother declared. "We also had to send money to Cuba because your grandfather Alberto refused to help my parents and they didn't have enough to eat. 'I don't give money to drunks,' he said."

Exile was driving her crazy. And I received the brunt of her insanity. I don't remember my uncles ever saying a word about it. How could they? She ruled their universe. My father once told

me that he came home early and caught her hitting me while I was in the shower. "I grabbed her by the neck and told her I would kill her if I ever saw her doing that again."

I don't remember any of that, only that the terror continued. "God help you if you tell your father!" she would whisper. At night, she'd threaten, "You'd better go to sleep, or '*la ventana*' will come to get you!" I had recurring nightmares about zombies. A woman with dark, hollow eyes and outstretched palms clutching at me as I tried to run. To this day, I cannot stand to be alone at night in a place with too many windows.

One day, when I was six years old, my mother came home with what appeared to be a head in flames. "Highlights were ruining my hair, so my hairdresser suggested that I dye it red," she explains, laughing. I ran off, terrified, and lay on the bed and cried.

"I don't remember that," she says.

But I do. It was an outward symbol of the conflagration raging in her. Of everything I was experiencing at her hands. Most Cuban parents spanked their children in the 1960s. My friends joke about it, but I can't. My mother's punishments were laced with turbulence beyond her control, a violence born of pure rage at the world that had betrayed her, the sort of thing that feels like it will escalate dangerously toward irrevocable tragedy. It never did. Never did she draw blood, break a bone, burn me with a cigarette she smoked, or leave me with a mark that lasted more than several hours. Never was I locked up, chained, or starved. On the contrary, she could be loving at times, encouraging me to eat and eat, then telling me I was fat. Though her behavior appeared sadistic and designed to terrorize, I see now that she was simply drowning in her own suffering.

Still, her words led me to think that she could take it further. "I wish you'd never been born. Keep crying and I'll give you something to really cry about!"

I believe my mother when she says that she does not remember these incidents. The literature of psychology has terms for this: *splitting* and *dissociation*. It happens to people who've been traumatized early in life. This is how a person who considers herself "not just a good mother, but a hell of a good mother," as mine does, could get into the face of her five-year-old and see a creature she wished had never been born. She comes apart, the polymers of personality dripping apart and growing treacherous, like plastics leaching into monomers as they disintegrate. Dissociation is the memory loss that allows her to forget, the following day or even later that evening, that she did anything at all.

IN THE SUMMER OF 1963, we moved to a two-bedroom apartment in the northern part of Miami Beach. My father and Enrique started a business selling wholesale eyeglasses. Jack Barnes begged my father not to leave him, but my father did not want to work for someone else. Enrique got married, and both sets of grandparents finally managed to leave Cuba.

Alberto was crushed by exile, but true to form, he began working for my father, saving money as he always had.

Samuel did not like the United States, and he left for Puerto Rico, where he immediately developed liver cancer. "I went to get him and was told he had three months to live," my mother recalled. "I brought him home, and he lay on our couch all day. I

injected him with morphine for the pain. He was so thin that I was afraid to puncture one of his bones or organs."

Blanca died first, of a stroke. Samuel was next. My parents were inconsolable. "My mother was the sweetest person in the world," my father always said. Of her father, my mother always insisted, "He was a terrible drunk, gambler, and womanizer, but no one has ever loved me like that!"

Our next-door neighbors in the new apartment were transplants from Brooklyn. They had two daughters almost my age, and we played every afternoon after school. My mother began working at Mount Sinai Hospital in Miami Beach. "I was a translator from Yiddish and Spanish to English. I didn't really speak English, but I figured it out."

My mother's job upset my father. He said, "People are going to think I can't support you."

"What do you care what people think?" she retorted. "We need this money to send Rosita to private school."

The decision to send me to the Hebrew Academy of Greater Miami came within months of John F. Kennedy's assassination. I was seven years old, and I remember running home from second grade at Biscayne Elementary School, terrified that all Cubans were going to be sent back. I don't know what triggered that fear; I probably heard it at home or on the television, where we watched President Kennedy's funeral with the rest of the country. Maybe it was at school, for shortly thereafter, my teacher Mrs. Potamkin called my parents and told them, "Rosa does not know how to behave like a good citizen." A note was sent home: "Rosa would be better served by a school that can teach her how to be a proper American." The xenophobia was palpable. My mother exploded—this time not at me, but at my teacher.

What led to my teacher's declaration was my being taunted in her brief absence to write "fuck" on the blackboard. Not knowing how to spell it, I wrote "fuk." I was rowdy, the class clown, craving attention. And so, I was removed from public school and sent to private Jewish school along with my mother's best friend's kids, Lito and Roselyn. We took the bus together, and Roselyn remembers that I was raucous and bullyish toward other children. At home, I was the opposite—meek, worried, tiptoeing around my mother, and still always managing to set her off. I got home from school an hour before she came from work and waited for her at the neighbors', doing my homework while they had their dinner at five o'clock.

One afternoon, I sat in the sisters' bedroom, consumed by envy. I could not stand how much the sisters had. Parents who never hit them. And each other! What did I know of their other troubles? All I saw was that they did not live in a powder keg. In a fog, I walked into their closet, where a lovely pair of lace-trimmed blue dresses hung. I had nice dresses, too, but these were matching, a tangible sign of what I was missing. Taking a child's rounded scissors, I snipped several V-shaped holes into the fabric, then I put the scissors back where I had found them and walked out to the dining alcove, where the family was eating. "Do you know that Susan and Madeline's blue dresses have little holes in them?" I innocently asked.

I knew what would happen. I waited for it, with a lump not in my throat, but in my whole body. A car wreck was careening toward me. Eleanor, our kindly neighbor, gently asked, "Rosa, did you do this?"

I shook my head.

"Really, honey, did you cut the dresses?"

I shrugged and looked down at my shoes.

And so, it finally erupted in front of someone other than my family. A conflagration. The beating lasted hours. My mother screamed so loudly and with such acerbic ferocity that I thought I was going to faint. "What's wrong with you? Why did you do this to me? Don't you know we need Eleanor to help out, so you can go to private school? How can you be so stupid and selfish? I could kill you! We don't have money to throw around!"

When my father came home, it continued. This time he could not help but agree with her. I was a monster. Something was wrong with me. At some point I fell into bed and slept. They briefly sent me to a child psychologist, but I remember nothing of those sessions.

FROM MY MOTHER'S POINT OF VIEW, I must have seemed possessed, a demon child. Not only had I cost them money that they did not have, I had also exposed our family's cracks and knots in front of other people. But that was the point. A therapist I had later in life said it was my way of "displaying the worthlessness she made me feel, the outside mirroring what the inside felt like." And had I not cut those dresses, I might not have remembered how bad things were. For as the great Jorge Luis Borges wrote, "Our minds are porous, and forgetfulness seeps in." My childhood was marked by hundreds of violent episodes, but I remember few in technicolor. Mostly, I retain snippets of a door thrown open, a belt snapped, eyes blazing, and nostrils flared, and me cowering in my bed, choking with tears, or pressed against the passenger door of my mother's green Impala as she

shrieked at me, building up steam at the injustice of having a daughter who was so stupid and selfish or at herself for allowing me to be the way I was instead of the ideal she wanted.

Luckily, old friends hold my memories for me. My best friend lived across the street from me, and she recalled a time when we were playing at my house when she was ten years old and I was eleven. "Your mother came home from work. You had forgotten to take the rice out of the refrigerator. She started hitting you on the head with a slipper. You begged her, 'Mommy, Mommy, please stop, I'm sorry.' But she got angrier by the minute, pulling on your hair, throwing our board game onto the floor, then going into your room, opening your drawers, dumping the clothes onto the floor, and ordering you to clean it up. I ran home in the middle of it. A few hours later, after dinner, you called me and told me to come back. When I did, your mother acted like nothing had happened."

THE PLASTIC BARBIES THAT I loved to play with in my early years are made of polyvinyl chloride. PVC is an incredibly versatile polymer, used for making everything from rigid plumbing pipes and window frames to credit cards, medical catheters, and toys. PVC can splinter, darken, harden, and leach toxic plasticizers. Throughout my childhood, my mother also seemed to ooze a dangerous substance. Unlike the phthalates that are used to soften the plastic of children's toys, this substance had no scent or texture. It was simply there, threatening to burn at the drop of a hat, especially on birthdays, holidays, and Mother's Day, when I would somehow always fail to get her a gift she wanted or a card

that gushed effusively enough. I longed for a sibling. My mother told me she could not have other children. Then in my adulthood she confessed that she had been afraid of pregnancy and had had two abortions, a legal one in Cuba, two months after I was born, and an illegal one done by a doctor friend at Mount Sinai Hospital in Miami Beach. "I had escaped what happened to my mother once, but who knew if I could do it twice."

Not long after my twelfth birthday, my mother announced that she was pregnant. I had no desire to think about her sexuality when I was just discovering my own. She wielded her condition like another club in her arsenal; anything I did was now me "trying to harm the baby." My brother, Steven, was born a week before my thirteenth birthday. By then, I didn't need a baby sibling; I needed to get out of there.

My father and Enrique added several brick-and-mortar optical stores to their wholesale business. Because my father was experiencing difficulties obtaining plastic eyeglass lenses, he got the idea to open a factory that made injection-molded CR-39 lenses himself. This was an audacious thing to do, but it was along the same lines as his love of architecture: It was "building, creating," as he told me. He hired a French chemical engineer to help him. For capital, my father partnered with a fellow Cuban Jew, a longtime friend known as El Capitán because of his wealth and success.

My father designed the laboratory himself—including a filtration system for keeping dust out of the room where the lenses had to cure. Finally, my parents' finances were stable. They bought a little house on Biscayne Point, an artificial island formed in the early 1900s by the dredging of a navigation channel. My friends Lito and Roselyn lived several blocks away, but my mother had

had a fight with their mother, and they'd stopped speaking to each other. Our families no longer spent time together.

The fights and breakups escalated. There were blowouts with our next-door neighbors, betrayals by accountants, partners, and friends. Eventually, El Capitán's right-hand man, Feinstein, began suspecting that my father was stealing from them. "I was traveling to Japan for them, bringing back huge stacks of cash," my father explained, "but Feinstein couldn't believe I wasn't keeping some for myself. He couldn't imagine that a person wouldn't steal from his own partners."

"He's the type of person who would put out his own eye if it would keep another man from seeing!" exclaims my mother whenever Feinstein's name is mentioned.

Feinstein's suspicion led to an internal investigation. They brought in a forensic accountant. They found no wrongdoing, but Feinstein told El Capitán, "Keep looking; you'll find it!" Nothing was found, but El Capitán nonetheless decided to pull out of the plastic lens factory. My father lost his business and livelihood.

Mortified, he went from old friend to old friend in La Colonia, but "everybody turned their backs on him," according to my mother. "No one wanted to make El Capitán angry, not even the people your father and grandfather helped in Cuba when they had nothing."

Anger laced with acrimony. That was the melody and harmony of my growing-up years in Miami.

I threw my energy into painting and studying. I went to synagogue and became best friends with our rabbi's daughter. During normal weekdays, Reena's house could be as chaotic as anyone's, but come Friday night, everything would settle into holy calm when her mother lit the Sabbath candles. How amazing was the

word of God, I thought, a supreme being more powerful than my mother. He who ruled the heavens commanded us to shut out the chaos and the trauma and spend twenty-four hours praying, reading, napping, singing, and of course eating—copious amounts of food that reminded me more of my Abuela Blanca's Hungarian pastries than the rice, meat, and plantains that were our family's staples.

"Don't think for a minute that I'm going to keep a kosher home," my mother warned when I grew more serious about Jewish practice. One time before Passover, when I said I wouldn't touch a bite of food if they did not throw out the bread and change their dishes, she hauled me into our school's principal, a rabbi, and said, "You people are breaking up our family!"

The wise rabbi looked at me and said, "Shalom Bayit [peace at home] and respecting your parents are the most important Jewish values."

"You see?" my mother crowed triumphantly.

DURING THE PERIOD OF relative financial stability when my father had the plastics factory, he bought a boat. A used, twenty-seven-foot, fiberglass Sea Ray cabin cruiser, it was kept on steel davits over the canal behind our house. My mother named it *Pucho II*, after her nickname for my father. Every Sunday when the weather cooperated, we would pack the *Pucho II* with towels, blow-up rafts, snacks, sodas, ice, and floaties for my little brother, then head out below the bridge at the end of our street (the expensive houses on the island faced the open water) for picnicking and swimming around the little islands that, years

later, would be surrounded in pink plastic fabric by the installation artists Christo and Jeanne-Claude.

Our boating trips were always within Biscayne Bay, the eight-mile-wide by thirty-five-mile-long (other measurements bring it north and south to sixty miles) lagoon that encompasses the cities of Miami and Miami Beach in a waterscape of islands, dolphins, seabirds, coral reefs, and manatees—gentle bovines of the sea whose existence is now threatened by the disappearance of seagrasses. We'd have a great time, until my mother would get inevitably pissed off. To be fair, she didn't like boating. For her, most of it was about serving and cleaning up, which she did not need after a full week on her feet as an optician at Sears. (She'd wanted to study nursing, but my father wouldn't allow it, because "the hospital was full of intrigue between nurses and doctors.") If it squalled, she would cower in the cabin, wailing, "Oh God, oh God," as lightning flashed and we rode the whitecaps back to the safety of our canal. She would then swear never to go on the boat again. But she always did. Because as much as she hated the boat, I never saw my father happier than when he stood open-shirted at the wheel of *Pucho II* wearing a bucket hat and aviator sunglasses, piloting beneath a causeway, waving at a passing sailboat, honking at a jet skier who was going too fast, or dropping anchor by the entrance to the crystalline aqua basin near the Marine Stadium, where more than once we watched the tail end of a hydroplane race.

Still, sometimes I heard my parents arguing with such hostility that I worried he would leave us, a thought terrifying to me, because then I'd be stuck with my mother on my own. Once, years later, I asked him why he never did. "Because she

threatened to kill you and herself, and leave a note that I was responsible," said my father.

Even a child could have seen through that bluff. But I could definitely picture her saying it. And yet, despite the constant fights, slammed doors, and vitriolic insults—"You're the worst thing that ever happened to me!" "My father was right! You're a nobody, someone who brings me down, not up!"—and one of them threatening to leave (usually it was her, which even then seemed laughable), they never even got close to separating. One of them would storm out holding car keys, but would be back in the time it took to drive around the block. When my father traveled for work, my mother would grow twitchy and distracted, her fuse ready to ignite over any small thing. Then he would burst into the door, suitcases stuffed with gifts, and they would be all over each other, kissing and retiring to the bedroom (to my teenage mortification) or huddling at the dining table, mulling over trends in the optical industry—what frame types are in style, is metal making a comeback, how close are the Japanese to copying the styles of the Italians. My parents never seemed to talk about anything but eyeglasses.

The year I applied to college, one of my mother's young coworkers died by suicide. The girl was in her twenties. My mother had befriended her at Sears, and the girl repeatedly came in to work with swollen red eyes, complaining that her mother abused her physically and stole her paycheck money. At the funeral, which everyone in the optical department attended, my mother could not contain her sense of injustice. When it was time to pay respects to the family, she stood before the weeping, bereft mother and said, "It's a little late to be crying, isn't it? You caused this."

The shocked family filed a complaint with Sears. My mother was fired. She protested, "But it is true! The girl moaned about it all the time." My mother came home that afternoon mortified and scared about the future. "Why on earth did I have to step on my own tongue?" she cried, using a Cuban expression. Then she turned to me and warned, "You'd better forget about going to a private college."

"But I've already been accepted. We paid the deposit."

"Well, things have changed."

"Just fill out the financial aid papers," I begged.

"We already said no. We don't take charity," my father barked.

"Enough, Rosa!" my mother yelled. "I've got more important matters to worry about. Not everything is about you. You can stay home and go to community college."

They slammed into their bedroom. I flopped down on my own bed, my head pounding the way it always did after one of her violent outbursts. I didn't need to worry for too long, however. The threat was empty, like so many in my family. Within a week, my mother got a temporary job with a wholesaler my father knew, one of his many friends in the eyeglass business. She was paid seven hundred dollars a week under the table, far more than at Sears. Community college was not mentioned again, until the summer before my sophomore year. And then before my junior year. Every August, my mother would pick a fight with me about the cost of college, leaving me hanging for a week or two. It would always work out. Eventually I came to realize this was a game, like when someone dangles a toy before a dog, yanks it away, then drops it on the floor.

IF ALL THIS FIGHTING and drama and manipulation had been the sum total of my youth, my history with my parents might have fizzled when I left for college. Like an artwork too deteriorated to conserve, our love would have been wrapped in tissue, boxed up, and placed on a back shelf. But there was also active kindness, humor, and generosity in my family. It was hard to see it, just as it's hard to notice anything but the dents and cracks and gouges in an otherwise beautiful sculpture. When I was fourteen, my mother opened our home to my friend Carol, whose parents were in the middle of a rancorous divorce. Carol was the same friend who'd been at my house when my mother knocked our board game over and started hitting me on my head with a slipper. My mother seemed monstrous to her at the time, but she wound up living with us for a year, sharing not only my bedroom, but the love, attention, and tempests of our fractious brood. Years later, when my brother was in high school, my mother did the same thing for a friend of his whose father had a drug problem and could not take care of him.

"How is it that you were always so worried about money, and yet, twice you took in the children of strangers?" I once asked her.

My mother paused, then said: "They weren't strangers. They were your friends. Besides, I know what it means to need a home, a family."

So many words were on my tongue. I swallowed them.

"You may not realize this, Rosita, but everything I do is so you won't have to suffer the way I did. All I've ever wanted was for you and your brother to have everything I never had as a child."

So many cracks and contradictions. I know she meant this from the bottom of her broken heart. All she ever wanted was for me to have the happiness she lacked. And for me the only way to find that was to get away, primarily from her, but also from Miami, with its cloying melancholy for the island lost, its lack of art museums, and anything that mattered to me. Cuba had been just an accidental stopping point for our family. We were Jews from Eastern Europe. It was time to set things straight, to head to the Northeast, where my grandfathers had hoped to land when they'd first left Transylvania and Bessarabia. I applied only to colleges in Boston and New York. I know my parents did not want me to leave home. But despite their normal turbulence, and the ache this must have caused them, they let me go.

PART TWO

BRONZE

n the early hours of November 4, 1966, a chilly fall evening in Tuscany, police precincts in the city of Florence began receiving urgent requests for assistance from villages upriver in the Arno River Valley. It had been raining hard all night, the culmination of weeks of steady downpours, and the Arno was cresting alarmingly high, about to burst its banks. The river soon began to pour into those towns. Hydraulic engineers scrambled to let water out of a nearby dam, to stem the pressure, but the Arno kept careening toward Florence at the speed of sixty-seven miles per hour. At noon, when the churning flood-waters jumped the banks within the city proper, the current was moving at 145,000 cubic feet per second, nearly twice what the river's banks could handle. For the next six hours, about 225,000 gallons of muddy water per second poured into the capital of the Renaissance. By evening, when the waters began receding, thirty-three people were dead and twenty thousand homeless. Mud was

everywhere, mixed with rotting carcasses of pets and farm animals and slick iridescent oil from burst heating tanks.

The destruction of the city's art collections was unprecedented. Floodwaters had slammed Florence before, but nothing like in 1966. The force of the torrent tore panels of Lorenzo Ghiberti's fifteenth-century gilded bronze doors, the *Gates of Paradise*, from the portal of the Florence Baptistery. At Santa Croce, the burial place of Michelangelo, Galileo, Ghiberti, and Machiavelli, muddy water rose to a level of nine feet, stripping the paint from Cimabue's *Crucifix* of 1265, ravaging altarpieces by Vasari, and barely missing murals by Giotto. More than a million books and documents in the Biblioteca nazionale, a library founded in the eighteenth century, were soaked in filth. The basement of the Uffizi, where works of art by Giotto, Botticelli, and Filippo Lippi were undergoing conservation, was flooded nearly to the ceiling.

Overall, one hundred and twenty frescoes, three hundred panel paintings, five hundred sculptures, eight hundred works on canvas, and millions of books were damaged or destroyed by the flood. The devastation also galvanized restorers, conservators, and volunteers from all over the world to flock to Florence to help salvage the city's treasures. It marked the first time in history that the world's restorers and art historians came together in such a manner. It changed the field of conservation from one of isolated museum laboratories and training centers to a global profession with shared principles, ideologies, and guidelines for practice.

In 1978, when I began my conservation studies at New York University's Institute of Fine Arts, the specter of Florence remained palpable. Established in 1961 under the directorship of former Monuments Man Sheldon Keck and his wife and fellow conservator, Caroline Keck, the Conservation Center of the

Institute of Fine Arts was the first graduate training program founded in the United States. The goal of master's-level conservation training was to codify professional education in a field that had, for centuries, been a vocation learned by apprenticeship and called simply "restoration," a term that is broad and insufficient. Over time it encompassed everything from wax-lining Rembrandt's *Night Watch* in the 1850s to a 1775 treatise on basic concepts of preventive conservation by the director of Restoration for the Public Pictures of Venice and the Rialto. In the nineteenth century, the term "restoration" became used for hands-on repair processes, of paintings primarily, while "conservation" addressed broader issues of preventing damage, securing the safety of archaeological artifacts, and scientific examination of pigments and processes. Among these technical reports was an 1851 study by Michael Faraday, the "father of electromagnetism," on the impact of London's fog, coal smoke, and gas lighting on the discoloration of surface coatings, and pigment studies conducted over ten years by Louis Pasteur, the founder of vaccination and microbiology. Conservation facilities were established in 1900 in Berlin; in the 1920s at Harvard Art Museums' Fogg Museum; and in the 1930s at the Louvre; the British Museum; the Museum of Fine Arts, Boston; Walters Art Gallery in Baltimore; and the Metropolitan Museum of Art. The 1930s also saw the first international (meaning European) "Conference for the Study of Scientific Methods for the Examination and Preservation of Works of Art" in Rome. This led to the establishment of professional organizations and technically based training programs in Rome and London.

By the mid-twentieth century, conservation as a codified scientific profession was squarely rooted in a nineteenth-century

tradition that revered European and some Asian cultures above all others. Paintings and murals were the top of the artistic heap. Archaeological artifacts came next, probably thanks to the discovery, in 1922, of the tomb of King Tutankhamun by British archaeologist Howard Carter. Then there was everything else—sites, books, buildings, carpets, furniture—anything and everything that was collected by major museums. Still, with few exceptions, art restoration was seen as dusty, finicky, basement-level work— the "hands" that did the bidding of more intellectual connoisseurs and curators.

Then Florence happened. Two weeks after the flood, the Committee to Rescue Italian Art was born at Brown University. The committee amassed hundreds of thousands of dollars for materials and equipment and sent a delegation of conservators led by Lawrence Majewski, the director of the conservation program I would later attend, to aid not just with pulling works out of the mud, but to help Italian conservators define the methodologies that would recover those millions of cultural objects using the latest modern technologies. Quoting committee founder and Brown University professor Bates Lowry, the *New York Times* wrote on December 18, 1966, "New techniques must be devised at once to determine what is required to treat such different materials as fresco, oil on canvas, tempera on wood, leather, paper, parchment, marble, and other stone." This virtuosity was detailed in the press for years, with illustrated features about the work of the "mud angels," as conservators were called, appearing in *Life, Look, Saturday Review,* and *National Geographic* magazines. Suddenly we went from being sedentary, eye-loupe-wearing basement dwellers to Indiana Jones–style heroes who braved muck and slime to rescue the world's most

beautiful city. A number of my fellow students told me that they had decided to become conservators after seeing images of the work in Florence.

Kind and modest, Professor Majewski never spoke much about his work in Florence. He never boasted about any of his accomplishments, not the least of which was being part of the team that, in 1972, used technical analyses to re-authenticate a Greek bronze statue of a horse in the Metropolitan Museum's collection that had been unceremoniously declared a fake by the Met's operations director.

I found Majewski enigmatic and distracted or going off on tangents as he taught us the nuts and bolts of understanding fabrication as the basis of knowing how to care for artworks. After classes we would glimpse him lingering in his office, occasionally drinking vodka from beakers with fellow professor Kay Scott, a woman who had pretty much invented the field of textile conservation in the United States.

Eccentricities aside, Majewski had an air of true wisdom about him. Even when he spoke about practical matters—how to clean a bronze that has completely lost its metal core, or how he stabilized sixth-century mosaics at the Sardis archaeological site—his words were imbued with philosophical urgency.

Our job was not simply to "repair things." Our task was to do our work in a way that nullified our presence, refrained from fanciful interpretations, and remained reversible. Reversibility, especially, was fundamental. Everything we used or did had to be removable by someone else in the future. What a moving, transcendent idea. Our mark was to be temporary, short term. We were beholden to the object and were not to change it permanently.

Majewski and others like him—Paolo and Laura Mora in Rome, Sheldon and Caroline Keck in Cooperstown, George Stout at Harvard, as well as a second generation, like Joyce Hill Stoner at Winterthur and Carolyn Rose at the Smithsonian—worked hard to codify these ideas into standards for our practice. My notes from that time have circled sentences like "Corrosion products hold the history of a work within their surface." I don't know if Majewski said that or if I thought of it while listening to him lecture. The importance was that every aspect of an artwork, even what appears to be unwanted, was part of its story.

At New York University, conservation training took four years. Two years were spent in class and two in internships. At the end you got a master's in art history and a certificate in conservation. We were eight first-year students, and we studied and trained together with the second-year students. In the mornings we heard lectures; in the afternoon we were in studios. There our first task was to learn how to make everything we'd later treat—frescoes, panel paintings, wood carvings, Japanese ink painting, and copper bowls that we hammered from flat rounds of metal, then annealed in fire and pickled in cold water. It was our version of dissecting a cadaver.

We used large format cameras to document our work, learned the apertures and shutter speeds that gave the clearest pictures, and how to develop our film and print our own black-and-white photos in the darkroom. We were taught rudimentary scientific instrumentation—the X-ray diffraction machine, the mass spectrometer. We learned to detect gemstones by their color and crystal patterns, and wood types by their color and grain. Polarized light microscopy was taught by a forensic chemist named Walter

McCrone, whose projects included analysis of the pigments and fibers of the Shroud of Turin.

There were so many tools, so many processes. So many chemical formulas to memorize, so many case studies. I walked around New York half dazed by the mounds of information I carried in my head. The way frescoes are painted on wet plaster. How salt bores into a bronze, mixing with water to produce cuprous chloride that then turns into a self-perpetuating chain of damage known as bronze disease. Once you dive into the chemistry of artworks, you can't ever walk into a museum and see the works in the same light. Every scratch, spot, blemish, and bloom conveys meaning. It's erudite and intimate, like membership in a private club. Also, we get to touch what no one else is allowed to.

Twice a week, when I called home, I tried explaining some of this to my parents.

"I have not the slightest idea what any of that means, but if you like it and you'll be able to get a job when you're done, I'm happy," said my mother.

Their dismissal annoyed me, but what else was I expecting? I could have studied many topics that would have seemed unusual to my family. Conservation was uniquely esoteric. Fixing something in a way that makes it still reversible? "Why waste your time?" my father asked, when I tried to explain.

My mother was more pointed. "I prefer the new to the old," her blanket dismissal of the entire profession. Nonetheless, conservation had another singular benefit that suddenly struck me: There was no way to practice this profession in Miami. In the late 1970s, South Florida was a cultural backwater. There were almost no museums, and certainly no jobs for an art conservator.

Inadvertently, I had stumbled upon the best profession in the world for remaining far away from my family.

But there was a problem. My fellow students had spent at least three years trying to garner the requirements for admission. They'd interned unpaid in museum jobs (a practice that our field has recently stopped doing because it preferences people of socio-economic advantage), taken the French and German that were necessary for an NYU master's, and two years of inorganic and organic chemistry that were required by the conservation programs for admission (for the University of Delaware you also needed biology, physics, and physical chemistry). When Gaehde had urged me to apply, I'd had a mere summer of museum work experience and a single year of chemistry. I called to get the application and was told, by an infamous secretary who worked there named Violet Bourgeois, that I had "absolutely no chance of being admitted."

"Apply anyway," Professor Gaehde said casually. "This is right for you. And you might get lucky."

What Gaehde did not tell me was that he was being courted by the Institute of Fine Arts to be its director. I was a shoo-in because of his letter of recommendation. Then he did not take the job. This I learned upon entering the program from none other than the pinched-faced, nasal-voiced, acerbic Violet. From the get-go, I felt like an interloper, someone who had jumped the line and did not deserve to be there. In our work, science matters. Not having taken organic chemistry, I did not understand the basics of cleaning, adhesion, or how solvents worked. My professors knew I was unprepared. Majewski treated me with his typical largesse and courtesy, but the science professor, a haughty, ill-humored man who seemed to detest his students, made a

point of calling out my shortcomings. "Miss Lowinger, does this make sense?" he'd ooze as he wrote a complicated equation on the blackboard. I felt as if I'd come to class wearing a bathing suit and a visor inscribed with the words, "Belongs in Miami."

I floundered and grew anxious. I froze all winter long, the park feeling unsafe to traverse at night as I headed from 5th Avenue, where the Institute of Fine Arts is located in a French classical mansion, to West End Avenue, where I shared a cramped and roach-riddled apartment with two law students. I had few friends in New York, but fortunately one was a fellow conservation student, a native Manhattanite named Holly Hotchner. Holly was five years older, the scrappy daughter of a famous writer who nonetheless struggled to make ends meet, like the rest of us. Holly had interned at the Museum of Modern Art before entering conservation school. She had lived in Rome and had love affairs with famous men. She took to calling me Rosita, the diminutive used only by my family.

A month or so into our friendship, she said to me, "You don't know shit about organic chemistry, do you, Rosita?"

I confessed my secret.

She rolled her eyes, laughing. "Okay, I'll help you out."

Holly had a giant personality. Brilliant and uproariously funny, her filter was nonexistent. Talk about street smarts. Holly knew every corner of Manhattan. She took me to Chinese restaurants, where she was appalled that I kept kosher, and assured me that "all New York Jews eat pork and shrimp," as she plied me with moo shu and dumplings. Her manner could grate others, but I fell into her thrall without hesitation. We laughed our heads off, and she took care of me, showed me what streets were safe to walk in, and where I could pick up takeout food for pennies.

Working late nights in the Institute's basement, smoking cigarettes, and eating day-old cheese and pastries that a fellow student procured from a Madison Avenue bakery in exchange for quaaludes, Holly helped me learn what I should have known before entering graduate school, including most of organic chemistry. She, of course, knew her specialty from the get-go.

"Paintings. What else is there?"

Paintings was definitely *the* thing back in those days. Everyone wanted to work with the masters of Old Master "picture restoration," as the insider snobs called it, like John Brealey at the Met, or an Italian named Mario Modestini at his Upper East Side studio. I didn't even think about competing in that league. I toggled back and forth, instead, between paper and objects. But right after the winter break, when I still could not make up my mind, I felt an icy dread come over me. This was becoming a reprise of my college years—when I couldn't decide between majoring in sculpture, printmaking, or art history.

I wondered: Did I really belong in this graduate program? I looked like every other white graduate student, but no one in my family had ever been to college, or set foot in a museum for that matter. We spoke Spanish at home, and my mother got her hair and nails done once a week at the *peluquería*. My father "moved merchandise," whatever that meant, and always teetered on the brink of bankruptcy. My uncle Enrique had moved to Venezuela, and there began working for a millionaire who spent most of his time cruising around the Caribbean on an eighty-foot yacht, working at some job no one in my family could define. Occasionally he and his boss would show up in Manhattan without their wives. They'd pick me up in a limousine and take me to Studio 54, where they ordered magnums of champagne and danced with girls my

age who looked high. And now my parents had severed contact with my mother's beloved brother, Felix, whose Cuban-Jewish father-in-law had sued my father over some business disagreement. "After what we did for him?" my mother wailed on the phone when she told me the story. "After I took him out of Cuba, raised him like my own child, after your father paid for his schooling, fed him, housed him, taught him the optical business?"

"I am not breaking ties with Felix," I flatly told my parents.

"No one's asking you to!" my mother sniped, her voice cracking.

She was heartbroken over her brother's betrayal. So was I. And just as angry as she was that Felix had put his cigar-chomping father-in-law above our family. Deep down, though, I knew my parents were at least partially responsible. It had happened to them too many times—with Roselyn and Lito's mother, with our neighbors, even with El Capitán, though undoubtedly that fiasco was influenced by the unctuous, backstabbing Feinstein. There were other lost jobs and ruined relationships. And now my pal and surrogate brother Felix, too, even though he had just substituted one domineering person for another—my mother for his father-in-law.

In some ways, I had done the same with Holly. She ruled me with love and wicked humor. She was so much fun to hang out with, to stroll around New York, going to downtown openings, and bargain clothing sample sales and occasionally to Elaine's restaurant for dinner when her famous father paid for us. With her, I began to love New York, "the way you love the first person who ever touches you and you never love anyone quite that way again," as Joan Didion wrote. On top of that, Holly understood what it meant to struggle. Her well-off father gave her no money,

and he had left her mother when she was dying of cancer. "All families are nuts. Get on with your life," she liked to say.

In the spring of my first year at New York University, I took a seminar in medieval decorative arts. As part of our studies, the professor brought in objects from his personal collection for the students to examine. This was far from ethical, but I did not know that. I was assigned a bronze censer from the thirteenth century, a small, filigreed, dome-shaped object used to burn incense in a church. The surface was covered in lustrous reddish-brown and verdigris corrosion products. The professor instructed us to: "Look at your object carefully. Analyze it, *dismantle it*, discover what it reveals to you."

The next day, in the laboratory, I did what I thought was expected. The censer's bottom pan was adhered in place with ancient corrosion products. I photographed the piece from all sides, then wrapped needle-nose pliers with tape to avoid scraping the patina. Using the pliers, I carefully bent back the edges of the bottom pan and wiggled it out. Inside the censer I found a cornucopia of green, brown, and maroon minerals, all typical of naturally weathered copper alloy. Among them were vivid green pinprick eruptions. My heart raced. These spots were evidence of bronze disease. Non-conservators tend to throw this term around liberally. But bronze disease only happens when copper, the main component of bronze, comes into contact with chlorides, either through burial in salty soil or by being washed with tap water or exposed to ocean air. It is an urgent, self-perpetuating condition that will continue to tunnel into an object as long as there's humidity in the air.

I probed the green spots. Beneath them was a white waxy layer, further proof of bronze disease, because the reaction

happens when the white cuprous chloride (CuCl) reacts with oxygen (O2) and moisture in the air (H2O) to create the fuzzy electric green cupric chloride (CuCl2) in the following reaction: $4 \text{ CuCl} + 4 \text{ H2O} + \text{O2c} \rightarrow \text{CuCl2·3 Cu(OH)2} + 2 \text{ HCl}$.

Sampling both corrosion products, the ash residue, and a few other materials that turned out to be normal malachite and copper oxides, I prepared them for analysis using a clunky old-school X-ray diffraction machine, then the latest technology available for characterizing crystalline substances. My results came in as expected. I had found bronze disease! I reassembled the censer and photographed it again.

The following week, I came to the seminar with my results. Certain that the professor was going to be pleased with my discovery, I laid out my carefully conducted tests. Before I could explain my findings, he hit the roof. In front of everyone, he began yelling and pounding the table. "Who do you think you are to take a piece apart without permission? Do you realize you've ruined the integrity of this work? You aren't fit to study conservation—how in this world did you even get into school," and so on.

"But this is what you said to do!" I protested, holding back tears.

"I did not!" he bellowed. "No one in their right mind would ever dismantle a piece this old." The other students stared at their notes, embarrassed. The tongue-lashing ended with him telling me that he was going to recommend that I be put on probation for ruining an art object and send me a bill for restitution of its loss in value.

I left class in a fog. Humiliation lanced me, an utterly familiar feeling. Now my fellow students knew the truth: I did not belong there. I ran across soggy Central Park, my shoes caked with mud

from thawing snow. How could this be happening to me? How did I manage to go back to being the girl who was yelled at in public, the one whose mother would start honking any time she came to pick me up, and if I happened not to stop what I was doing right away, literally drop my books or ball or anything, she would roll down her window and start yelling, "Rosaaaaaa, get over here right now!" for everyone to hear. Then when I got in the car, it would be, "Where were you?" And if I happened to begin explaining, she would say: "I don't want to hear your excuses! When I come to pick you up, I want you waiting outside."

The censer incident opened my eyes to a clear fact. I needed therapy. For some insane reason, I told this to my parents. "You don't need any therapist! I'll come up to help you," my mother declared. That same week, she told her boss at work that she had to have an emergency D & C and flew to New York.

"Go on, Rosinke, tell me what's wrong. I'll help you sort this," she said upon arrival, using the diminutive Yiddish name she sometimes called me.

She seemed genuinely worried about me. And to leave her job like that, with my little brother still at home, was surely a great sacrifice. But what was I supposed to say? That it was her? Frankly, I wasn't sure what was happening with me. I felt a cloud pressing on me constantly.

"I'm fine, just confused," I said, shrugging.

"You've always been confused. You just have to learn to make decisions."

This was her fallback description of me. I was disorganized; she was decisive. I was stubborn; she was flexible. I thought "life was learned from books," but she "knew it came from experience, *inteligencia de la calle*, street smarts, what really matters."

"Come home if you're depressed," she urged. "You'll be happier in a sunny place. What's the point of wasting money being a perpetual student if it's making you unhappy?"

"I'm not a perpetual student!" I snapped. "And you aren't paying for graduate school so it's not your decision to make."

She switched on a dime. "Shaddup your mouth! You aren't too old for me to crack you across the face."

It had been years since my mother had lifted a hand to me. But she always told me she reserved the right to do so anytime she wanted. "You know, your father and I have been talking. We should have been stricter, not let you study art," she said.

"Is that what you came here for? To tell me what a failure I am?"

She shook her head and pointed to my nightstands. "Milk crates. Is that what you've come to? I used to live like this in Cuba when I didn't have enough to eat!" She actually sobbed when she said it.

After four excruciating days that felt like months, my mother was headed home. I told her I felt better, that she had helped me.

"Promise you won't go into therapy," she said.

I lied.

IN LATE SPRING OF 1979, Professor Majewski called me into his office. "Have you thought about your summer internship?" he asked.

Had I thought about it? I'd been fretting about nothing else since winter break.

"If you'd be interested, Iris Love needs a field conservator at Cnidus."

Iris Love was a 1970 graduate of the Institute of Fine Arts. A wealthy New York socialite, she was also a formidable archaeologist who had uncovered temples to Apollo and Aphrodite at Cnidus, an ancient Hellenic site on the Aegean coast of Turkey. Love and Cnidus had been profiled in the *New Yorker* the previous year. The site had been described as "one of the major commercial ports of Asia Minor," and the location of "the most famous statue in antiquity: Praxiteles's Aphrodite."

I said yes on the spot. If it worked out, I'd specialize in archaeology. I'd also been toying with paper conservation. I loved the clean, rice-scented feel of the paper studio, with its choreographed Japanese processes and papers—strips of *gampi* cut by using water-tipped brushes and bone tools, wheat-starch paste made by letting the milky mix run through your fingers before cooking it to a translucent and gelatinous consistency. Not to mention the audacious thrill of soaking drawings in baths of deionized water sprinkled with powdered calcium carbonate. New York University's paper conservation lab was taught by Antoinette King, chief paper conservator at the Museum of Modern Art. She was a pioneer of modern and contemporary art conservation, and so anxious about a student actually damaging a drawing or print that she made us practice lining using pages of the *New York Times*.

That appreciation for the lusciousness of paper notwithstanding, I knew as soon as I accepted the summer work at Cnidus that objects conservation would be my path. It was like a near-electromagnetic bond between me, the budding professional, and sculptures, vases, bas reliefs, and artifacts. Bronze was especially key to my decision. Those crusty surfaces that held entire histories. I felt like a sorceress, patinating surfaces, dousing

them with heated wax. The ancient alchemists had paired copper (bronze's main component) with the planet Venus. Copper is female, sexual, alluring, nurturing, demanding. In Cuba, those are attributes of Ochún, the deity who syncretizes with the Virgin of Charity, and whose day, September 8, was my mother's birthday.

In 1994, I was living in Los Angeles when a 6.7 magnitude earthquake struck the nearby town of Reseda (although it was named the Northridge earthquake). I had barely finished cleaning up the broken dishes that fell out of my kitchen cabinets and the ceiling plaster that littered my dining room when the phone started ringing. Before the power was fully back on and people were allowed to leave their houses, I had a week's worth of appointments. A month later, every table and bit of floor space in my studio was crowded with ceramic vases, terracotta busts, plaster reliefs, and dented bronzes.

Though most of the work consisted of straightforward repairs, some projects had complexities that I had not yet figured out. I learned, fairly quickly, that people's aching needs in times of disaster can overpower one's professional judgment. I found myself frequently saying: "Sure, this can be repaired. It won't be perfect, but it will be pretty close to it," even when I had no idea how I would approach an object. It was a product of inexperience; I had never faced a disaster of this magnitude. But it was also a yearning to help people deal with the stress that accompanies upheaval. I can't fix the city and your house, but I can put back together the tiny, broken Sevres vase, not much bigger than

my hand, that had been a birthday gift from your deceased husband.

Several months after the quake, a correspondent from *ABC World News Tonight* called me looking for a story about conserving cultural property in the aftermath of a disaster. The airwaves had been swamped with stories about collapsed freeways and parking structures. This was going to be a new angle. A cameraman shot footage of my studio as the reporter asked me questions. He pointed to a broken terracotta portrait bust of a woman. "Isn't this impossible to fix?" he asked.

"Not at all," I responded.

"Come on, really?"

"Yes, really. Repairs to terracotta and ceramics are pretty straightforward. It takes time, but you get it done. There aren't many unknowns to this sort of thing."

"Okay, show me a project you consider daunting."

I looked around the room and settled on a large copper sculpture with a pattern of concentric circles and a warm brown patina. The piece had fallen off a pedestal during the temblor. It had a deep creased dent on one side, and a corresponding crack along a seam. To make it right, we were going to have to heat the metal, possibly using a dent puller. This was going to darken the patina, which would then require tricky blending.

I explained all of that to the reporter. He asked the right question: "Why can't you just polish it up and let it darken again?"

"Conservators try to make as few changes to a work as possible," I explained. "Our goal is always to retain original patinas where we can." The cameraman circled us, his lens trained on my face as I spoke. The reporter nodded knowingly, appearing to understand. Months later, however, when the segment aired, our

conversation was replaced by a voice-over. You could see me talking, but all you heard was the reporter saying, "She isn't daunted by broken ceramics, but *she hates metals.*"

Hates metals? Not only had he misrepresented what I said, he had missed the entire point of conservation. Conservators don't hate what's daunting. We live to problem-solve. We unpack the structure of the physical world, untangling the nature of deterioration one step at a time. Bronze technology was discovered in a similar way: by trial and error, using fire on minerals and metals.

When it was finally perfected, around 3400 BCE in Thailand and China, then three hundred years later in the Middle East, the world changed radically. The Bronze Age was the first time in human history when objects were purposely fabricated by combining materials chemically in a way that changed their original composition. It led to mining, smelting (the process by which copper is extracted from its ore), and the first trade routes and migration paths. Corrosion and patinas are nothing more than the entropic transformation of metallic copper into the oxides, carbonates, sulphates, and sulfides that the metal was extracted from. Those green, black, brown, and red products are copper's way of reverting to a state where it is less reactive.

Metaphors abound for this. Don't we all wish to revert to states of being that are calmer? To be less reactive to our surroundings and circumstances? To go back to the times before we were exposed to orphanages, exile, abuse at the hands of a beloved parent, or the death of a lover? If only we, like copper alloys, could rewind and become less jaded, less quick to smolder and singe. If only our damaged states of being were as beautiful as copper patinas.

IN THE SUMMER OF 1979, when I was twenty-three years old,
I sought that sort of redemption at Cnidus. I wasn't good enough
to land an internship at the Met, Brooklyn Museum, or the
Museum of Modern Art. The important museums and upscale
galleries, the endless streets upon which I meandered, the insider
events with Holly were all transitory lapses from the real place in
the world where I belonged. But where was it?

In college I'd had one steady boyfriend. Now I had lovers.
Lots of them. No one I would even consider bringing home to
meet my family. The nineteen-year-old brother of my former col-
lege roommate; an Israeli who was traveling after the army; an
optical business associate of my father's—a man ten years older
with whom I found myself besotted, though he was an unapolo-
getic misogynist who slept with a pistol on the nightstand of his
Syosset, Long Island, bedroom. The night I took the train to see
him out there, we had wicked, scary sex. Before we went to sleep,
he warned, "Don't get up in the middle of the night, or I might
think you're an intruder and shoot you." I slightly wet the bed
that night. In the morning, his cousin Joey showed up to drive
me to the train. The two of them began to feel me up—one in
front, the other in back. Somehow, I managed to avoid a further
assault, but the incident left me wobbly and frightened. What
was wrong with me? Why had I gone to the home of someone
who was clearly dangerous? I was in therapy already, but
self-loathing gripped me amid the grit and subway brakes and
darkness of the frigid winter in Manhattan.

I was eager to go far away, to that lucid, marbled Mediterranean
coast where the Greeks and Romans ruled the world, then

cratered into dust. Beyond the ruins of my family, where ancient history teaches us that one tradition starts when another one ends, that everything is transitory, and discovery is redemption. Iris Love would teach me how to be an adventurer.

But that year, the Turkish government denied Love's permit for the excavation. Turkey was doing this to others also, but Love seems to have been singled out. Maybe it was the *New Yorker* story, which described her as having "the flamboyance and eloquence of a gifted performer." Mostly male colleagues were also quoted describing her largely female crews of archaeologists as "Amazons" and "beautiful girls in bikinis."

My stomach sank when Professor Majewski delivered the news. It wasn't just the excavation. Once again, I was besieged by confusion about my choice of specialty. Then Majewski said, "If you can find another site to go to, we'll pay your stipend and travel expenses."

Which is how I found myself that summer on a windswept hill along the Mediterranean coast of Israel, digging for bronze, and making a discovery of far greater value.

Chapter Six

BONE

The day begins in darkness. Above your tent the stars are out. It's 4:00 a.m. and you're groggy, even if you managed to fall asleep at 8:00 p.m. the previous night. You stumble into dust-caked clothes from yesterday, shake sand out of your boots, and check them for scorpions. You splash your face at the communal washing trough, then nibble on a biscuit, drink some juice or instant coffee, and fill your canteen. You trudge uphill to where the earth is mounded with a palimpsest of history that's slowly being cut into six-by-six-foot squares marked off with twine and corner flags. All of this happens in silence; at this hour, there is little energy for banter. Only the occasional "watch the edge of the baulk" or "bring up the plumb bob" or "we want to go another ten centimeters by breakfast" wafts toward you in the stillness. When the eastern sky ribbons with pink, you see the bent backs, picks lifted and dropped, trowels scraping the ground.

A shovel pings a rock, sand shudders into a sieve, a wheelbarrow rattles as someone grunts it uphill.

Along the coast of Israel, dawn revealed the azure Mediterranean foaming at the base of a hill made of windblown rock and sand. Located a few miles from Herziliya, a coastal suburb of Tel Aviv, Tel Michal was no Cnidus. Not by a long shot. There were no marble temples here, no towering Aphrodites or vessels made of gold. Only an acre square, the site consisted of several low knolls of mud-brick houses bordered by ravines dotted with scrubby plants.

What the site had was layer upon layer of human habitation—the definition of a Tel in both Hebrew and Arabic. Beginning in the Middle Bronze Age (around 1800–1500 BCE) with a small fort used to receive traders who arrived in ships from places like Cyprus and Sardinia, the Tel (or mound) had been inhabited for almost four thousand years and used primarily as an outlook post, a garrison, and a wine production facility. The Iron Age levels (1000 BCE) had two wine presses and a Phoenician cult house. Above these, archaeologists had found a fort, houses, and cemetery from the Persian Period (sixth and early-fifth century BCE), an even bigger fort and wine production facility from the fourth century BCE, when Alexander the Great conquered the region, and remnants of Roman settlements from the time when Pontius Pilate was prefect in Palestine. The last of the settlements, coming hundreds of years later, consisted of a watchtower that dated to the Early Arab or Abbasid Period (eighth century CE), the third caliphate to rule the Arab world after the death of the Prophet Muhammad.

I was there to be the site conservator. When I arrived, I realized that the archaeologist who'd hired me did not really have

any idea what field conservators did. We had talked on the phone when I was scrambling to find a position after the Cnidus debacle. I'd been offered a position at a site called Tel Afek, along the northern Coastal Plain, but I hadn't yet accepted. The archaeologist explained: "Tel Afek's a great site to work at, as long as you bring plenty of mosquito repellent. We're located on the beach so that's not a problem for us."

Upon meeting in person, A.B. and I shared a good laugh about his clever salesmanship.

"You sounded like you'd be fun to spend time with," he admitted.

A.B. was fun himself. He had kind eyes and a great sense of humor. Still, I wasn't sure what I was supposed to do all summer on a dig that seemed to have no work for a conservator. "Something will come up, don't worry," he assured me. "Meanwhile, you can learn how we dig, or work with the pottery restorers."

Like most easily identifiable archaeological sites in Israel, Tel Michal had been excavated several times before. First surveyed by the British Mandate for Palestine's Antiquities Division in 1922, the mound was dug by the Division in 1940 and then in a slapdash salvage excavation conducted by the venerated Israeli archaeologist Nahman Avigad, who had worked at Masada, the Jewish Quarter of Jerusalem, and had published one of the Dead Sea Scrolls. The current dig was led by archaeologists Ze'ev Herzog of Tel Aviv University and James D. Muhly of the University of Pennsylvania. Several years earlier, members of the Tel Aviv team had excavated the site of Be'er Sheva in the Negev desert. That site was impressive, filled with artifacts and remnants of an altar table and the well that gave its name to the site and therefore connected it loosely to biblical references. In past

years, some archaeologists used to dig with a bible in hand, looking for proof of the stories in the texts. Not at Tel Michal, or the Expedition to the Coastal Plain of Israel, as the greater project of this team was called. There the archaeologists worked with scientific rigor. "The science of filth," A.B. called it.

A.B. was finishing his doctorate at Penn. He dug in Israel because, like most Jews at the time—like me—he was barred from working in Arab countries. Majewski had told me as much when Cnidus fell through. "Find a dig in Greece, Turkey, or Israel," he said coyly, without much explanation. The Arab-Israeli wars of '67 and '73 were still fresh in memory. Also, earlier that year, the Shah of Iran had been deposed and the regime of Ayatollah Khomeini was bursting with US antipathy that in November of that year would result in the breach of the US embassy and the taking of American hostages. Jews and Middle Eastern archaeology did not mix, except in a few countries.

The Tel's coastal location meant that after the work was done, we could go swimming in the sea. I went every day. This was the only part of Miami I had missed since I left home. The warm eastern Mediterranean had the same bounce to the waves, the same salinity as the Atlantic near Miami. I dove below the frothy surface, feeling more at home in coastal Israel than I'd ever felt anywhere else. I spoke some Hebrew, a remnant of my schooling in Miami. I tried communicating with the artifact specialists in their own language, but most had no interest in my help. There were no trained conservators working at this site back then, and artifacts of value—coins and metals primarily—were whisked off for treatment at Tel Aviv University's rudimentary laboratory. A.B. had the dig's driver take me there to meet the "specialists." I could not figure out what they were trained to do. They

made pleasant small talk but they, too, had no interest in my background or assistance. Neither did the pottery restorers who worked on-site at long tables shaded by screens. When I asked them—they were three women, also from Tel Aviv University—if I could help with the sorting and gluing, they shrugged and said, "*Betach, ken*" (Sure, yes), but just waved me over to an isolated place along the far end of the table, gave me a basic lesson in sorting, and left me to my own devices. Naïvely, I tried to explain that the polyvinyl acetate emulsion they used for repairs—better known as white PVA or Elmer's Glue—was now considered inappropriate because it cross-linked and grew stringy as it aged, darkening repairs, pulling off the join edges. They shrugged and said, "*Zeh mah she'yesh lanu*" (This is what we have), not even bothering to humor me.

THE POTTERY OF THIS REGION is not beautifully decorated. You sorted by color, shape, a lip for a bowl, a handle for a jar, the size of inclusions along the join lines. Some surfaces were decorated with fine slip (a liquefied clay slurry used in lieu of glaze). Over time I settled into the meditative process. Pottery sorting teaches one to treasure small successes. Any join between two fragments feels like a cause for celebration. Even the near misses—when you feel you've found a match, only to find that the two fragments don't quite lock into place—teach you about not taking your own prowess for granted, not counting your chickens until they hatch. The Israelis were involved in no such reflection. They gossiped spiritedly as they sorted, cigarettes in one hand, glue brushes in another. They seemed to have a heightened

super-vision for the subtlest color changes. Eventually, as I put two, then three fragments, then half a vessel's worth together, swallowing my conservator's pride as I brushed the joins with the gloppy white Israeli Elmer's, I got the occasional, "*Eh, metzuyan!*" (excellent!). I grew comfortable in my role of restorer rather than conservator. Then one day, A.B. raced over to the table where we were working. "We found the cemetery," he said. "The bones are starting to crumble."

ALL CONSERVATORS HAVE favorite materials, ones whose texture, fabrication, or ability to be conserved dovetails with our particular sensibilities. Some of us like paintings on canvas and others prefer wallpaper or space-age objects like the moon lander. Conversely, we all prefer to leave certain materials to other experts. For me it is distinctly bone, especially human remains. The reasons are obvious. These are not artifacts. They are someone's ancestors, the last vestiges of people who had once laughed, loved, fought, and then were "resolved to earth again," as American poet William Cullen Bryant wrote in "Thanatopsis." In Israel, any grave uncovered during excavation had to be reported to a Religious Services Ministry, which prohibits any scientific examination of remains. Bones in Israel are not considered antiquities. Rabbinic ministries pay particular attention to Jewish remains; if excavated graves are found to be Muslims or Christians, they are turned over to religious councils of the peoples in question.

The preservation and study of human remains is always a politically and philosophically charged issue. Caucasian remains

have historically been treated with greater deference than those
that could be traced to indigenous or Black communities. This
began changing in 1984, when Australia passed the Aboriginal
and Torres Strait Islander Heritage Protection Act (ATSIHPA),
the first national law that placed greater importance on the claims
of indigenous communities than all other parties and required
all excavated indigenous remains to be turned over to tribal
authorities—even if found on private property. In the United
States, change began in 1976, when the activist Maria Pearson
launched a formal protest into the fact that the remains of a
Native American mother and child uncovered during road con-
struction in Glenwood, Iowa, were sent to a lab for study, while
the skeletons of whites found at the same site were quickly rebur-
ied. In 1987, looting of Native American graves associated with
the Mississippian culture (1400 CE) at the Slack Farm site in
Kentucky led to a broader international outcry into the practice
of disrupting Native graves for scientific study. The result was the
1990 passage of the Native American Graves Protection and
Repatriation Act (NAGPRA). Like ATSIHPA, NAGPRA
transformed the way Native American cultural items and remains
are handled in this country. It bars any institution that receives
federal funding from keeping such remnants and recommends
repatriation to lineal descendants and culturally affiliated tribes
of the peoples in question. NAGPRA establishes strict proce-
dures to be followed if Native American graves or artifacts are
accidentally found during excavation and criminalizes trafficking
in these remains and objects. Penalties are severe: A first offense
can result in a twelve-month jail sentence and up to $100,000 in
fines. This law has since fomented the welcome act of repatriating
artifacts that have been long held in museums to their respective

original communities. Currently an active component of cultural stewardship for any museum with indigenous artifacts, it also requires engagement with tribal members in stewardship of the objects and allows for their use in tribal rituals and events. All in all, NAGPRA has demonstrated that repair is possible at a cultural level when it comes to fostering respect and dignity where they had long been lacking.

THE BURIAL PIT AT TEL MICHAL was about six feet down from where we stood. It was only the second layer down of excavation, but it showed how quickly marks of our existence are erased by sand. As I climbed down to inspect the remains, it was hard not to think of the poem "Ozymandias" by Percy Bysshe Shelley, which ends with:

> Look on my Works, ye Mighty, and despair!
>
> Nothing beside remains. Round the decay
>
> Of that colossal Wreck, boundless and bare
>
> The lone and level sands stretch far away.

LIKE MOST CEREMONIAL BURIALS, the humans laid to rest at Tel Michal looked quietly peaceful. Arms were flat along their sides. Some had bits of beads or pottery vessels beside them. Most of these humans had come from another place. They were

conquerors, soldiers, mercenaries, settlers, someone's ancestors. I sat on the ground beside one figure and gently touched my finger to a chalky clavicle. Tiny crumbs came off. "Cover them with burlap," I said. "I need to find a consolidant."

Consolidation is a major technique in the field of conservation. Used by nearly every specialty, it refers to the act of stabilizing crumbling, flaking, powdering, or otherwise degraded materials by introducing a new binder—the consolidant—into the surface. Paintings conservators consolidate flaking paint. Paper conservators might affix a signature that is detaching from a drawing with a consolidant, or friable paints onto illuminated manuscripts. Objects conservators consolidate everything from sugary stone to crumbling terracotta blocks, with the added burden of trying to deliver the consolidant into a mass that is thick and more or less impenetrable. Typically made of two parts—an adhesive and a carrier solvent—consolidation only works if the adhesive can penetrate deep enough to work. You manage this by using slow drying solvents and creative delivery methods like mists, sprays, and controlling the environment around an object.

At Tel Michal I had nothing to work with: no tool kit, resins, solvents, or a proper glass jar, let alone a scale to measure ratios. Moreover, bones are composites of inorganic minerals (mainly calcium and potassium), which provide strength, and organic matter, mostly collagen. At New York University, our two-year program had started with the inorganic tract of classes—metals, stone, minerals, anything that was not once alive. Wood, shell, bone, silk, ivory, cotton—anything that had once been an animal or plant was going to be part of the second year's classes. But there I was, the field conservator, finally asked to help with a real problem.

Here's what I knew:

- As partially organic materials, bones deteriorate more rapidly than inorganic matter like stone, ceramic, or metals.

- Oxygen is necessary for most chemical reactions. Removing the soil exposed the bones to conditions that were rapidly destroying them.

- Block lifting an entire body would have been an option, if we had had enough plaster to encase the entire burial (we did) and if anyone at the site had ever done it before (no one had).

- Because of the heat, humidity, and salt, we had little time to waste.

- Yet, without the right consolidants to intervene, I was risking ruining the bones for good.

- Last, human bones were not artifacts. They were people. I was slightly daft about this humanity as I pondered what to do. But even taking the scientific rather than cultural/humanistic approach suggested caution. Within our bones is vital information about how we live and die—our ages, ethnicities, nutrition levels, and migration patterns. Back in 1979, most anthropological information was obtained through measurements of the length of bones, rather than DNA analysis; but conservators already understood that technology evolves quickly and there were future studies

that would be thwarted by anything we impregnated into a bone's chemical matrix.

Beset with doubt, I made my way back to the laboratory at Tel Aviv University and asked the specialists, "What are you using for consolidating bones?" I don't remember what they answered. I just know that I left empty-handed.

Back at the Tel, I mixed up a concoction of what I had, which was none other than the odious white glue I had turned my nose up at when I saw it used on pottery. Without a scale or beaker, I had to wing the measurements. I poured some into a glass pickle jar, diluted it with water, and added a few drops of isopropyl alcohol to reduce the surface tension of the water molecules so the mix would penetrate. I tested it on the bones. The adhesive beaded up like tiny pearls. I tried adding more alcohol. Still nothing happened. After a bit more alcohol, the mix started separating into globules. Then I remembered that the best thing to reduce the surface tension of water was introducing a surfactant, like detergent. This works by breaking the cohesive bonds between water molecules. I had no conservation-grade detergents with me, but dishwashing liquid works, and the one used at the site was fortunately undyed. I added a drop and vigorously shook the jar. That did it.

Carefully applying it through cheesecloth, so the brush I had repurposed from the pottery sorting table would not dislodge any bone fragments, I consolidated a series of burials, leaving untreated places on every bone for future sampling. I felt queasy that I'd made the wrong decision. Calamity hovered above me with the baking sun, a version of what had happened with the censer in class. What I didn't realize then is that I was learning

a lesson about conservation that I'd confront over and over again: that there are hardly ever perfect solutions. Sometimes you don't have what you need to work with, but you must work anyway. At other times the right decision is to wait, hold back. The trick is knowing the difference. And the only way to do it is by honest, personal scrutiny, which is difficult for most of us to do. This, I would soon learn, is the main reason training and experience are both essential. I had little of either then, but I was learning.

My doubts aside, the archaeologists were pleased when the bones stopped blanching and crumbling. A.B. took me out for ice cream in the nearby town. I don't remember what we talked about, but I remember that my face hurt afterward from laughing so hard. We spent every evening of that week together, talking about our lives beneath the star-studded Mediterranean summer sky. I told him the basics: "My mother is extremely funny, but volatile. My father is morose, suspicious, and we always have money problems. I have a brother who is thirteen years younger than I am. I'm in therapy."

A.B. had no siblings or parents. His father had died when he was fifteen, his mother three years later. In the 1930s, they had both been in the Communist Party but quit in 1939, when Stalin made a pact with Hitler to divide Poland. "My mother was a true believer, but my father only joined because it was where you met the hottest girls," he explained, his kind eyes smiling.

On archaeological digs, romances grow quickly. The next weekend, we took off for the mountain town of Safed in the Galilee, a place where Jews, Muslims, and Druze peoples had coexisted and prospered in the 1500s (there were numerous instances of later massacres), and where Jewish mystics gave rise to the Kabbalah. On the windy bus ride back to Tel Aviv, we sang

all of Warren Zevon's first album from memory. By summer's
end, we were planning a future together. We decided to rendez-
vous over Labor Day—in Miami.

A.B. arrived on a Friday. By Saturday morning, a hurricane
warning was in place. As the winds picked up, my parents scram-
bled to move the patio furniture indoors and install the storm
shutters on the windows. Meanwhile, we sat around, chatting
and laughing in the way of new lovers, excited about the absur-
dity of this particular event as the prelude to our stateside
romance. Suddenly, my father barked at him: "Can you please get
up and help me?"

"What is wrong with him? Is he just lazy or stupid?" my
mother later hissed at me when he wasn't in earshot. "And what's
with those dirty sneakers? What kind of slob is he?"

One tiny mistake, and he was in their crosshairs. "He's just
come back from digging all summer," I explained.

"So what? He couldn't wash his sneakers? They're disgusting."

THE FOLLOWING YEAR, we moved to Philadelphia. A.B. got a
teaching job in rural New Jersey, and I began a conservation
internship at what was then called the University Museum at the
University of Pennsylvania. Founded in 1887 to house collections
from the university's upcoming excavation to the ancient city of
Nippur in Iraq, the Penn Museum, as it is now called, contains
some of the most important indigenous and archaeological col-
lections in the world. Most notable among them are the cache of
gold and lapis lazuli artifacts from the royal tombs of Ur, which

Sir Leonard Woolley had excavated between 1922 and 1934 on behalf of Penn and the British Museum.

As an intern, I got to dust the crowns and musical instruments worn in the afterlife by kings and queens of Sumeria. I cleaned ancient Aztec artifacts made of *tumbaga*, a gold and copper amalgam, vacuumed Navajo rugs, and guarded mummified humans when a film crew came to shoot a documentary. Every single thing I put my hands on was remarkable. The conservator in charge, Virginia Greene, had been at Tel Michal the year before me. Though she had hated being at the dig without anything to do, she loved A.B. "He's a keeper!" she said to me over and over. "The rest of them aren't worth a damn."

Like Larry Majewski, Ginny Greene was instrumental in the professionalization of conservation in the United States. She had trained at the University College of London's Institute of Archaeology, the first graduate program to focus on the special conservation needs of artifacts that are suddenly exposed to the environment after millennia of burial conditions, or that hold information about indigenous peoples, and whose stabilization must therefore be done in a manner that does not thwart later scientific study. Because she liked me, she let me work on anything I wanted. This included sewing the silk cords and stabilizing the lacquer helmets of ancient Japanese armor, vacuuming moldy Guatemalan textiles, and implementing a project to remove salts from ancient Peruvian anthropomorphic ceramics.

The department's assistant conservator did not approve. "It's inappropriate for her to take risks like this." This conservator criticized Ginny relentlessly behind her back. I got some of the blowback for being the favorite.

But though Ginny had a laissez-faire manner, she kept a careful watch on me. I would feel her hovering behind me as I scraped dirt and rust from an archaeological iron quiver from ninth-century BCE Teppe Hasanlu. She'd say, "The corrosion will feel different when it changes," or "Try holding your scalpel at a different angle."

The other intern in the lab had studied conservation at the science-heavy University of Delaware program. She had a way of lording her superior knowledge of organic chemistry over me. But I noticed that she repeatedly seemed unable to actually undertake her treatments. This, I would learn over time, was common in conservation. It's hard to make the first move, especially with artifacts of high monetary, cultural, or artistic value. Some practitioners will bury themselves in documentation and analytical testing to avoid getting off the dime. Part of becoming a professional is knowing how much information is really needed to get going. You can always do more and more testing. But sometimes you have to take the plunge.

"Taking the plunge," of course, is also a colloquialism for getting married. Despite my parents' seeming disapproval of A.B.'s sneakers and "laziness," they knew that I was living with him, and that meant that we had to get married. They didn't say anything for about six months. Then my mother began planting seeds of doubt in my mind. "Are you going to get married or what? At your age I already had a child."

I was not really ready to get married, but my mother's worries burrowed through my skin, becoming my own. Fear was her

normal currency, and I her unwitting disciple. "You'd better think twice about giving the milk away without making him buy the cow," she said on several occasions. I bristled at the patriarchal subtext of the comment. But soon I, too, began doubting A.B.'s intentions. *Why isn't he proposing? What's wrong with him?*

In Philadelphia I had made a wonderful new friend named Linda. A writer for the *Philadelphia Inquirer* and five years older, she was an only child who had been raised by educated parents in Connecticut. Linda had spent her youth visiting museums in New York and going to Broadway shows. But her father had practically no relationship with her, and her mother was darkly manipulative. When Linda was nine, her mother had accused her of stealing a $20 bill from her purse. She had not done it, but her mother harangued her so badly that she falsely confessed, only to have her mother wake her in the middle of the night and tell her the police were coming to get her. About Linda's ulcerative colitis, which she developed in early adulthood, her mother said, "If you cared more about other people and less about yourself, this wouldn't be happening to you." Her mother routinely returned birthday presents unopened with nasty scribbling on the packaging.

One day, while sitting around and talking about our parents, Linda said, "Your mother might've been violent, but she always showed you love."

I thought about it for a moment. Having left home only several years earlier, I did not habitually process most of my mother's behavior as being motivated by "love." But Linda gave me books to read about psychology and personality disorders. And there was my mother described in black and white: the paranoia,

sudden anger, the root cause of childhood abandonment, the constant fear that someone's trying to get you. Even the charismatic brilliance, the bursts of unfettered love, and the ability to keep my father wrapped adroitly around her finger, tiptoeing around her moods. Although I knew it was not possible to diagnose a person in absentia by reading a book, especially one's own mother and without psychiatric training, I was floored by what I read. This was the first template I'd ever had with which to potentially *understand* my mother and feel empathy for her behavior—to see her actions as not designed to hurt me but outside of her own control or even potentially "triggered" by her love for me, because to love is to be vulnerable, and to be vulnerable unearthed her deepest fear of abandonment. But if my mother's behavior didn't just seem "out of control," if it might be *literally* outside of her control, what burden did this place on my relationship to her? Was I now, as an adult, supposed to set aside, forgive, endure, continue to allow her to treat me any way she wanted?

When I told Linda that my mother was pressuring me to get A.B. to propose, she sagely warned, "Be careful. Don't take it out on him." It did not take long for me to do exactly that. One afternoon, when we were folding laundry in our tiny bedroom, we got into an argument. In the middle of it I demanded, "Why aren't we getting married? Are you planning to or not?"

A.B. looked at me bemusedly and said, "Of course." For him, the answer was obvious.

"What's that supposed to mean?" I shrieked in the glassy, breathless voice my mother used. He stood there, a deer caught in the headlights. He should have turned around and run away. I had never even mentioned marriage before and must have seemed completely unhinged. But instead, he sat me down and

reassured me that he had noble intentions. That he loved me. After an hour, I was as fizzled as a spent firecracker. I fell asleep, the way I did after my mother raged at me in childhood.

A few weeks later, he snuck up behind me in the bedroom. In a singsong voice he said, "Hey, Ro, d'you want some pearls? You wanna get married?" He held out a plastic bag. In it was a short necklace of amber-colored graduated pearls. "These were my mother's," he said.

Who delivers a marriage proposal like this, in ripped cutoffs, with a rumpled plastic bag instead of a proper velvet box containing a ring? What kind of person is this? Are you sure this is who you want to marry? I could hear my mother's words in my head, presenting themselves as my own thoughts. Abruptly, A.B.'s gentle gesture, actually so in keeping with the person I had met and fallen in love with, appalled me. *Something is wrong with him. And me, for choosing him.* Suddenly I wanted him to be a different person. Instead of an academic known for humor, quirkiness, a sparkling intellect, and generosity, I expected him to be the kind of person who would show up in a suit with a diamond in a velvet box.

I flopped onto our bed, shaking my head. "Not like this. This is not how this is done."

Even as I spoke, I loathed myself. Those pearls had been his mother's whom he'd lost when he was just eighteen years old. It was beyond romantic. Trembling with anxiety, I vacillated between yes and no, wondering what I wanted, what my parents would say either way. I cried, but not from happiness. He waited, knowing I would get to yes. And, of course, I did.

WE GOT MARRIED IN MIAMI on a scorching Labor Day Weekend, just two years after meeting on a bone-strewn Tel along the Mediterranean. My simple wedding gown was made by a Cuban dressmaker in Little Havana, one of many seamstresses who had worked for socialites in Havana and had amazing skills to copy styles from magazines and department stores. My mother and I fought every time I went for a fitting. There were also arguments about the number of friends I could invite; the menu, which was to include an extravagant reception with an open bar, three choices of entrée, and a sprawling Viennese dessert table; and the balance of Latin to Jewish to American music that would be played by the Cuban band my parents had hired for the occasion. There were 120 invitees, only a few dozen of them A.B.'s and my friends. All of this was being planned against the backdrop of another business failure of my father's. This time it was some sunglass stores that he had opened and shut within half a year. He was a respected member of Florida's professional opticianry board, but the catastrophe with El Capitán and Feinstein had taken the wind out of his sails.

One day, after I heard my mother yelling on the phone about the cost of the cake, I said, "Mami, why spend so much money on a wedding? This is not important."

"It absolutely is. This is the only wedding I will ever throw," my mother said. "And don't you worry yourself about the money. We have what we need."

How was that possible? A.B. and I had even been paying for my little brother's private school tuition. I prodded gingerly. My

mother avoided answering me, then finally she said, "Okay, fine. I'll tell you. Do you remember Silvio Werner, your friend Eva's father?"

"Sure. What about him?"

"Well, you know they're multi, multi, millionaires. But with all that money, his son, your friend's brother, couldn't pass Florida's medical boards. Silvio has known your father since they were little kids in Havana. He knew your father had connections in Tallahassee. So, he gave him some money to look into it."

I thought about it for a second. "Are you saying he asked Papi to bribe—"

"No one was bribed!" my mother countered sharply. "Your father found out that the boy had already passed the medical board. On his third try, by the way, so I'd rather die like a dog than have *him* treat me!"

My mother was positively cheerful as she told this story. But I knew my next question was going to change that. "So, if I understand correctly, Papi kept the bribe money and this is what you're using to pay for my wedding?"

"*Por favor*, Rosa, don't be naïve!" she spit angrily. "And stop saying 'bribe.' No one was bribed. How do you think Silvio got so rich anyway?" My mother proceeded to recount a story I'd heard many times before, about how after a hurricane in 1963, this onetime immigrant clothing-store owner, now a respected accessories tycoon who appeared in newspaper articles about the success of La Colonia, smashed his store's plate glass window and purposely scattered merchandise into the floodwaters. It was insurance fraud. My father helped him do it. "Silvio was smart. Your father was not. Now he is. And he did not bribe anyone!"

Our wedding celebration ended well after midnight. A.B. and I got into a rental car and headed for a two-day honeymoon at Miami Beach's Fontainebleau Hotel. We both had work to get back to and hadn't planned to take a trip until the following summer, but my parents had surprised us with a reservation in the fabled beachfront hotel's honeymoon suite. "You'll love the room," my mother gushed. "It has two televisions, a king-sized bed, a view of the ocean. Even a balcony!"

Though it was past midnight, the air was soggy with humidity. I unpinned my veil and kicked my shoes off as I got into the front seat. I could not wait to get to the hotel and take off my sticky wedding gown. But as our car windows defogged, I noticed that, instead of heading toward the Fontainebleau, A.B. had turned onto the causeway that led to the mainland.

"You're going the wrong way," I said.

"Nope. I'm heading for the Keys. I don't feel like spending our wedding night in a room picked out by your mother."

I was stunned. "How could you do this? Without consulting me?"

"I wanted it to be a surprise."

"But what about my parents? Did you tell them? They'll be worried."

"What's the big deal? We'll tell them tomorrow."

"But what if they can't get the money back?" I could hear the splinters in my voice.

"Sweetie, this is our honeymoon, not theirs," he said, as he drove west and turned onto I-95 South. Anguish flushed through me, a creature rising from a murky swamp. What would my

parents say? How could I explain? At the most romantic, inti-
mate moment of my life, I could not concentrate on anything but
what they wanted. What I *thought* they wanted. At the lone last
gas station before the Overseas Highway began, I yelled, "Stop
the car!" Trailing white chiffon, I tripped across muddy asphalt
to a pay phone. "Everything okay?" a trucker in the parking lot
asked, as my mother answered.

A.B. nodded. The men exchanged a look.

"What happened?" my mother gasped, when she picked up the
phone at 1:30 a.m.

I explained. The line crackled in silence, then she said, "Okay."
Her tone was as heavy as the humid air. She asked whether A.B.
had managed to get the money for the hotel room back. I don't
know what I answered. My skin itched unbearably.

Back in the car, I said everything was fine. But it wasn't. Not
for me. All the way to Duck Key, our first stop at mile marker 61
on the Overseas Highway, I kept crying. "You've ruined this for
me! Why didn't you think to ask me?" In our motel room, I lay
face up on the bed, unable to remove my wedding dress, weeping
intermittently, wondering why nothing ever worked out right.
A.B. sat quietly beside me, occasionally stroking my arm. I lay
awake for hours, not able to make love or get out of the wretched
funk. I wish I could say it got better when we drove the next day
to Key West, but it did not.

Chapter Seven

PIGMENT

The wooden mask was painted white, fringed with grass, and topped with a bird. An elegant, intact ceremonial object from the Bayaka tribe of Central Africa, it stood beneath a tall binocular microscope while a conservator gently touched its surface with a tiny brush. The day before, a curator had seen what she thought were powdery specks of termite droppings, known as frass, around the object. Conservators moved quickly to isolate the mask in plastic. After five days, no infestation was detected. However, the white bits that had been found on the shelf under the mask turned out to be equally problematic: detachment of the white chalk pigment that covered the face of the mask.

Such incidental discoveries happen all the time in conservation. Someone brings in a ceramic with a broken lip, and you find that all the glaze is detaching. These are lucky findings; like discovering a tumor during an MRI for a torn kneecap. Here the problem was a product of too little binder. Binders are what hold

the pigment particles of paint together. They're the oil in oil paints, the latex in commercial house paints. Works made by indigenous tribes use natural materials like blood, milk, animal fats, beeswax, plant-based saps, and tree resins. The shedding would only be stopped by adding a binder to hold the paint together. The trick was finding what would work without darkening the paint or making it glossy. Nowadays there are fancy instruments for delivering the resin through a mist or in a solvent-saturated atmosphere, but in the 1980s this was done entirely by hand. It was never perfect. We didn't really have a good solution, but at least we'd found the problem before too much pigment had been lost.

After my disastrous honeymoon, I made an incidental discovery of my own. Back in Miami, I expected my parents to be angry about the hotel. But they weren't. They were delighted to welcome us back and eager to relive their favorite moments of the wedding, like our wearing Charles and Diana masks at the cutting of the cake. The Fontainebleau had given them their money back, and everything was fine. We spent the weekend with them, swimming in the pool, having a barbecue. I felt deflated physically, a popped balloon. My breath would catch as if I had been struggling with high altitude.

All the turmoil I had churned during the honeymoon—I didn't even enjoy swimming in the turquoise Gulf of Mexico, which I normally adored—had been my own creation. The incidental problem lived in me. I went back into therapy and told my new husband that I would work to repair this issue in myself. If only it were as easy as consolidating matte pigment onto a sculpture. Part of the solution, said the therapist, was keeping a healthy distance from Miami.

But that was easier said than done for me. And not just because my parents lived there. In 1981, Miami was front-page news across the country. The Mariel boatlift, which had taken place a year earlier, had changed the character of the city, state, and US politics. The events began in April 1980, when six Cubans drove a city bus through the gates of the Peruvian embassy in Havana, asking for political asylum. Castro's government demanded that the Peruvians return the dissidents. When Peru refused, Cuba withdrew its guards from the embassy's gates and announced that any Cuban who wanted to leave could do so. Within days there were twelve thousand people inside the embassy.

Overnight Miami's Cuban exiles mobilized. Every boat available sped toward Havana to pick up relatives. Earlier that year, the *Pucho II* had been badly damaged in a storm, but my father still managed to sell it for a good price to a marina, which repaired it and flipped it for a small fortune. Within months, 125,000 Cubans and 25,000 Haitians poured into South Florida—more than a third of the region's current population of 345,000. The influx of so many immigrants is considered one of the main reasons Jimmy Carter lost the 1980 election to Ronald Reagan by a lopsided electoral margin of 489 to 49. Cuban Americans gave Reagan 90 percent of their vote, the largest percentage of any ethnic group in the United States.

"I have never once in my entire life voted for a Republican!" my mother says. Nevertheless, this moment in US history underscored more than ever the differences between my parents and myself, scraping old wounds. My mother protested the influx of the Marielitos. I told her she said that only because a large contingent of the new immigrants were Cubans of color, unlike the first wave that had left in the 1960s.

"Don't you tell me I am racist!" she vehemently protested. "I was raised in Old Havana, among Black people." But she also proudly voted in favor of a Dade County "anti-bilingual" ordinance that designated English as the official language of the county, preventing bilingual education, government business in Spanish or Haitian Creole, and most nonemergency county services in any foreign language.

"Did you speak English when we came here?" I demanded.

"I did not. But I made it my business to learn. When you come to a new country, *you* have to change. The country doesn't change because of you."

In some ways, I was the embodiment of those words—the ideal in which my mother claimed to believe, yet often heaped guilt upon me for exemplifying. I had fully transformed from Cuban to American. I never spoke Spanish, except with my family. I had no Latino friends except those from Miami, no connection to Latin America except through ancient artifacts. Philadelphia, that most iconic of American cities, had become my genteel firewall against the exile trauma. I relished strolling through riverfront parks filled with dogwoods and azaleas, watching sweatered scullers slicing the glistening water in perfect harmony. Philadelphia had a symphony, a ballet, and great museums—including the hilltop monolith where Rocky Balboa had run up the steps in triumph. Best of all, the city "did not raise the specter of intimidation as Manhattan did, it was intimate but not provincial, a city that might yet be kind to you," as Nigerian-born Chimamanda Ngozi Adichie noted in the 2013 novel *Americanah*.

When my internship ended, I made do with a short-term position at the art museum. There I met a conservator who had graduated a year earlier from a conservation training program in

Cooperstown, New York. Stella was getting ready to open a private practice and asked me to partner with her. Like my father and his father before him, I was headed into business.

IN THE 1980s, when the field of conservation was transforming from an artisanal trade into a science-based profession, private practice was far less desirable than working in a museum. Private business bore a glare of crassness, implying that one was in it for the money rather than academic satisfaction. In my case, it was partially true. I needed financial stability. Luckily, Stella did too. We bought recycled chairs and tables, two cameras, a range of dental picks, trays, scalpels, power tools, brushes, paints, adhesives, plaster and fill materials, glass bottles of reagents and solvents, a makeshift steel cabinet for isolating chemicals, a vacuum cleaner, and head magnifiers so we could see our surfaces in detail. Though not as glamorous as a museum laboratory, our studio started filling up with works of art from private collectors, government agencies, and small museums. Many of our projects were eccentric—a castle-like mansion with a replica of the ancient biblical tabernacle, a maritime collection of globes and wooden mastheads, and firefighting memorabilia belonging to the Insurance Company of North America. Anything too large or too valuable to move, like nineteenth-century horse-drawn fire pumps and outdoor sculpture, would be treated on-site. This made for voyeuristic fascination as we saw how others lived, the pets they owned, and what they ate, wore, and slept on. Stella relished these settings. At private homes, she sidled up to clients, finding common threads of conversation about whom they knew

and where they might have crossed paths at a museum opening or party. It made me uncomfortable. When I told her so, she waved me off as if she were drying a manicure. Then one day she told me that she alone should be the one to handle our high-end collectors.

I was mystified. "Aren't we a partnership?" I asked.

"Yes, but most of those people are my connections."

Partnerships, I quickly learned, were even more complex than marriages. They have all of the same tensions and petty grievances, but there's no love to keep the relationship from unraveling. I grew wary of Stella. She began to blithely elbow me aside at every opportunity, speaking to clients in scientific tongues to make it seem like what we do is obscure and exotic. It annoyed me, and it seemed like a sleight of hand to make herself sound smarter than she was. As far as I was concerned, our work is not splitting the atom. If you can't explain it, you don't understand it.

One day, after a particularly stressful meeting, where Stella interrupted me each time I tried to speak, I asked, "Why are we partners if you don't want to hear what I have to say?"

She smiled wolfishly and shrugged. I don't remember her words, but I saw the writing on the wall. I couldn't sleep at the thought of having to compete with her. Looking back, it is impossible not to wonder how my own impostor syndrome, feelings of inadequacy, and the full-immersion training from my parents to hone in on the conflict in every relationship played into the problems we were having. At the time, I only knew I was miserable and I blamed Stella for it. I also had no idea how to simply break free. In the end, however, our breakup was easy. Not long after our first anniversary in practice, Stella announced that she was taking half the tools and equipment and moving to

New York to focus on modern and contemporary sculpture conservation.

"Philadelphia is a backwater. You should get out of there too. You have too much to give the world," said Holly when I told her what had happened. But, of course, I could not. I had a husband. Besides, I *liked* the city.

I moved into a cheaper studio in the run-down jewelry district. Accessed by a cage elevator with a claustrophobic feel, my two small rooms had peeling paint, fluorescent lighting, and a patchwork of linoleum flooring that looked nothing like a laboratory. I scrounged for clients and taught myself the elements of outdoor sculpture conservation by reading other people's treatment records and by volunteering to wash and wax a bronze statue of George Washington in front of Independence Hall. A photo of me doing the cleaning made the *Philadelphia Inquirer,* and that set me on a path of winning outdoor sculpture bids, including one to treat the bronze plaques on the National Memorial Arch at Valley Forge National Historical Park. I said yes to everything that came my way.

Everything went well, until I made a mistake. A big one.

MISTAKES ARE DEVASTATING to conservators. We rarely talk about them. Failure is not built into our practice. Though our errors aren't matters of life and death as they are with doctors, damage makes us panicky. In its preamble, the "Code of Ethics" of the American Institute for Conservation states clearly that "the primary goal of conservation professionals, individuals with extensive training and special expertise, is the preservation of . . .

an invaluable and irreplaceable legacy that must be preserved for future generations." Pretty lofty stuff. And though this code is not legally enforceable—that would only be possible if we were licensed professionals, which the field of conservation can't seem to figure out in the United States—saving cultural heritage is the one unalterable bedrock of our vocation. Damaging that heritage is radioactive, the counternarrative to what we're trained to do. A photography conservator I know told me that she had to take antidepressants after accidentally scratching a contemporary Cibachrome print during treatment. These days, the American Institute for Conservation holds a lunchtime session on mistakes at our annual conference. The tone of it is upbeat, humorous, collegial. It's fun, but it doesn't begin to dig into the sorrow you feel when you bomb at your job. In my long career, I've been happy to talk about minor failures, but never big ones. Never this one. So, here goes, in conservation parlance:

Object: Damaru Sago Palm Flour Storage Jar with Bird Face

Artist/Maker/Date: Aibom Village, Sepik River, New Guinea, ca. 1965

Materials: Low-fired earthenware, powdered pigments (carbon black, calcium carbonate)

Dimensions: Height 22"; Diameter 12"

Description: A medium-sized low-fire earthenware jar common in the middle Sepik River lakes region of New Guinea (island). These pots are built by hand by women from specific clay deposits in their villages. After they are fired, they're decorated by men using pigments and clay slip. The pigments are typically made of

clay, chalk, and carbon. In this case both calcium carbonate (chalk) and carbon black were observed.

Condition: The jar is structurally sound. There are no breaks or losses. The lower half and interior cavity are efflorescing salts, a fact confirmed by observation and wet chloride tests. The jar is crumbling and spalling where the salts are thickest. The pigments are powdery, especially the white.

Recommended Treatment:

1. *Test pigments to find a suitable consolidant.*

2. *Consolidate as appropriate.*

3. *Immerse the jar in distilled water. Change water baths as necessary, testing for chlorides until all salts are removed.*

4. *Remove the jar from the bath and allow to air-dry.*

SOLUBLE SALTS ARE THE ENEMY of most materials. They damage both chemically—because the chloride in the salts transforms into hydrochloric acid in the presence of water—and physically—because each time they get damp and then dry out, they crystallize in different shapes and push away grains of stone and ceramics. The consequences can be drastic; I've seen entire surfaces of buildings delaminating from salts. That said, removing soluble salts can be as simple as soaking the object in distilled water. You change the bathwater after measuring the chloride coming out with a simple silver nitrate test. When the chlorides are gone, you remove the object from the bath, let it air-dry, and,

presto, you're done. It's a different story if the object is the size of
a building or if it is already crumbling or has unstable surface
pigments, which this object did.

I decided to bind the chunky loose pigments with an acrylic
resin called Paraloid B-72 in a solvent called xylene. B-72 is our
profession's favorite resin. Developed by Rohm and Haas chem-
ists in the 1950s, it's an incredibly stable polymethylmethacrylate
that can be easily resolubilized. Xylene is a slow evaporating aro-
matic hydrocarbon that could drive the resin deep into the pores
of the jar. It has a heavy, syrupy, headache-producing odor. It's
also pretty toxic.

Using a small sable brush, I tested the solution on a small area
of pigment. I waited a week to make sure that all the solvent had
evaporated, then tested the surface by rolling it with a dry cotton
swab. No pigment came off. I tried next with a lightly dampened
swab. Again the pigment felt well bonded. This was not very
precise testing, but it was what was possible, given my lack of
scientific instruments. I repeated the tests over the whole surface,
then, when everything seemed to be stable, I set the relatively
heavy jar into a plastic tub. Slowly I filled it with distilled water.
Bubbles began rising as water penetrated the ceramic's pores. I
kept my eyes on it for an hour. All was going well. I went back to
another project.

Before heading home at the end of the day, I checked the bath.
A cloudy film had risen to the surface of the water. Panic thudded
through me. The pigment was coming off! Because the jar was
too heavy to lift out while wet, I grabbed a bowl and started
bailing, trying to save the water in a bucket, hoping to sieve out
the pigment and reattach it, though that was clearly impossible.
Only the white chalk was coming off.

That night I barely slept a wink. I raced to work just after dawn the following day, dreading what I'd find. The damage was not as awful as I'd expected, but it was bad enough. The black pigment had not changed. But the white was half gone, and what remained was crackled, swollen, clinging by a hair. How could I have been so stupid? Would I would be sued, destroyed? I had insurance, but that wasn't the point. Failure is bad for most conservators; for someone who'd been battered all her life for the most minor infractions, it was like being hit by a truck. I wracked my mind to understand why this had happened to the chalk and not the carbon black. The issue, I discovered after further tests on the pigment, was that the white was not simply calcium carbonate (chalk), as I'd surmised; but a mix of chalk and clay. The calcium carbonate had absorbed the consolidant. The denser white clay had not. When water hit the mix, the clay simply popped off.

I spun doomsday scenarios. I was finished in conservation. I'd lose all my clients. Stella had been right about me. I had proven my worthlessness once and for all.

But as it turns out, most conservators will blow a treatment at least once in their career. We don't like to admit it, but it happens, just as even excellent doctors can make mistakes. A few years later I would learn of a colleague who accidentally caused a Henry Moore bronze to blow up by letting solvents build up in the sculpture's hollow cavity while hot waxing the sculpture with a propane torch. The individual has a thriving practice to this day.

I fretted for days without anyone to talk to. Ginny Greene would have offered practical advice, but I was too ashamed to reach out to her. Eventually, I picked up the phone and called the client. "Some of the pigment came off in the bath," I said. (It was

more than "some"; it was "a lot.") I braced myself for anger. Instead, she blithely asked, "Can you fix it?"

"Sure," I said, without thinking.

"Can I get a discount?"

Oh, man! What relief. I hunkered down to work. First, I consolidated what was left of the chalk. Next, I used compresses of shredded blotter paper mixed with distilled water to poultice out the remaining salts. This is what I probably should have done in the first place, had I thought the problem through correctly. I used a brush to dab dry calcium carbonate pigment to the areas of loss, scumbling earth tone pigments to improve the appearance and also to sort of mask the extent of the damage. In the report I wrote, "Losses to the pigment were retouched using fresh calcium carbonate and other pigments." That was true, but like the pigment itself, it hid a deeper meaning. I had crossed a threshold. I was a conservator who had *caused* damage.

In the end, my client was happy with her object and her discount. But to this day I've carried stinging shame around this episode. Some conservators I know have quit the field after damaging an artwork. I didn't—but I sure thought about it. What really stuck with me, gnawing at my sense of self, was the way the client accepted my failure with a shrug. I wasn't used to making mistakes without receiving terrible punishment. It made me think that I had misled her. When I was young, half-truths and sly deceptions were a buffer against my mother's constant probing. "I know you better than you know yourself," she used to claim, to keep me in line. In conservation, a field of science, rigor, and disclosure, half-truths are as bad as bald-faced lies.

"Maybe you should consider a different profession."

Linda always had a practical solution to what seemed like an insoluble problem. The mistake with the jar had taken whatever joy I'd had from private practice. It sucked to work alone, barely making a living. A sole practitioner has to write proposals, send invoices, take phone calls, coddle clients—all tasks that have nothing to do with actually conserving objects. After four years in graduate school, I worked mainly on tchotchkes, novelties, personal possessions, nothing of importance.

At Linda's suggestion, I signed up for one of those professional aptitude tests that measure one's tastes and talents. In a windowless office in Center City, part of downtown Philadelphia, I sat under fluorescent lights at a Formica desk penciling in answers to questions like, "Do you think problems are better solved by teaming up with others, reading a book, or taking a long walk?" "Rank in order of preference: I would spend a vacation climbing a mountain / helping build a treehouse at a school / visiting churches and museums." None of it made sense, but that was the point. The test tricks you into revealing hidden predilections.

My result was a so-so score in the arts, and off-the-charts abilities in a wide range of healing professions—nurse, physical therapist, massage therapist, operating room technician, everything medical except physician. I felt worse than before the test. The notion of working with patients and their blood, shit, vomit, sores, and stenches was horrific, out of the question. Non-bodily grossness was my thing: rust, mold, stickiness, colonies of glistening larvae. I see now that I missed the point: Conservation *is*

a healing art. We are, as Elizabeth V. Spelman writes in her slim but brilliant volume *Repair: The Impulse to Restore in a Fragile World,* "devotees of repair . . . [who] toy with certain illusions and seek out certain consolations about the impermanence and inevitable decay of the objects around us."

Nevertheless, I considered a career switch. Fuck it, I would try medical school. That was sure to make my parents proud. But that summer, life took a turn that made that impossible, at least in the immediate future.

I was in Israel, on a fellowship at the W.F. Albright Institute for Archaeological Research in Jerusalem, while A.B. was on a dig. The Albright is an institute for Syro-Palestinian archaeological study founded in 1900 as the American School of Oriental Research. Housed in an elegant 1920s limestone building in East Jerusalem, a neighborhood that had been part of Palestine until the 1967 Six-Day War, the Institute offered residential fellowships to academics and archaeologists doing doctoral research in archaeology, biblical history, and related fields. It also had a collection of pottery and artifacts that had not been examined for half a century. I had won a small grant to study the collection's condition. It was a way to work and be close to my husband for the summer.

Also living at the Albright that summer was the teenaged son of a Penn professor who was one of my husband's colleagues on the dig and his academic advisor. Nick was bored out of his skull in Jerusalem. I made him my assistant, and he took notes while I scoured the shelves of pottery, wiping away decades of dust, and noting which bowls and jars had joins that were pulling apart because of that awful white glue adhesive that archaeologists

loved to use. We had a great time working together, listening to David Bowie on Nick's Sony Walkman and laughing constantly. I started to realize that maybe all I needed back in Philadelphia was an assistant.

Then one day, out of the blue, anguish bloomed inside me, drenching me like a desert cloudburst. I stopped joking around with Nick. At night, I cried in bed, while cataloging what was wrong with my life. *I hate my job. I'll never make enough money and neither will A.B.* I began wondering if this life of academia and archaeology and conservation was what I really wanted. I doubted my love for A.B. and felt caged, unsure of my future. Spending hours in a dank and poorly lit storage basement didn't help.

Each afternoon the Albright scholars gathered in the shady courtyard to sip tea and eat cardamom cookies. I was a bit of an outlier among that group, and one day I got into an argument about the importance of artifacts with a prominent archaeologist, someone who knew my husband and with whom he did not agree about some arcane piece of information related to dating the beginning of the Iron Age. Stroking his white goatee, the professor remarked that it was a waste of a proper fellowship to give it to a conservator.

"The pottery is in terrible condition," I countered. "Many of the pieces are ready to fall apart."

Professor goatee dismissed me with a wave of his hand. "Artifacts are only significant when they're in their archaeological context," he said. "Once they're dug up and published, their scientific use is limited."

"Usefulness to who? To archaeologists? Other people might want to look at the material sometime. You might as well throw out all ancient collections, then."

The others present chuckled sycophantically. To them only objects of value—metals, mosaics, jewelry—merited conservation. Someone remarked that the resources that were being spent on my condition reports would be better spent funding new excavations so that more research could be published.

"Without the physical evidence, how can anyone ever challenge your conclusions?" I asked.

Professor goatee took that as his cue to make some snarky, sexualized comment about the role of women in archaeology (this was when people could get away with such behavior). He made an oblique comparison between the Albright and the apartment building in *Breakfast at Tiffany's*—a 1961 film based on a Truman Capote novella in which a writer and a young socialite have misadventures among a group of misfit cohabitants—and wisecracked that the place would be better if Holly Golightly—the name of the protagonist played in the film by Audrey Hepburn—were in residence also. Beneath my desire to throw my cup of hot mint tea into Professor goatee's face, I remembered then that *Breakfast at Tiffany's* happened to be the first movie I ever saw. We were then living in South Beach, and my mother had dropped me and my friend Raquelita off at the theater in Miami Beach. Too young to understand the film's sexual subtext, when my parents asked, "*De que se trato la pelicula,* Rosita?" (What was the movie about?), I said, "*Un gato.*" That memory of going to the movies in South Beach suddenly cleared my head to the fact that my period had not come in weeks. Maybe I was pregnant. The following day, a test confirmed my hunch.

———————

NINE MONTHS LATER, I WAS pushing with a midwife at my side, when the room swirled into colors and then blackened. I was having an eclamptic seizure. I found out when I woke up under glaring lights after an emergency cesarean. I was rushed in for a brain scan. Everything was normal. A.B. and I also had a healthy baby boy.

But everyone was rattled, especially my mother, who rushed to Philadelphia, a cantankerous bundle of nerves. "I'm here to help," she exclaimed, then snatched my son away and started talking nonstop about how this experience nearly killed *her*, because of her history with childbirth mortality. She was scared, and what she does when she is scared is get upset. What seemed to upset her most was my nursing the baby. "He looks thin. How do you know he's getting enough food? Why can't I just feed him one bottle a day?" she demanded.

"Nursing is better for the child. The doctors say so. It's proven to prevent allergies."

She rolled her eyes and told whoever came into the room. "Breastfeeding is a thing of the past. I never did it. I am not a cow."

I WENT BACK TO WORK when my son was four months old. Private practice finally made sense. I worked three days a week. Nick helped me out after school, so I was often able to go home early, leaving him to lock up. My husband and I bought a 1920s row house on a cul-de-sac. It had a fireplace that A.B. never managed to light without filling the house with smoke. It annoyed me

that he couldn't get this right, but I was unwilling to try to do anything about it myself. "That's his job, isn't it?" I said to Linda.

"It's whoever's job can do it," she said laughing. She tried it herself and couldn't make it work either. It didn't matter in the end. Philadelphia was home. Life was falling into place, my parents far away but not so far that they couldn't come up once in a while.

Then A.B. was denied tenure at his college. For those who don't know how this works, academia has (or used to have, because now job security is even more unfairly stacked against young faculty) a crazy set of employment rules. After a few years, you either get hired permanently (tenure), or they kick you out. There's little in between. Anticipating the possibility (I, on the other hand, could not fathom this, given his clear talents and the relative insignificance of the college in the New Jersey Pine Barrens where he taught), A.B. had been applying for jobs all over the country. None were even a day's drive from Philadelphia. He was offered a tenure-track position at the College of Charleston.

"The South? No way," I said.

"Why not?"

"I didn't leave Miami to wind up someplace even less interesting and backward."

A.B. tried to reason with me. But then he was also offered a one-year fellowship in Los Angeles. "There's no guarantee of it turning into a job," he warned. He persuaded the College of Charleston to defer his job for a year.

"Let's take our chances," I said.

We rented our house, loaded up our Honda hatchback, and headed for Los Angeles.

Chapter Eight

SILVER

ome native Spanish speakers use the word *plata* (silver) to refer to money. My mother does this, hitting the word with a streetwise swagger that reminds me of the term "*plata o plomo*" (silver or lead) that was popularized in the 1970s by Medellín Cartel leader Pablo Escobar. *Plata o plomo* is a threat that means "take my money (silver) or you're looking at a bullet (*plomo*, or lead)." My mother has, of course, nothing to do with a murderous drug lord, but like many people born into poverty, she has a slew of choice expressions about money. When my brother and I were living at home she liked to say, "I pay, so I say," or "You can't have champagne tastes with beer pockets." Now it's "Money talks and shit walks," and "Rich or poor, it's good to have money."

In the early 1970s, my mother came into a windfall of *plata*—$18,000, to be exact. She found the money zipped into a suitcase while scouring closets for evidence of an affair. My father's other

woman was my uncle Felix's girlfriend, Norma, a chestnut-haired *americana* who worked as a hostess in a restaurant. My mother's first inkling of the affair came at the wedding of a close friend's daughter. She was in the kitchen, helping the mother of the bride with the dessert table, when another friend came running up to say: "Get yourself out there. Lindy's on the dance floor with Felix's girlfriend, and they look like they're fucking!"

My mother rushed out to find my father grinding away at her brother's girlfriend. She cut in smoothly, laser focused, showing the upstart *americana* what Cuban dance moves looked like. Without letting on to my father, she began tracking his movements. While his office was south of our house, when he had to work late, his car would appear from the north end of our street. It was out of character for my mother to remain calm in such a situation, but she knew she had to be strategic here. La Colonia's men were infamous philanderers and several wives had been left for other women when they did not handle matters wisely.

A week after she found the $18,000, which she figured out was money my father had skimmed from cash sales and was his way of keeping his dalliance from appearing on their joint credit card bills, my mother met him at the airport when he was coming home from a business trip to Puerto Rico. Norma got off the same plane. The lovers feigned surprise at suddenly meeting, and my normally volatile mother played along, laughing, kissing my father passionately, and dragging him home without questioning the so-called coincidence.

Now that she had airtight confirmation, she prepared to pounce. My father was headed for a monthlong work trip to Japan and Switzerland, and my mother was to meet him afterward in Paris—her first time in Europe. When her friends offered to

take her out to lunch to revel in the impending trip, my mother suggested they go to the restaurant where Norma worked. When they arrived, Norma gasped: "What are you doing here?"

"I'm here to celebrate a trip to Paris with my husband."

"He's taking *you*?" Norma demanded.

Coolly, my mother arched an eyebrow. "What do you mean, he's taking me? Should he be taking you instead?"

With $5,000 of the discovered money, my mother bought a new wardrobe and sexy negligées and then upgraded the hotel room to a suite my father always talked about but said they couldn't afford. These strategies for seduction worked—when they met in Paris, he was newly besotted by her beauty and allure. They made love and ordered room service. Then she said: "Oh, by the way, I ran into Norma, Felix's girlfriend. When I told her I was meeting you in Europe, she seemed surprised, as if she thought she should be the one going."

My father faltered, a deer caught in the headlights.

"And, by the way, I found a suitcase full of money in a closet. Do you know what it's for?"

My father was out of his league, vanquished. He shrugged. "I have no idea."

"Oh, well. Then I guess it's mine."

THE SUMMER THAT A.B. and I headed to California, I used a version of the same calculated restraint with him. I played along with the idea that this was temporary, that we would spend a year out West, then move to Charleston.

But I had no intention of moving to the South and figured some opportunity would appear in California. Or we'd go back to Philadelphia. But as we drove across the Mason-Dixon line into Virginia, I was unexpectedly drawn in by the landscape. The Shenandoah Valley with its rolling hills and forests. The Blue Ridge Mountains. We took walks by waterfalls and rhododendrons. We spent nights in clapboard bed-and-breakfasts and drove on back roads, detouring to tiny towns with grassy squares and brick courthouses with tall clock towers. I learned to love the lilting drawl and cadence of the local speech patterns. I was an immigrant, and white, so when I saw monuments with men on horseback, or men with swords upraised, I didn't think of them as different from the statue of George Washington outside Independence Hall. Stonewall Jackson, Robert E. Lee, and Jefferson Davis were just antiquated names. All of their bronzes needed a good washing and waxing.

Our son was then twenty months old, a cheerful towhead with enormous blue eyes who refused to leave our motel rooms unless he was dressed in a cape and Batman pajamas. Everywhere we stopped along the southern route, people would drawl: "Such a gorgeous child! He looks nothing like either of you!"

A.B. and I shared some laughs about that. He was a kind and patient father, exactly what I had wanted for my son. Our boy was going to have a life of calm and joy, his home a place where friends would come for playdates, without worries about violence or arguments. At Graceland, where we stopped to see the former home of Elvis Presley, I watched him run around with A.B. on the lawn while we waited in line. He looked at, but did not touch, the teddy bears that people from around the world had placed on

the graves of Elvis and his parents. He was a pleasure to travel with, always happy-go-lucky, even when we filed into the 13,000-square-foot Colonial Revival mansion, where the crowd grew hushed with quasi-religious reverence.

Visiting Elvis's house had been a lark for us, a private joke. But other visitors were seriously oohing and aahing, some dabbing their eyes. What was it about crystal chandeliers, velvet upholstery, gilded candelabras, and marble columns that could make a person cry? A.B. carried our son as we peered into the famous Jungle Room with its indoor, faux-rock waterfall. A nearby TV room had three large consoles mounted into the wall. As we made our way along the hallway where the trophies, gold records, and rhinestone costumes were displayed, I had a sudden understanding. People came to Graceland to feel the power of a story told in objects. Graceland told a tale of triumph and morality, where money cannot buy redemption, where even a huge talent and a fleet of Cadillacs could not save someone from his own worst impulses.

Objects as the words and sentences of stories. This became my new read of the mundane, profane, elegant, and gaudy. At the Lorraine Motel several miles north, the tragedy of the assassination of Dr. Martin Luther King Jr. was framed in the modesty and commonness of the objects. One of the greatest leaders this country has ever known was killed on the simplest of concrete walkways. No gold or marble here. Just a low-slung, thoroughly American, mid-century motel. A water glass, a black tabletop telephone, and rumpled polyester bedcovers. Everything was ordinary. The only grand thing here was Dr. King's humanity.

As we traveled across the continent, America the beautiful became the America of strange material objects. Flashing neon signs, giant thermometers, concrete dinosaurs, and Cadillacs

buried nose deep in sand. I loved this wacky version of my adopted country. Unlike in Philadelphia, where much of the visible heritage was centuries old, many of these items had been built at roughly the same time that my family arrived here. On our trip we saw three separate renditions of Leonardo da Vinci's *Last Supper*—a full-scale painted one in Texas, one made of live flowers in Alabama, and a dead-on chiaroscuro copy made of slices of burnt toast in a California Ripley's Believe It or Not.

Somewhere near Carlsbad Caverns—where we marveled at the flapping spectacle of a million bats flying out at dusk—our son developed a strange cough. There was no controlling it. At the Grand Canyon, he seemed to be laboring to catch his breath. We sped west, rushing to find a pediatrician in Santa Monica, California. The diagnosis was asthma.

"So much for breastfeeding," boasted my mother, when I called to tell her what was happening. She sounded annoyed, as if I'd caused the asthma. "I know all about this. Your brother had asthma and what we did to cure him was . . ." She listed a series of treatments, some prescribed by a doctor, others Cuban remedies, like not drinking anything that's too cold or not going outside at night without a head covering. Then she added, "I'm sure staying in all those dusty hotel rooms didn't help." Our pediatrician assured us that the trip west had nothing to do with asthma. We put our boy on nebulizer treatments. A.B. went off to his fellowship. I made a few calls and landed my own fellowship to help prepare contemporary artworks for display in a new wing at the Los Angeles County Museum of Art.

I AM OFTEN ASKED WHY contemporary art needs conservation. Sounds like a fair question. All works of art were once contemporary, and many were conserved within years of being made. There are records that Michelangelo's Sistine Chapel was cleaned within a half century of its creation. Paintings by Rembrandt, Vermeer, and Titian were also restored during their lifetimes. The work was necessary then for the same reason it is today. Because everything gets dirty and accidents happen. Varnishes discolor from the smoke of candlelight and hearth fires. Certain colors darken; others fade. The dust that settles on your floor and coffee table also clings to sculptures and canvases. And people step where they shouldn't. More than likely once upon a time, some doge in Venice must have put his elbow through a Titian or a Veronese, just as casino magnate Steve Wynn did to Picasso's 1932 painting *La Rêve*, days before he was going to sell it.

That said, artworks from the late twentieth and early twenty-first centuries present a range of new problems. They're made of strange materials, like plastics, that don't always behave the way we expect them to. Contemporary artists also have wildly varying aesthetic requirements. Some artists produce polished metal sculptures that are expected to remain completely pristine, without a scratch, fingerprint, or any sort of blemish. Others fabricate work out of detritus—rusted metal, decaying Styrofoam, blistered acrylic, and broken glass. This begs the questions for conservators: How much flaking paint can be allowed to fall off a rusted I beam of a Mark di Suvero whose paint was flaking to begin with? Do we replace the images in moving picture sculptures by Nam June Paik with digital versions or amass a cache of

solid-state tubes (as MoMA has done) to keep repairing the television sets? Contemporary art is a veritable minestrone soup of varying and conflicting aesthetics. Nowadays, there is a quasi-cult over the need to interview artists, to record their every idea and notion as the basis for the care of their works. That's fine, if you are confident that the artists in question understand the realities of their material choices. Also, artists change their minds and rewrite their own histories. As their careers evolve, they move on, their memories just as porous as ours. And like the rest of us, artists will say and do one thing when they're experimenting with their own creative processes, and quite another when they have to go on record with a curator or journalist.

My days at LACMA were delicious delves into these philosophical considerations. Those of us working on the new Anderson Wing talked constantly about how to conserve the works of Frank Stella, Louise Nevelson, Bruce Nauman, and Ed Kienholz, to name but a few of the modern masters that were going to be displayed in the new building. I also got to participate in a silver-polishing project led by a fellow conservator named Glenn Wharton. This was the first time since my internship at Penn that I had been part of a team. I loved the measured and meticulous way we recorded the effects of polishing—which homemade slurries scratched, which were most efficient at removing the tarnish without altering the contrast of decorative undercuts.

The objects we were treating were part of the Gilbert Collection of silver at LACMA. This group of eighteenth- and nineteenth-century decorative objects was on long-term loan to the museum from a collector who had been born Abraham Bernstein in London and changed his name to Arthur Gilbert

after marriage. In 1949, Gilbert retired to Los Angeles. There he discovered a new passion for collecting lavish European decorative art objects, among them Renaissance micro-mosaics, which can have up to three thousand tiny stones per square inch. Most of the Gilbert silver pieces had been made by French Protestant smiths who had fled Paris for London in 1685 after Louis XIV revoked the Edict of Nantes that had allowed them to freely practice their religion. Some of the pieces were encrusted with jewels; others stood higher than I did at five feet three inches. My mother would have loved them, but to me they looked like eighteenth-century versions of the furnishings at Graceland—overwrought punch lines of self-importance, items a person collects to show off aristocratic taste. More than once, we conservators giggled when these monstrosities were rolled into the lab on padded rubber carts.

In some ways, Arthur Gilbert's longing for reinvention felt familiar to me. I'd thought of conservation as a transformative profession, but even though I loved the work at LACMA, Los Angeles felt off, the ocean too cold, the time zone wrong. These might seem like minor complaints to someone who's always had a place called home, but home for me was a moving target. I already had a warm place with palm trees to call home. Los Angeles was similar to Miami, but just different enough to be an uncomfortable fit, like a dress that was almost, but not quite, the same as another that you'd owned and loved as opposed to an entirely different piece of clothing.

I was fidgety and restless. A neighbor suggested I take acting classes (it was Los Angeles, after all). I got into one of those so-called exclusive workshops, and spent every Wednesday night being pummeled by an irascible acting guru for what she said was

my "inability to stay in the present." Was that ever an understate-
ment. If she only could hear the spinning in my head, the worry-
ing about the next problem coming my way. As much as Los
Angeles wasn't right, I dreaded the prospect of Charleston. I had
no reason to loathe South Carolina, but my stomach sank every
time I thought of living there.

The last and final part of the silver project aimed to find out
how well lacquers really worked at reducing tarnish. Lacquers are
clear synthetic coatings used to keep metal surfaces from oxidiz-
ing and darkening. Though tarnish is not in itself damaging,
unlike, say, rust on steel, it makes silver look grungy. Lacquers
slow that process and keep us from having to remove more and
more material each time we polish.

But lacquers are not perfect solutions. They're hard to apply
without seeing streaks or a bumpy pattern known as "orange
peel." They're porous on a microscopic level, so they don't actually
seal anything over the long term. If you don't get full coverage
when you apply them by spraying or brushing, you get an exposed
area that darkens at an accelerated level, and even leads to pitting,
because of the way the corrosion potential of the metal concen-
trates in the exposed spot. People love to claim that lacquers are
"sealants" that completely protect surfaces from the elements.
That's not true. Nothing fully seals anything. Epoxies come close,
but there the cure is worse than the disease, because epoxies yel-
low and they are difficult to remove without harsh chemicals. I'm
always amazed by claims of a miracle solution that keeps surfaces
from reacting to the elements. If only life worked that way. It just
doesn't. At least not yet.

And yet, I longed for the "miracle solution" of returning to
Philadelphia. Spooling back to those happy days walking along

the Schuylkill River, living near my buddy Linda, having a second child—which was starting to become a problem for us. That, and only that, would heal my inner hurt. A trained conservator should have known better. There are no magic coatings for the oxidation that resides within us. It takes constant excavation and maintenance to manage problems. As the end of A.B.'s fellowship neared, we argued often. I accused him in a breathless, high-pitched voice, using those same phrases that I'd heard my mother lob at me and my father: "You only care about yourself and your career. Not me, not our son's future. You'll drag us anywhere, from coast to coast—"

"It was you who wanted to come to Los Angeles," he countered.

"I wanted to stay in Philadelphia!"

"But that was not an option. What do you want from me?" my kind, generous husband shouted at me in bewilderment.

Some days I would feel myself lift from the room, watching this as if it were a movie. George and Martha from *Who's Afraid of Virginia Woolf?* Spite spewing from me, pummeling my husband into a corner for what was outside his control. One day we got so angry with each other that I reached up and tore his glasses off his face. Without thinking, he tried to sink his teeth into the top of my head. Such violence was so out of character for us that we stopped abruptly, fell into each other's arms, and wept, then laughed. But the big picture of our lives was not funny.

The one good thing about those days is that I never turned my darkness against our son. One morning, he was refusing to get dressed, as children do, kicking and thrashing as I tried to pull off his pajama bottoms. When one blow landed on my gut, instinctively, and without thinking, I whacked his thigh. His blue eyes

opened in wide shock. "You hit me?" he announced in disbelief. My child did not fathom that his parent could hit him. For me this was like a shower of pearls, never mind that he was still in his underwear and now really not about to do anything I asked.

WE LEFT FOR CHARLESTON IN AUGUST. We arrived in the heat of summer, when the air is even thicker with humidity than in Miami and the mosquitoes are ferocious. I finally understood the Confederate vibe. It dripped from the trees, like Spanish moss. We rented a nineteenth-century, white clapboard, neoclassical house in the peninsula district, a colonial neighborhood of stately mansions framed by palmetto palms and glossy magnolias. Nearby was a little artificial lake where ducks swam. On the barrier islands there were beaches with water warm enough for me to swim in. The sand was grey and soupy—perfect for making drippy sandcastles. It wasn't a bad place, but I did not want to be there. I missed Linda. She came down to visit, and we reminisced about our snowy afternoons of hot chocolate and conversation. When she left, I cried for hours.

I had a small home studio in Charleston, but mostly I worked in museum basements on porcelains, silver, farm tools, firearms, and objects that defined southern plantation life. Among them was a pair of heavy iron leg shackles used on enslaved Africans. I found it hard to even touch them. They seemed to require other hands, African American hands, but I knew no African American objects conservators in Charleston, or, to my knowledge, anywhere else in the United States. Along with the rest of our field, I was not yet attuned to the fact that heritage preservation

requires the input and participation of communities that pro-
duced, or were impacted by, artifacts. Though certainly these
shackles did not originate with African Americans, their story
was marked by their use as tools of enslavement. It felt weird to
be the one to scrape off their corrosion and brush them with
tannic acid.

But it was there in Charleston—surrounded by that old-time
yearning for the lost cause and pining for Philadelphia—that I
found myself wondering for the first time about Havana. I now
knew what it meant to mourn a lost, beloved city. I had neither
been born in Philadelphia nor grown up there. As I traveled to
work in Columbia, Greenville, Beaufort, and Savannah, I found
myself imagining what it must have been like for my parents to
leave the place that held all their memories, their families, lan-
guage, food, and worldview.

In Atlanta, I found steady, if intermittent, work at the High
Museum of Art. I worked on contemporary sculpture and
American neoclassical marbles. The museum put me up in a
nearby hotel, one of architect John Portman's 1980s round tow-
ers, with its soaring atrium and glass-walled elevators. One night,
in the hotel's revolving rooftop bar, I stepped beyond the bound-
aries of my marriage. I had a drink with an old flame from high
school. Attraction crackled between us, and as evening rolled
toward midnight, we took the elevator with a view of Peachtree
Street to my room. I drove back to Charleston the next day, high
on the illicit sparkle. By the time I reached my house, the shame
had settled onto my shoulders. *I don't forgive and I don't forget.* My
mother's words rasped in my ear.

My lover and I met again. And then again. It continued for a
year, the backdrop to my swabbing stains and filling chips and

cracks on marbles. I told no one but Holly and Linda. Their responses could not have been more different.

Holly's was: "Enjoy it. It's an adventure. You gave up a lot to be there. Just don't get caught."

Linda's was: "You'd better think twice. You have a lot to lose."

In the parlor that served as my home studio, there was a built-in mirror over a limestone mantel. The mirror had dark streaks and spots. It's called *de-silvering*—the deterioration of the metallic silver that is used to turn glass into mirrors. It is not reversible. Every time I saw my reflection in that failing mirror, I felt like I, too, was coming apart. The darkness was rising to the surface. I'd wanted my marriage to be calm, loving, and honest. I was careening in the opposite direction. Corroding, tarnishing, delaminating—there are not enough metaphors in conservation to describe what pulsed through me in that humid Charleston house. I won't say I did not relish the reckless pleasure of those wild Atlanta nights, but I was also drawn, like a moth, to the hot burn of the flip side.

All my life I had been told that I was selfish, inconsiderate, a liar. Now I really was. It felt like picking at a scab. I'd sense the waves of loathing rolling in, a haunting self-destruction, and I would lash out: *I hate our life. I don't love you. Why did you make us come here to this awful, godforsaken city?*

Some people consider Charleston the prettiest city in the United States. I fought tooth and nail to leave. A.B. hit back at a disadvantage: He did not know what was really going on. Every day the words were on my tongue. I clamped my teeth shut and hissed my accusations.

Our son's asthma flared when we argued. It was like clock-work; he'd be fine, we'd start raising our voices, and within

minutes he'd be wheezing. One night his asthma went from zero to sixty in minutes. We stopped yelling at each other and rushed him to the local teaching hospital. He gasped for breath, flailing and wheezing, as residents poked and tried to draw blood from his hand. Panic thudded through me and A.B. "Isn't there some other way to test his blood oxygen levels?" I begged. Just then one of the residents brought out a small meter that did just that. They had been experimenting, using our toddler to train their residents.

"Shame on you!" I shouted. The nurses averted their gazes.

"Calm down," A.B. said.

But I was inconsolable. "This hospital is just as awful as the rest of this city," I said. I slept with my son in an oxygen tent, feeling that my infidelity was choking all of us.

Eventually, I confessed. A.B. was sad, angry, mortified, but he forgave me. If I was looking to be pummeled, I'd come to the wrong person. His generosity was like a blank page in a new book. The old page was ripped out, balled up, tossed over his shoulder. "You are not to blame," he said. "Come back to me."

Such love. Who could deserve this? Certainly not someone whose soul was as besmirched as mine. I vowed to do better. I stopped traveling, hunkered down, took a class in playwriting, wrote a piece that was produced at Spoleto Festival USA in Charleston. The play was about, of all things, Cuban immigrants. The main character spoke in my mother's voice. I had it all, I told myself. Why couldn't I feel good?

Sensing all of this, one day A.B. said: "Let's leave. Enough of this. I'll change jobs. I'll go to law school."

Our goal was Philadelphia. But every single program he applied to in the city or within driving distance rejected him. He

got, instead, a speedy offer from UCLA. California beckoned. Law school would only take three years. Then it would be back to the Northeast, where we belonged.

THE PLAN WAS FOR ME to support our family while A.B. went to law school. Though I was totally on board, the arrangement brought back memories of the years when my father would be out of work, and my mother would turn into a loose live wire— vibrating with tension, counting pennies, ready to electrocute me at a moment's notice, railing to my face about having married the wrong person, though he happened to be my own father. I vowed not to do the same. But now I understood the fear of falling into poverty. I doubted my ability to carry this responsibility. I worried that the move west was permanent. I worried about everything.

I set up shop in Santa Monica, subletting space from a paintings conservator who specialized in contemporary art. In the blink of an eye, I had more work than I could handle, most of it high-end work, including a Donald Judd aluminum progression sculpture that had been sitting outdoors for decades, and an Andy Warhol soup can that needed to be drained because it was about to burst.

Within weeks, I hired an artist to help me. Robin Carter had just gotten her MFA in sculpture. She had great hand skills, knowledge of sculpture, and a deep curiosity about the science and rules of our profession. Also, a wicked sense of humor that rivaled Holly's. We grew close quickly. Our complementary abilities allowed us to take on large outdoor sculpture treatments,

which no other women were doing at the time west of the Mississippi. Robin lamented the fact that she was unable to go back to conservation graduate school, but to me that was unimportant. The field of conservation still allowed for people to be bench trained, which means learning on the job, rather than in a formal graduate program. And with Robin at my side, I found myself able to devote time toward getting pregnant again. I'd been having trouble conceiving a second time. There's a name for this: secondary infertility. It's caused by increased age (check), complications with a first pregnancy (double check), increased weight (not so much), impaired sperm production (who knew?), sexually transmitted diseases (gulp), and drug and alcohol abuse (not us). Our son was already six years old.

A.B. and I went to a fertility specialist. "Nothing's wrong with either of you," the doctors said and prescribed drugs that were astronomically expensive. But a few hours away, in Tijuana, both Clomid and Pregnyl, the major cocktails of the time, were 90 percent cheaper. A group of patients formed a posse, taking turns driving to Mexico to buy for all of us. It was all a bit insane, but I had goals to meet. Money, family, stability, changing the paradigm of my lonely, chaotic childhood. I had always longed for a sibling close in age, with whom to ally when my mother went off the rails. And while most parents seem to want their children to have siblings, it did not occur to me that my longing perhaps carried with it an implication that my son might need someone with whom to commiserate about me.

My largest project in those days was the Watts Towers, an installation made up of seventeen interconnected concrete sculptures, some rising to a height of one hundred feet. Located in a predominantly African American neighborhood that had been the epicenter of a violent 1965 rebellion to protest police brutality, discrimination, and unfair housing practices, the Towers are one of the world's best examples of outsider art, which means a work made by someone without formal training or connection to the museum and gallery world. Built by Sabato "Sam" Rodia, an Italian immigrant who worked without assistants, they were made of railroad ties and concrete, with decorative inlay that included broken tile and glass bottle fragments (including green glass from 7Up, Squirt, and Bubble Up bottles and blue Milk of Magnesia glass), shell, mirrors, and random objects. Rodia worked on his project from 1921 to 1954, then he signed the property over to a neighbor and took off for the Bay Area. Two years later, the City of Los Angeles condemned the Towers and ordered their demolition.

By the time I was asked to serve as the project's conservator, they were a cultural phenomenon—the subject of a 1957 documentary and featured in Charles Bronowski's 1973 BBC television series, *The Ascent of Man*, Charles Mingus's 1971 autobiography, and a host of television shows and movies. A famous pull test, conducted by an aerospace engineer named Bud Goldstone with steel cables and a pickup truck, found the Towers safe enough to withstand ten thousand pounds of lateral pressure, kiboshing the city's demolition plans. Despite this, the work on these idiosyncratic marvels felt beyond my capabilities. They were the

size of buildings, but made of a mishmash of wire-tied steel and mortar of different thicknesses. Cracks were oozing rust everywhere, some of them sixty feet above the ground. Shell decorations were powdering, and almost every day a piece of ceramic inlay would fall to the ground. Bud ran the project for the city. I found him maddeningly frustrating. He'd call to ask my opinion about a problem. I'd offer it, and he'd then suggest the opposite position. I'd consider it, perhaps agree, then he'd return to my original answer in this toneless, level demeanor that drove me mad. I started to think that he was actually more interested in sparring than in solving the problems of the Towers. It seemed like only ongoing maintenance would manage a monument of this scale.

Meanwhile, after months of fertility work, I finally got pregnant. At my first ultrasound, we learned that I was carrying identical twins. It felt like a windfall—two more kids for the fertility price of one. My parents were also thrilled. My mother bragged to her friends, "I'm going to be a grandmother of twins!" and made plans to come in for the birth.

But before long, dread replaced the excitement. Three children were a tall, expensive order. There was no way I could give up my private practice. Moving back to Philadelphia was off the table, at least in the near future. A.B. and I made an offer on a small duplex, which was cheaper than a single-family house. Once it was accepted, I lay awake at night, swimming in the unknown waters of the future I had wanted desperately, but which now seemed to be pulling me under: three sets of needs, three potentials for asthma, accidents, and who knows what else. Once, when we were living in Charleston, a doctor thought that our son's small size and labored breathing were signs of cystic fibrosis.

They tested his sweat, and it took a week to get the results, a week in which I could barely keep from tearing up every time I watched him running in the yard or stacking LEGOs. The more people you love, the more you have to contemplate their loss. In phone calls, Linda did her best to assure me that everything would be fine. I needed her more than ever now.

The amniocentesis began with an ultrasound, to know where to insert the huge needle to remove amniotic fluid. The radiologist—a tall, Iranian-born immigrant—spread icy blue gel on my huge belly and rolled the wand around. I saw him frown as he gazed at the computer screen.

"Anything wrong?" I asked.

The doctor pursed his lips and sighed. A.B. let his hand rest on my forearm. The doctor put the wand down and wiped his hands. "They're in one sac, the placenta favoring one twin over the other," he said. Or words to that effect.

The upshot was that identical twins can mess with each other in utero. One starts to take the other's nutrients from the placenta. The other one flounders, and frequently doesn't make it. In our case, one fetus had not developed lungs and would soon die. The other one was growing like gangbusters, the brain getting too large too quickly. Aborting the sickly twin might have helped the other one thrive, but they were positioned in a way that made surgery impossible.

"What do you recommend?" A.B. asked, his voice cracking.

The doctor said: "Your only chance of saving one baby is to take them both to term. But that would mean carrying a dead fetus for a few months, and it's dangerous for the mother to have necrotic tissue in the body. I'd need you in here at least once a week, and we'd need to do an amnio every one to two weeks."

A.B. squeezed my hand and looked at me with tears in his eyes. "Let's not do this. We've already got one healthy child. We can't risk your health."

The doctor told us to take several days to make the decision. We spoke with a rabbi, the mother of one of our son's friends. She said, "Jewish law requires us to preference a mother's life over that of the unborn child." The procedure was scheduled. Robin's husband, a photographer, offered to take pictures of me. The portraits were heartbreaking—a Madonna blended with a Pietà and a Mary Magdalene who was petrified that doubt and infidelity had caused this. The twins knew I didn't want them. The gears within my heart rusted into place.

THE NIGHT OF THE ABORTION, I stayed overnight at the hospital. The movie *Jaws* was playing on the small TV, the sound lowered to a murmur. I saw the images when the nurse woke me for my blood pressure. I had avoided the film when it had come out fifteen years earlier, thinking it would scare me away from swimming in the ocean. When the nurse left the room, I turned up the volume and watched the whole thing. The raw menace struck me as appropriate. Life was just as savage as the monster creature that lurked beneath the water. When Robert Shaw delivered that famous speech about the World War II soldiers who were picked off by sharks after they had deployed the atomic bomb, I felt a cratering inside of me. Drowning, lungs collapsing. Bright lights blinking overhead, beeping in the hallways. A beast had chewed my arm off. The poor twins. Lost forever. The

doctor who had performed the abortion told me they were girls. We had names picked out for all combinations. These two would have been Lily, for my husband's mother, and Blanca, for my grandmother.

"Man plans and God laughs," said my mother bitterly. She was heartbroken, but to me she spewed platitudes. She was always a master of these sayings, many taught to her by our former neighbor Eleanor. Expressions rife with bluster: *He can whistle dixie in Macy's window.* I needed her. But only the wound-soothing version of her. The one who made me chicken soup with plantains and malanga when I had terrible hay fever or made me laugh with her Cuban expressions: *Me cae como un hígado frito a las doce de la noche* (You're like having a fried liver steak at midnight). *Chenche por chenche, guanajay por tierra* (a contorted sentence that means "show me the money"). *¡Éramos pocos y parió Catana!* (a common Cuban expression used to say "things were bad but got even worse"). As the *Jaws* credits rolled, I knew that she, too, was awake, awash with grief. If only I could be assured that if I called her, I would reach the woman who could make it better.

When she arrived two days later, she was not that person. She ached, and her default on those occasions is wrath. "*Por favor*, Rosa, stop crying for God's sake!" she'd snap, as I lay in bed, not wanting to do anything but have my son beside me playing with his toys, or watch *Dirty Dancing*, which I watched ten times in one week because the ending made me cry. My mother banged about the house, washing dishes, swabbing counters, making dinner, taking our son to the park, trying to be helpful, keeping her own pain at bay with activity. I'd hear her muttering: *Losing*

a pregnancy is not like losing a child that was already born. It's not as bad as being born and having your mother die. You could have died yourself, and then what? What about your son and husband and your father and me?

I wanted her to leave. When she finally did, my stomach churned with loathing. That same week, I penned a searing poison pen letter to her and my father. I shook as I filled the pages with vitriol about the way she had hurt me as a child, and how much I blamed him for being a chump and not protecting me. I mailed the letter and promptly left for a vacation in Hawaii with our small family. This was before cell phones, and the three of us spent an uninterrupted week walking on lava beds and swimming in the tropical ocean. We hiked to a canyon, ate papaya and pineapple, and never talked about what had happened to us. My heart thudded every time I thought about my parents, but I never called. It felt good to be ruthless.

When we returned to Los Angeles, there were a dozen messages on the machine from my father. "We understand you're upset," he said when I finally called back. "There's always been something wrong with you. You should get psychiatric help."

"Great idea, Dad." I hung up before my voice cracked.

A month went by. My mother wouldn't speak to me. Finally, she called. Sobbing on the phone, she begged me to forgive her, that she did the best she could, that she didn't have a mother and didn't know how to parent any differently, that all she ever wanted was the best for me, *blah, blah, blah*. It was not lost on me that my father had been quick to blame me, to essentially say I was damaged goods, taking my mother's part even when she herself knew she had made a devastating mistake. I thought again of

the book Linda had given me that might explain my mother's interpersonal instabilities, of the possibility that she couldn't help her own behavior.

I relented. I forgave her. I am not really ruthless.

But any healing I might have experienced from hearing my mother express atonement for the past (even if I knew full well that her remorse was not going to last long) was undermined by the fact that my father's narrative remained unchanged from the one I had heard my entire life: I was the problem. How was I supposed to forgive myself for aborting my twins, for cheating on my husband, for never being enough or always being too much, if my own father believed I was flawed by design?

WE MOVED INTO OUR NEW HOUSE. The plan had been to convert the duplex into a single four-bedroom. Now the upstairs lay empty, rooms gaping with disappointment. I moved my studio to the upper floor. My husband and I continued to avoid all conversation about the twins. We tinkered with light fixtures and had our 1960s rock wall fireplace plastered over.

Through all of this, Robin could not have been kinder. She kept the office going, first during my physical absence, and then, later, as I drifted in and out of concentration. I could not focus on the world in front of me. Calls went unanswered. Reports unwritten. Robin wrangled me into outlining treatment protocols, sending invoices. Without her, everything would have fallen apart. Still, I started wondering what it would be like not to be here on this earth. How might one depart with minimal pain? It

was like skipping on a cloud, nothing tangible. I wasn't about to permanently wound my little boy—besides, I am profoundly pain averse, and I was sure to fuck suicide up the way I'd fucked up everything thus far—except, apparently, my career. I supposed it wasn't too late for that either. Although I knew dying was not a choice I could make by my own hand, the amount of time I spent thinking about how painless and preferable it might be to just *not be alive* would have terrified me, had I been able to care about my own life enough just then to feel terror.

Stop with the paja *mental*, my mother would have said if she'd heard what I was churning. *Paja* is masturbation.

One day, while leafing through a pile of mail Robin had left on my desk, I found the American Institute of Conservation's newsletter. Thumbing through it, I noticed a small ad:

INTERNATIONAL CONFERENCE — PATRIMONIO
CULTURAL — CONTEXTO Y CONSERVACIÓN

CENTRO NACIONAL DE CONSERVACIÓN,
RESTAURACIÓN, Y MUSEOLOGÍA

Convento de Santa Clara
Havana, Cuba

THE TIME FOR APPLICATIONS HAD already passed. For reasons I still cannot explain, however, on a whim, I wrote up a description of the Watts Towers project and sent it to the Cuban Interests Section in Washington, per the instructions. I could not

concentrate on any of the work right in front of me, much less my marriage, or at times even my beloved son, and yet I cranked out that application instantly, almost on autopilot.

Man plans and God laughs, as my mother would say. Four months later, I was headed to Cuba.

PART THREE

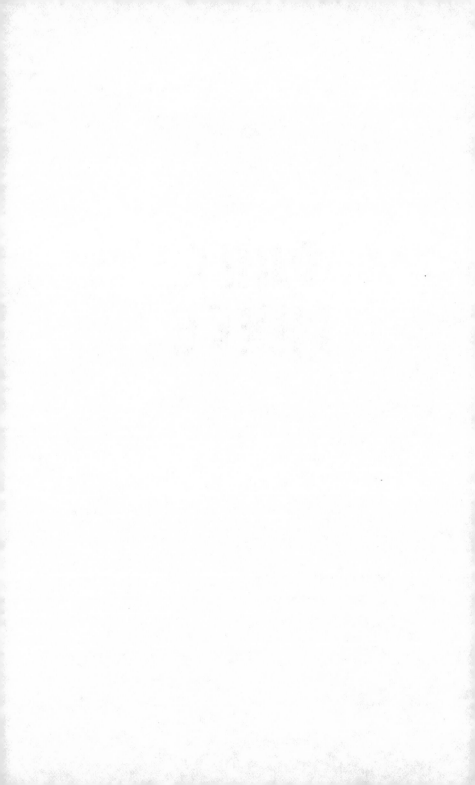

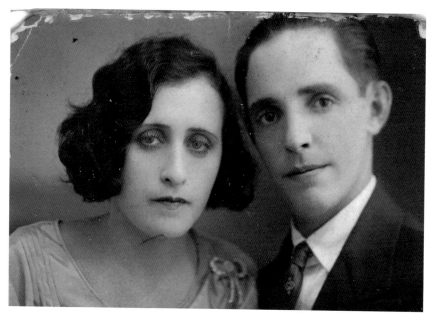

The only extant photo of Rosa Oxman, the author's maternal grandmother, with her grandfather, Samuel Peresechensky, ca. 1931 (Collection of the author)

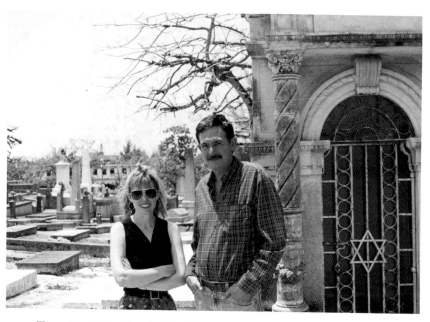

The author with architect Luis Lapidus at the Guanabacoa Jewish cemetery, 1992 (Collection of the author)

(L–R) Enrique, Blanca, Lindy, and Alberto Lovinger, Havana, ca. 1945
(Collection of the author)

Hilda Peresechensky,
the author's mother, ca. 1949
(Collection of the author)

The author and her parents,
March 3, 1960 (Photo by Mandel Studio,
collection of the author)

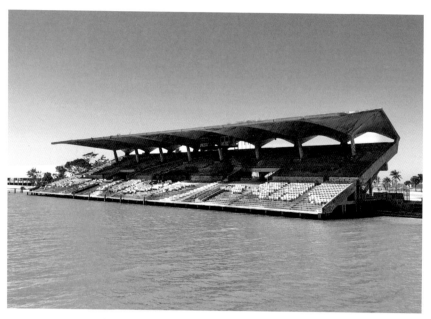

The Miami Marine Stadium, 1963, architect Hilario Candela
(Photo © Rosa Lowinger/ RLA Conservation, 2018)

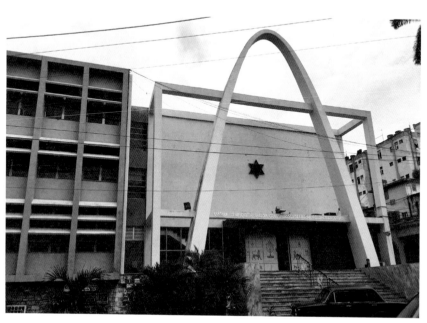

Temple Beth Sholom, "El Patronato," architect Aquiles Capablanca, 1951
(Photo © Rosa Lowinger, 2016)

The author's mother, Hilda Lowinger,
with her new red hairdo, ca. 1968
(Collection of the author)

The author teaching bronze patination
at Havana's Cemeterio Colon, 1994
(Collection of the author)

Apartment building where the author lived in Cuba at Calle 5 in Vedado,
designed by her father, Leonardo Lowinger, ca. 1950 (Photo © Rosa Lowinger, 2015)

Interior terrazzo floor and mid-century modern staircase of the Leonardo Lowinger building (Photo © Rosa Lowinger, 2015)

The author and colleague Emily Macdonald-Korth performing graffiti removal tests at the Miami Marine Stadium, 2017 (Photo © RLA Conservation)

Terrazzo repairs to pavement artwork (before treatment), Kansas City, Missouri (Photo © RLA Conservation, 2016)

Terrazzo repairs to pavement artwork (after treatment), Kansas City, Missouri (Photo © RLA Conservation, 2016)

A view of Trinidad de Cuba, 2016
(© Walter Sedovic / WSA ModernRuins)

Ruins of the mural Baptism *by Haitian painter Castera Bazile in the collapsed interior of St. Trinity Episcopal Cathedral, Port-Au-Prince, Haiti (Photo © Rosa Lowinger/ RLA Conservation, 2011)*

The Havana Hilton Hotel, now Habana Libre, by architects Welton Becket and Arroyo and Menendez, with the monumental façade mosaic mural La Fruta Cubana *by Amelia Peláez, 1958 (Photo © Rosa Lowinger/ RLA Conservation, 2018)*

Technicians cutting and removing sections of Extending the Arms of Christ, *1963, by Bruce Hayes (Photo © RLA Conservation, 2017)*

Fire-damaged nineteenth-century painted wooden sculpture of San Gabriel after arson at San Gabriel Mission (Photo © RLA Conservation, 2020)

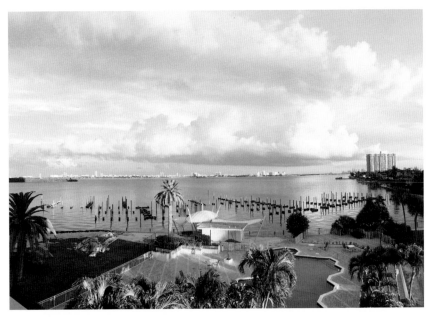

View from the author's parents' window at the Jockey Club Condominium, Miami (Photo © Rosa Lowinger, 2019)

Chapter Nine

TERRAZZO

The tarmac shimmered bright and hazy, the humid air musky with an aromatic brand of cigarettes I didn't recognize. Beyond the airport's boundaries there was a tangled field dotted with royal palms. I stood on the top of the aircraft stairs, waiting for my turn to descend and board a small bus. I was alert to everything: dogs barking, engines buzzing, a chain saw, a cloud covering the sun. I'd been awake for five hours, four of those spent going through check-in at the airport, then waiting at a remote, unmarked gate in Miami. I wasn't sure why I was here, but I was glad to be here. I felt bad to be leaving my family, but my husband had been totally supportive of my trip to the conference.

I made my way down the stairs and boarded a bus that drove about a hundred feet before stopping in front of a soldier holding a Kalashnikov rifle slung over his shoulder. All of us passengers

crushed into the terminal. Long lines formed in front of two passport control kiosks. My heart raced. I took slow deep breaths. People murmured to one another, shifting from one foot to another, some fanning themselves with magazines. One man wore a stack of baseball caps piled onto his head. Another had on what looked like several shirts and pairs of pants. It was about eighty-five degrees in the room, hotter outside, but piling on clothes was one of the many ways Cubans from Miami maximized what they could bring into the country. While checking in, I'd seen the swollen duffels, tied with twine and ribbons. Taut with clothes, shoes, medicines, laundry soap, shampoo—just about everything one could think of was needed in Cuba. Six months earlier, on Christmas Day 1991, the hammer and sickle flag had been lowered from over the Kremlin for the last time. The Soviet Union was dissolved, the Cold War over. Cuba now stood alone. In line in front of me was a woman from whose straw hat dangled diaper pins.

At the security window, I handed the agent my passport and visa. He looked up at me, then down at the document, then he called someone over. A woman sauntered toward him, stunning, dark-skinned, wearing tight military fatigues. She pursed her lips, glanced at me sideways, then turned her back and whispered in the agent's ear. More shuffling of my papers, another person called over. Three Cuban customs officials were now inspecting my passport.

"*Todo bien?*" (Everything okay?) I asked.

The woman nudged the first agent.

"*Usted nacio aqui?*" (You were born here?) he asked.

"*Sí.*"

There was another long silence, more conferring, more flip-ping, more sideways glances at me, then, "But you're here for *un evento*," said the original agent—a statement, not a question.

I nodded and handed him a formal invitation, typed on official paper emblazoned with the logo of Cuba's Centro Nacional de Conservación, Restauración, y Museología—the national conservation center, also known as CENCREM. The woman took the invitation into a little room and closed the door. I waited, my heart thumping, though I understood that the problem was that I'd been born in Cuba, but I was coming back for a professional visit, not for the more common reason of visiting relatives. I wanted to explain that there were few here in my family and all of us had left in the 1960s, but I'd been warned by a friend of my parents named Bernardo Benes—a member of La Colonia who'd been to Cuba many times and had helped free dozens of political prisoners—just to answer questions straight at customs without embellishment. For his efforts, Benes had been targeted not by Cuba's agents, but by Miami's right-wing exile community and media, to the point that there were bomb threats at his work and he had to wear a bulletproof vest. I wasn't currently worried about being targeted by anyone, but I wanted to get into the country and I knew that Cuban exiles, even those of us who left as children, were always scrutinized more carefully than other visitors to the island. My visa had taken months to get and cost hundreds of dollars. Cuban immigration officers were alert to anything suspicious, and my being here for conservation, rather than to visit family, seemed off.

Once they let me through, I grabbed my suitcase and headed out into a throng that pushed against a barrier rope a few feet

from the exit. Relatives waved at one another, wept, crossed themselves, kissed, slapped backs, and thrust children into the embrace of people they had never met before. There was a great deal of shouting and weeping: *Lourdes! Paco! Coño! Ay dios mio!* While waiting in the airport, I had learned that some of these were siblings who had not seen each other in decades. There were lots of wheelchairs. Everyone had mountains of luggage, except me. Half of my one rolling duffel was filled with pens, paper, soap—gifts for my local hosts. I felt embarrassed to be carrying so little into a country that needed so much.

I saw a sign with my name written in ballpoint pen. The man holding it introduced himself as Omar and placed my luggage in his trunk. We were to go straight to the conference, he said, as I got into the plastic-covered back seat of his Soviet-made sedan that smelled strongly of gasoline. Omar drove along a wide road lined with mango trees and nearly empty of cars. Crowds of people stood at crosswalks, sticking thumbs out. Without prompting, he looked at me in the rearview mirror and explained, "*No hay gasolina.*"

It was one thing to read about the economic crisis sparked in Cuba by the fall of the Eastern Bloc and quite another to see it. Before 1991, Cuba had enjoyed vastly favorable economic trade agreements with these nations. Ninety percent of Cuban sugar and 40 percent of the country's produce was sold to the Soviet Union. Soviet gasoline was provided to the country at a fraction of its normal price, as were most imported items used in industry and households. When this subsidy ended, Cuba was thrown

back into the nineteenth century. The country had daily rolling blackouts, occasionally lasting fourteen hours. Food was tightly rationed. Coffee, laundry soap, and toothpaste were impossible to find. Produce rotted in the fields, because there was no fuel to harvest it. "*No es facil*," sighed Omar as we slowed to a crawl behind a horse and buggy packed with people. It was a term I would hear many times that week.

Despite the shortages, conferences and symposiums were nonetheless being encouraged as a way to bring cultural tourist dollars to the island. The preservation conference I was here to attend was being held at the Palacio de las Convenciones, a 1970s building located in what had once been Havana's ritziest suburban neighborhood. As we approached, I saw 1950s houses with sweeping porte cocheres and dramatic cantilevered rooflines. We got out in the driveway of the convention center, a low-slung, modern complex made of geometric concrete plates. Omar carried my luggage through a maze of hallways until we reached a lecture hall, where fifty or so people sat with the lights off and a projector humming, as someone at a podium lectured on the challenges of stewardship for coastal Caribbean sites. I settled into a seat in the back row where an air-conditioner blew directly onto my back.

"The coldest winter I ever spent was a summer in Cuba," someone growled close to my ear. I whipped around to see who'd paraphrased Mark Twain so close behind me. Whispering to keep from disturbing the speaker, he said that he was a representative of the CENCREM, Cuba's national conservation center, here to help with anything I needed during my visit. I had learned, during conversations with my parents' friend Bernardo, that I would be assigned a handler, someone to keep track of me.

This was the guy, I figured, then turned back to a lecture on the fungicidal benefits of chili pepper and tobacco juice. To manage the sudden loss of Soviet oil, Cuban professionals were pivoting away from using petroleum derivatives, like pesticides, solvents, and synthetic waxes. Another talk that afternoon was on the use of rice husks to create a lightweight aggregate for mortar. I hadn't known what to expect from this meeting, but I was already intrigued. These were professionals who knew what they were talking about. When the papers ended for the day, the CENCREM representative introduced me around, and then all us "foreign" participants boarded a bus to go to our hotel.

The Hotel Comodoro was set back from the street along the coast in Miramar, a onetime tony neighborhood in Havana. Built in 1957 for mobster Santo Trafficante, the hotel had a nondescript low façade, but the lobby, despite being a bit dilapidated, displayed all of its mid-century modern glamour in a travertine front desk, a mahogany bar with bronze fixtures, and stunning black and white terrazzo floors designed in a ladder and checkerboard pattern. I took pictures of the floor as the front desk checked me in, then headed to my room to change into a bathing suit to meet the others for a free afternoon.

The day was hot and windy. My hair blew around my face as I walked out onto the pool deck, which was raised above the beach level. A small band's jaunty Cuban tunes competed with the sound of waves crashing over a rectangular concrete jetty that marked off a protected swimming area, and I felt myself wanting to dance the way my parents used to, but I didn't have a partner, and anyway none of the conference participants were dancing. They were sitting in a large cluster of plastic lounge chairs, talking and drinking. Joining them, I learned that they had come

from all over Latin America—Ecuador, Colombia, Venezuela, Argentina, the Dominican Republic, and Peru—but I alone among them was originally from Cuba. A few had been to Cuba before, and everyone was excited to be here, eager to visit colonial Old Havana, Havana's main UNESCO World Heritage Site, some even taking extra days to go to Trinidad, another World Heritage city along the Caribbean coast.

The UNESCO World Heritage Sites program confers international designation for cities, archaeological sites, and buildings that have unique cultural, historic, or artistic importance. The fact that I did not know that Cuba had one, let alone two, such sites (as of 2023, it has nine) made me feel alone and separate from the group, even more foreign than other foreigners. In part I was. Being a Cuban exile made me a hyper-outsider, someone separated from the others by a steel trapdoor of misunderstanding born of the political situation.

Flooded with sadness, I suddenly longed to be near my husband. The loss of our twins had cracked the ground between us, a fissure doused with salt, and here, in Cuba, as the crushing sadness of it rose within me, hitching a ride onto those grand historic family losses that I tasted on the wind, I just wanted to be beside someone who loved me. Home was what I needed and that, at least for now, meant my small family of three.

As my handler strolled over in street clothes, holding a plastic cup in each hand filled with a yellow liquid and ice, I grew anxious that there was no easy way for them to contact me if anything went wrong—a car accident, an asthma attack, an earthquake. My handler sat down next to me and handed me a drink. Rum with some super sweet pineapple juice. He leaned in and peppered me with questions: Where did I work? Did I really live in

Los Angeles? How many siblings did I have? Were my parents still alive? As he spoke, he kept glancing down my bathing-suit top, every word oozing with double entendre. Surveillance through seduction was a tired tactic, but I could not help but relish the attention. The fertility work, the pregnancy, the loss of the twins had taken their toll on my sexuality. In no time, the rum and salty wind and conga drums and the handsome life-guards who winked at me each time they passed my lounge chair swept the sadness out to sea.

The next morning, I gave my lecture on the Watts Towers. As I spoke, the slide projector jammed. The second time it happened, I kept going, without images, sounding more and more absurd to myself as I spoke about an utterly idiosyncratic sculpture to people whose jobs involved conserving entire heritage districts, many of world-famous cultural value. Still, hands shot up the minute I finished. People asked me questions about earthquake planning, future maintenance, the pull test that had been done to determine the structural strength of the Towers. I couldn't answer everything, especially in my nontechnical Spanish, but these were clearly good questions.

Later, as we sat down to a box lunch, someone asked, "What else is there to restore in Los Angeles, a city that's barely a hundred years old?"

An architect from Buenos Aires swooped in to answer. "The world's view of America is filtered through Hollywood, so Los Angeles can be considered the quintessential American city."

I had to give that some thought, but I liked the idea of Los Angeles as the place of pioneers, outlaws, risk takers, immigrants, and self-realizers. I fit into several of those categories.

Lunch ended with the Cubans surreptitiously packing up all the leftover sandwiches. The government had coined a euphemistic term, *Periodo especial en tiempos de paz* ("Special period in the time of peace"), to describe the economic crisis. We boarded a repurposed donated yellow school bus and headed for Old Havana, and my handler slipped into the seat beside me. His hair smelled rank, unwashed. I felt bad for thinking that, given the shortage of shampoo. He growled more sly questions about my work and my family. I wanted to say, "Cut the crap and just ask me what you want to know outright." But I knew that wasn't how this cat and mouse game worked. Along the seaside Malecón Avenue, the bus passed a billboard with a red and black image of Che Guevara. Someone shouted, *Viva El Che!* Everyone clapped. I turned toward the window, my breath fogging the view of the ocean. I was here for conservation, not for politics or family. But just as I could not stand the way many Cuban exiles had turned to conservatism in a blind belief that anything "anti-communist" was good, clapping for Che, a murderous mercenary who had led the revolution's summary executions without trials, was a bridge too far for me.

The first stop on our tour was Plaza de Armas, the site where Havana was founded on November 16, 1519. The bus parked near a group of horses and buggies. The scent of trash, decay, and fish stung my nostrils as I stepped off the bus. Mangy dogs slunk past, their rib cages protruding. We gathered in a verdant plaza where one of our Cuban hosts pointed out a spiny ceiba tree,

considered sacred in Afro-Cuban religions, that marked the spot where the Spaniards held their first Mass. At the harbor's entrance was a fortress, complete with a moat and drawbridge, that is the oldest Spanish fortification in the Americas.

How, I wondered, was it possible that no one in my family ever told me about this?

In Cathedral Plaza, our next stop, I found myself facing the most beautiful baroque cathedral I had ever seen. The façade appeared to be in motion, the sides curling inward like the dried-out pages of an ancient book. Across from it were grand palacios with floor-to-ceiling windows topped with colored fans of glass. We walked down a narrow street lined with art deco and art nouveau buildings. The sheer volume of material related to my work was staggering: limestone with fossil inclusions, plaster ornaments, marble and terrazzo floors, mural paintings, majolica tile. There was so much to absorb, to wonder about, to try to embrace as mine, because it was mine in a way, since my mother had been born and had lived most of her early years just blocks away from here. In Plaza de San Francisco, a wide square named for a 1575 basilica that sits along one end, I recalled how she would always say, "You must have been switched on us at the hospital," in reference to my love of the arts, of antiquities, museums, clothes from thrift shops, items that needed repair. Here, even the broken windows and the façades covered in fungus looked beautiful to me. At our final stop of the day, the Plaza Vieja, there was a jarring, above-grade concrete parking lot, ugly as a scraped kneecap. Our guide explained that it had been built in the era of Batista, when Havana was poised to become Latin America's banking center. "The Historian of Havana wants to have it removed," he explained, "but he is getting pushback from

the city's preservation architects who are concerned that jack-hammering could collapse surrounding structures."

The tour ended in the central courtyard of the Convento de Santa Clara, a seventeenth-century nunnery being used by the CENCREM for offices and workshops. Welcome speeches were delivered, a toast was made with strong rum and watered-down, warm cola, then everyone walked back to the bus. I stayed behind. Using a map I'd brought from Miami, I walked toward Muralla and Compostela Streets, where my mother had lived as a teenager. Balconies flapped with laundry. Boys hit a ball made of rags. Men sat around a wobbly card table, rolling dominoes.

The fourth-floor walk-up at Muralla and Compostela had been a place of mixed memory for my mother. It was by far the nicest place she had lived before she married my father, with three airy rooms, two bathrooms, and a balcony just for her, my grandfather, and Ana Mintz, the woman who had taken care of my mother at the orphanage and whom my grandfather had recently married. Felix was born while they lived there, and the family enjoyed relative prosperity as a result of my grandfather's store in Cárdenas, until he lost the store to gambling and they were forced to move back to a dark two-room tenement. The roof of the building appeared to have caved in. Sunlight streamed through the interior, and vines crawled down the façade, prying the stucco open, telegraphing cracks diagonally. A young woman stepped onto a balcony, hefting a dripping ball of white fabric, which she wrung out then stretched over a rope that was strung onto the grillwork. I snapped a photograph, then headed toward the port to find a taxi.

The harbor was rainbowed with oil, and smoke rose over the distant hills. There was a strange noise in the air, which I soon

realized was the silence of a power outage. People fanned themselves on stoops and balconies, eyeing me as I trudged toward a taxi stand, my clothes and shoes broadcasting that I was foreign. Back at the Plaza de San Francisco, I found a yellow taxi where a driver sat with his elbow out the window as he read a newspaper.

"Can you take me to G Street in Vedado?" I asked.

"*Claro*," he said, and named a price. It seemed high to me, but what did I know? He took the same route that the bus had, along the narrow entry channel that had made Havana nearly unconquerable in the colonial period.

"*De dónde vienes?* Argentina? Spain?"

I hesitated, then said, "*Soy de aquí*."

"*Sí*, but you live over there now?" He gestured to the roof of the car, a sign for north, or the United States.

"In Los Angeles," I quickly said, to distinguish myself from the haters in Miami.

"Ahh, Hollywood. Francis Ford Coppola."

I would soon learn that the average Cuban was not just literate, but able to discuss novels, poetry, and cinema with authority. And not just Hollywood movies. People here regularly consumed Buñuel, Antonioni, and Truffaut. Right then I simply laughed, the ice broken. We began talking about the only thing that mattered: *El periodo especial*. My driver told me that people had been eating pigeons and cats (they called them "roof rabbits"), making rotgut rum by fermenting sugar, and fried steaks from the white spongy pith of grapefruits. Several people had died after eating "pizzas" that had "cheese" made out of melted condoms. "*No es fácil*," he said, sighing.

I got off at Avenida de los Presidentes, one of Vedado's main boulevards. A verdant neighborhood first developed in the late nineteenth century, Vedado's grid of streets is planned to maximize the cooling effect of ocean breezes by setting them at an angle to the coastline. Avenida de los Presidentes, also known as G Street, was bisected by a median lined with surprisingly manicured bell-shaped topiaries. Before the 1959 revolution, the boulevard was also known for bronze sculptures of Cuba's presidents. The current Cuban government had them removed in the 1960s, and now the pedestals stood weirdly empty. The one closest to the corner of our old street still had a pair of bronze shoes attached to the top, making it look like a monument to feet.

I had never seen a full picture of the building my father had designed, but I recognized it as if I had only just returned from a short vacation. Four stories high, it had wide square balconies, now painted a chalky cobalt blue, with a doorway and corners decorated with what looked like limestone. A driveway led down to a garage, and a long array of windows rose from the doorway to the roofline in between the balconies.

The power was out here also. People sat outside, fanning themselves. A woman sashayed out from the underground driveway in hair curlers, her flip-flops slapping the concrete. I wanted to look inside, but I felt self-conscious. Instead, I walked toward the Patronato synagogue, which my grandfather had helped found. This had once been Havana's nicest middle-class neighborhood, but now sidewalks were broken, and there were piles of trash in the gutters. And it had most assuredly been middle class, never mind that many people I knew, and with whom I shared most of my liberal political leanings, would say that Cuba before

the revolution had no middle class and that sugar barons and mafiosos owned everything and took advantage of a poor and desperate populace. That was only half the story; the footprint of middle-class life in Havana remained in block upon block of modest apartment buildings—some with fanciful art deco windows, others tall and streamlined, and still others with the portholes and sweeps of 1940s ocean liners.

The synagogue was locked. I had read that the building had been designed in 1952 by architect Aquiles Capablanca, whose work was also featured in the MoMA exhibition *Latin American Architecture Since 1945*. With its sweeping entry portal reminiscent of the Gateway Arch in St. Louis by Finnish architect Eero Saarinen, and doors that were decorated with symbols of the twelve tribes of Israel, the façade displayed all of the markings of someone obsessed with modernism, as my father had been. Peeking through the glass doors of the basement offices, I could see creamy terrazzo pavements across a wide expanse of floor.

As far back as I could remember, I had always loved terrazzo. It was on the floor of our second apartment in Miami and in the house my parents eventually bought, though my mother had it paved over with shiny tile. Terrazzo is not really a material; it's a composite and a process derived from an eighteenth-century Venetian method of combining small stone fragments within a cement matrix. From the 1920s to the 1950s, it was used everywhere in the Western Hemisphere. Here I saw dozens of buildings in otherwise terrible shape with beautiful terrazzo floors. Some of these were former mansions that had been turned into embassies and government ministries. Most of them were in terrible condition, with peeling paint and rusting iron. Where

façades were freshly painted, the colors were incongruous pastels in chalky finishes—mint green, bubblegum pink, robin's-egg blue. Yet, despite the overwhelming damage, I could not help but be amazed by the fact that so many historic buildings still stood. Everywhere I'd lived, except for Philadelphia, most old buildings were just torn down by developers. Castro's government had expropriated private property and allowed it to fall into ruin, but by removing the incentive for real estate speculation, they'd prevented the wholesale demolition of the city's historic fabric.

There was so much contradiction here. So much wreckage mixed with so much beauty. I strolled from one end of Vedado to the other, realizing that every direction represented a historic period of post-European contact. (Here, like everywhere in the Caribbean, Spain had decimated native populations.) Starting in the east, at the harbor's entrance, one could see sixteenth-century fortresses and eighteenth-century palacios. To the west were the remnants of the late twentieth century, the Mafia-owned nightclubs and hotels, and a Brutalist-style Soviet embassy situated amid low buildings, its tower resembling a sword, with its hilt at the top and its blade stabbed into the ground. It felt like reading the history of the Western Hemisphere in an architectural pop-up book.

I longed to work in Cuba. I wasn't sure how I would make it happen. I had a young son and a husband. And there was also the embargo, which made it impossible to spend money or offer services in the country. But how long could this *Periodo especial* last? How much could the people endure? Back in the United States, everyone expected Castro to be gone any day. Within months of my visit, there would be several speculative books on the topic

from noted investigative journalists like Andrés Oppenheimer of the *Miami Herald* and Ann Louise Bardach of *Vanity Fair*. A post-Castro Cuba would surely need additional materials conservators. The Watts Towers had readied me to work on a large scale. I would talk to Robin about taking over for us in Los Angeles so I could focus on developing a practice in Havana.

The sun was loping toward the ocean. I needed to find a taxi. About a mile away was the Riviera Hotel, a building built for Meyer Lansky that had opened on December 10, 1957, with a performance by Ginger Rogers. It closed a year later, when mobs stormed Havana's casinos on January 1, 1959. As I headed toward it, I found myself, again, passing my father's building. The power was back on. I heard running water, radios, pressure cookers hissing. I peeked into the stairwell. Inside, the floors were black terrazzo with large white chunks of aggregate. I put my hand against the marble walls. They were warm. I peered closer. They were not marble at all, but a faux painted finish.

"*Señorita*, may I help you?" asked someone behind me.

I turned around, alarmed. It was the woman I'd seen come out of the garage in flip-flops. "Are you looking for someone?" she asked.

"I used to live here," I stammered. "My father designed this building."

She knit her brow and thought. "Alberto?"

I was almost too shocked to respond. "No, Leonardo. Alberto was my grandfather."

"Alberto was your grandfather," she repeated, thinking. Then, suddenly smiling, she asked, "Are you Rosita?"

BACK IN MIAMI, where I stopped en route to Los Angeles, my mother was unimpressed. Though I told her that Maria, the wife of the old *encargado*, remembered that my grandmother Blanca used to take me outside and sit me on the stoop so I would eat when I was little, all she could say was, "Did you meet the son of a bitch we had to hide from when we left the country?"

I shook my head. "He has throat cancer."

My mother's lips curled and her eyes narrowed. I could hear her thinking that he got what he deserved, but thankfully she didn't say it then. (She said it later.)

"Maria was very nice to me. She invited me into the building, let me see one of the apartments."

"She invited *you*?" my mother sneered.

"So, I guess the building's still standing," my father remarked idly.

"Yes, and it's in very good condition, all things considered."

"*Si?* How?" he asked. My mother rolled her eyes, got up, and left the room.

"Buildings close to the ocean don't do so well. The salt damages them."

"In our day, the closer to the coast you were, the more expensive the property," he said.

"Well, now nothing is expensive there," my mother shouted from the living room. "It's all worth shit. A shit country. For all I care, the ocean can swallow it."

A FEW YEARS BEFORE my first trip to Cuba, my parents had sold their house on Biscayne Point and moved to a two-bedroom condo in a soon-to-be-incorporated town called Aventura. I disliked Aventura as much as my parents loved it. The place's sole landmarks were a golf course and a gargantuan shopping mall. My parents' building was one of dozens of gated high-rises with ponderous security checkpoints, where I had to valet park my car. My parents loved their twenty-fourth-floor view—"The higher the better," exclaimed my mother—but it gave me vertigo.

Unfortunately, they were struggling to keep the condo because my father was unemployed, having been fired from his job as a regional manager for an optical retailer. He was in his sixties then, and the company hired someone twenty years younger to replace him. My father learned that the boss had been referring to him as "the old man," so he was suing them for age discrimination. Eventually he would win, but the company would go bankrupt and he'd get nothing. Meanwhile, he was hanging around the house while my mother went to work, so tensions were high around the apartment.

On Monday morning, my mother stormed through the kitchen as she prepared her lunch for the workday, barking orders at my father, who was in his pajamas, about what he needed to take out of the refrigerator for dinner. My stomach tightened; this brought back bad memories.

"Cuba. What a waste," she muttered to no one in particular. "If your fucking grandfather had let your father take money out of Cuba, we wouldn't be in this mess." My mother slammed into

the bathroom. My father stole into their second bedroom, where I slept when I visited, and quietly closed the door. Through the closed door my mother yelled, "Rosaaa, come here!"

My stomach knotted further. Now what? I headed to the bathroom, where she was looking in the mirror, slashing liner across her eyelids.

"Have you heard the latest?" she hissed. "Your father wants to open a store so your brother will work for him!" My brother, Steven, had just graduated from optometry school. "I'll kill myself before I let him do that. Do you know how much we lost last time he opened a store? He can't hold down a job because his ego is too big. He can't get it through his head that he's a worker, not an owner!"

My mother scooped up her handbag, keys, lunch. "Maybe I'll drive my car into a tree, or disappear into the ocean," she spit viciously. "Maybe I'll die on my way to work and none of you will ever have to see me again!" She slammed the door so hard that I thought the mirrored walls would crack.

I felt bad for her. But even worse for my father. He wore his failure like a shackle, head drooping as he skulked around, smoking or biting his nails. I could not help but feel that I had tossed the burden to him when I left for California. That said, I could not wait to get back, not that my own home life was so fabulous.

I waited until I was sure my mother was long gone, then I knocked on the door of the second bedroom.

"Come in." My father sat at the desk, tallying numbers on a yellow pad. In one hand, he held a cigarette. His handwriting was beautiful.

"Papi, can I talk to you?"

He nodded and looked up. His eyes were glassy, drooping at the corners, his oily skin glistening. Throughout my childhood, he'd been stern and enigmatic, always distracted by earning a living and traveling and dealing with my mother's moods. I wanted to let him know how much I admired his building. I wanted to ask whether he, at the age of seventeen, had chosen the faux finish for the walls and that beautiful terrazzo that resembled the night sky.

He stubbed out the cigarette. "Sure. I need a word with you also."

Surprised, I told him to go first. He nodded somberly. "Can you lend me $5,000?"

I hesitated, shocked.

"I need it to open a small optical store. If I can do that, and I get your brother to work for me, I can get on my feet again."

I nodded. "*Claro*, Papi."

This was no time to talk about what had been left behind in Cuba.

"Thanks. And please don't tell your mother I asked you for money."

MOST OF THE PLACES I've called home—Havana, Miami, Los Angeles—are known for their terrazzo pavements. Among my favorites are the ones in Havana's Teatro America, a 1941 art deco movie house whose floor is emblazoned with signs of the zodiac surrounding a world map. Los Angeles's Eastern Columbia Building and Meyer Lansky's Habana Riviera both

have masterfully colored floors with patterns separated by strips of metal. Then there's the upstairs bar of the former Havana Hilton, a casino hotel built in the waning days of Batista's free-wheeling dictatorship. The pavement there is a bold black and white checkerboard terrazzo pavement that is visible in photographs depicting Fidel Castro bivouacking with his troops in January 1959. My father's building is much simpler. A single pour of black terrazzo speckled with white marble that looks like the night sky.

Terrazzo is robust, but it yields easily to gouges and cracks from settling or expansion. It's hard to fix without leaving enormous scars. It reminds me of my family, those Eastern Europeans who left for America and found themselves settled in the tropics, only to be forced to bust out of their foundation within a few decades. It's true of my profoundly damaged mother, who had the spark of inspiration and presence of mind to know when it was time to flee the country of her birth, but has a way of smashing relationships to smithereens.

It took me many years and several iterations of my private practice to learn how to conserve terrazzo. It's not much different than one would imagine—mixing the cement, figuring out the aggregate, pouring sample coupons, routing out the cracks to remove all dirt and previous fills. It takes perseverance to make sure the surface is prepared properly and restraint to let the repairs dry fully before you try to polish them. Most important, it takes a core belief that you can reverse engineer a process that's normally done on a commercial scale. There is no magic here. It requires talented hands, but also belief and patience. That's true of all repair, redemption, healing, restoration. It only works if you start with the notion that you have a chance of succeeding.

Our house on Biscayne Point originally had white terrazzo floors with yellow and brown aggregate. I remember it had cracks and punctures from a previous installation of wall-to-wall carpeting. I hated that my mother paved it over, but I understood that she saw no other path to its repair.

Then there's that photo of me and my parents sitting on a modern sofa in our apartment on 79th Terrace. This was our second home in Miami, where my mother met Eleanor and I cut the dresses and my mother was always flying at me, shoe in hand, for forgetting to take the rice out of the refrigerator or whatever. In the picture, my father sits between us, one arm around me. I am tucked into myself, scowling. My mother is draped on his other side, languid, smiling coquettishly. He looks tense, in the literal middle of whatever had just happened. The white terrazzo that expands in front of us is as pristine and spotless as a sheet of ice.

SIX MONTHS AFTER my first visit to Cuba, I returned for a vacation with my husband. I took A.B. on a walk that started in the 1500s and ended hours later in the mid-twentieth century. I saw my first home through the eyes of an archaeologist, an expert in stratigraphy, the layering of history, someone who was also intimate with loss. We then traveled together to colonial Trinidad. We swam in the Caribbean, got lost on rutted roads, and walked beneath a star-clotted sky that reminded me of my father's terrazzo pavement.

It was a beautiful trip, but not enough. Our marriage was fracturing. Cuba pulled me toward it, away from my family,

private practice, all the friends I'd had since college. My husband and I still never talked about our twins. It was a gaping mistake, but I, for one, did not even realize it was happening. I put it out of my mind, and kept traveling. I loved my son and husband, but I left them often. And each time I did, I was swimming farther out into that unknown ocean, where I was no longer rooted to Los Angeles. Though I would be wracked with guilt, I never stopped the forward motion. My parents, uncharacteristically, said little to stop me. Maybe they understood that my world was unspooling—my dream of domestic bliss, of propriety, of a home so rowdy with children and their friends that it would drown out the low suck and hiss of one's dreams going down the drain. I also know that my interest in Cuba intrigued them, even though they never said so directly. Through Cuba, I began to understand them.

WOOD

R obin, the artist-assistant I'd promoted several times and who had shown me unfettered kindness at the moment of my greatest loss, was acting weird. It was barely noticeable at first. But being raised by a volatile parent teaches you to be alert to people's humors. When we first started working together, we'd joked around, shared confidences. Now she always seemed clipped and aloof. When I asked her what was going on, she smiled, cocked her head, and said, "Nothing."

Even when we talked about impersonal subjects—politics, the weather—she'd resort to that strange cocking of her head, a nervous tic. She'd get combative if we spoke of anything that smacked of money or the American healthcare system (she was Canadian) or rich people. When I reminded her that most collectors—our clients—were wealthy, and that is why they were able to pay our fees, she'd wave me off.

Meanwhile, the business was thriving. The Northridge earthquake had delivered us a mountain of work, and we were now up to five staff members. I had the sneaking suspicion that the other four were socializing on weekends without me, and at night I lay awake, wondering whether I was being paranoid or whether it was a case of "just because you're paranoid doesn't mean people aren't talking about you."

In the mid 1990s, we were asked to help conserve the finishes at the original Bullocks Wilshire department store in Los Angeles. Designed by architects John and Donald Parkinson, Bullocks was the city's best art deco building. Outside it had a 241-foot patinated copper tower, reliefs designed by the sculptor responsible for the Oscar statuette, and a porte cochere mural that depicted airplanes, trains, and a Graf Zeppelin, an airship that had been inaugurated a year before the 1929 opening of the department store. The interior was a cornucopia of art deco decoration that telegraphed old Hollywood glamour. We had been hired to provide recommendations for repairing nickel silver, travertine, and wood, while the building underwent transformation into a law library. We were also asked to repair a wood-and-colored-stucco mural in what had been the men's sportswear department.

I was excited about these architectural projects. Cuba had been nudging me in that direction, though I wasn't any closer to actually working there. Against all expectation, the Castro regime was hanging on, and Cuba-US relations remained as fraught as ever. Bill Clinton's election to the US presidency, however, boded well for an end to the embargo. Many of my colleagues in architectural conservation were talking about

exploring work in Cuba, since once the doors were open, there'd be enough to do there to keep hundreds of us working. I was doing everything possible to be first in line. On my frequent trips to Cuba, I met with decision-makers like the Historian of Havana and the CENCREM's directors. Many of these parties didn't actually get along with one another, but that seemed like valuable currency in and of itself. A few people tapped me to give them backroom advice about procedures, and I wrote up specifications without putting my name on them. It made sense to be as helpful as possible, provided that no money exchanged hands, which would have violated US Treasury Department rules.

But while preservation professionals on both sides of the Straits of Florida waited for Clinton to lift the embargo so we could all begin to work together, the Cuban government started acting in ways that, to me, seemed designed to keep that from happening. First came the unleashing of the Balseros Crisis, a 1994 migratory wave that brought thirty thousand new seafaring migrants to Florida. Then, in 1996, Cuban Air Force MiGs shot down two unarmed, American-owned Cessna Skymaster planes over international waters. The Cessnas belonged to a Miami-based, anti-Castro activist group called Brothers to the Rescue. They were heading to Havana to drop leaflets, an act they'd undertaken before, and had been warned by Castro himself not to do it again. But shooting down unarmed airplanes in international waters? Killing four American citizens? That sure smacked of a gauntlet thrown down, especially once it was revealed that the mission had been the brainchild of a member of Brothers to the Rescue who was actually a Cuban double agent.

Sound paranoid? Not if you follow the history of Cuba-US relations and the actions of Cuban Americans in the United

States. Consider this: Three of the five so-called White House Plumbers who had broken into the office of Daniel Ellsberg's psychiatrist, sparking the Watergate scandal, were Cuban. So were many of the operatives working for Ronald Reagan's secret Iran-Contra scandal. Right-wing Cuban involvement has been linked to the Kennedy assassination (the Tropicana Nightclub's owner Martin Fox is mentioned in the Warren Report), the contested 2000 presidential election (according to Miami-based pollster Sergio Bendixen, the huge Cuban turnout for George W. Bush was "payback" for the raid on rescued child balsero Elián González's house and his return to Cuba), and the January 6, 2021, insurrection at the US Capitol, where Cuban American Proud Boys chairman and Florida director of Latinos for Trump Henry Tarrio was at the center of the seditious conspiracy. (As of this writing, he has been convicted of the crime and faces up to twenty years in prison.)

For a country of only eleven million people, and an immigrant group that is a fraction of the Mexican American population in the United States, Cuba has had an outsized influence on American politics. The CIA spent decades trying to kill Castro, using harebrained methods like exploding cigars, poisoned pens, LSD to make him sound crazy while giving one of his endless speeches, and a wet suit doused with a fungus to make his beard fall out. It really wasn't much of a stretch to see the Cuban government's actions during the Clinton administration as their effort to keep the decades-old status quo in place. Also, it made practical sense. A proper enemy is always good for staying in power. Without it, who could the Cuban government blame for the failure of its economy and its continued repressive policies that keep citizens from traveling or opening businesses?

Before I started going back to Cuba, none of this had ever crossed my mind. While we worked at Bullocks, it was all I could think about. "You're like a born-again Cuban," said Linda. I laughed, but it was sort of true. Through architecture and conservation, I had developed a personal connection to the island of my birth. It mattered more to me than any of the work I was doing in Los Angeles, where I earned my living. In response to my total distraction over Cuba, Robin suggested we hire an artist friend of hers to help us out at Bullocks. I agreed.

Work on the *Spirit of Sports* mural was straightforward. We were to clean off decades of grime, repair some splintered wood, remove old varnish, and fill losses. For me, the only difficulty was the marginalization I felt every time I came to the site. Robin, who was running the project, seemed to grow cagey and anxious in my presence. I felt she was avoiding me, and not letting me know when there were meetings with contractors. If I happened to stop by when one was in progress, she'd keep talking to them as if I weren't there.

"Fire her," my mother said when I told her what was going on.

"I can't. I need her." I didn't add, *Without her, I can't keep going to Cuba.*

She laughed harshly. "No one is indispensable. Look at your father. He's smarter than any of his bosses, but they toss him out anytime they want. You're the boss here. Act like it!"

My mother went on and on for a while about what I was doing wrong in business, letting my "assistant," as she called her, take advantage of me, losing my authority by always gallivanting off to "help *los comunistas*." I'd brought that lecture on myself. But I was actually interested in her opinion. After being fired from Sears,

she had worked exclusively at small family-run optical stores, negotiating great commissions for herself, and often making more money than my beleaguered father. She knew what it was to be an employee and what people expected from their employers.

"Tell her where you stand. Make a decision," she insisted.

A few days later, I sat Robin down and said, "Either we talk honestly, or you'll need to find someplace else to work." My voice cracked as I said it. Hardly the "boss" my mother expected me to be. I was hurt by Robin's behavior, and worried she would say, "Fine," and hand in her notice. Instead, she cocked her head and said, more or less: "I don't mind carrying the practice while you're always off to Cuba. But it's time for me to be a full partner."

She had a point. Though she lacked formal conservation training, and I had started the business, she was a loyal, valuable employee and talented at our line of work. But I no longer had confidence in our ability to be a team, so I said: "Why don't you buy me out and take full charge of the practice? We can come up with an easy way to do it, and then you'll be in charge."

We each took the evening to confer with our spouses, and the following day, shook hands on an agreement. We met with our accountants and arranged for her to buy me out over time, without having to put money down. This seemed a bit risky to A.B., as well as my parents, but I was hell-bent on being free of this relationship and available to travel to Cuba as much as I wanted to. Robin and our camaraderie never went back to being what it had been—the staff had, indeed, been having secret weekend dinner parties without me—but that didn't matter to me anymore. I was ready to move on from private practice. To what, I didn't know yet, but it was certain to be connected to Cuba.

FLIGHTS TO HAVANA only left from Miami, so every time I traveled to Cuba, I spent a few days with my parents. My father was working again. His new boss was an ophthalmologist who'd hired him to set up a plastic lens laboratory. This was my father's favorite type of work—creating a physical place from scratch. My brother had made the introduction. My father was earning almost $100,000 a year, his highest salary since the fiasco with El Capitán. He had a company car, a mobile phone, three weeks' paid vacation, and most important of all, authority. His self-confidence returned. My mother, needless to say, was over the moon. "Doesn't Papi look handsome?" she'd croon as he got dressed in the morning for work.

On the day of my flight, as we were having breakfast in the kitchen, my father and mother exchanged a look. "What is it?" I asked.

My father sighed, and dunked a slice of challah toast into his *café con leche*. "*Bueno*, your mother and I are wondering. Do you work for the CIA?"

I almost spit my coffee onto him.

"This is nothing to joke about!" my mother said.

"Trust me, I'm not working for anyone but myself."

"If the Cubans find out, you could go to jail for life!" my mother exclaimed.

"I'm not working for anyone or going to jail. Geez, you're just like the paranoid officials at Cuban immigration."

"They aren't paranoid," said my father. "A conservationist who teaches classes, takes groups to see architecture? It's the perfect cover."

"I don't need a cover."

But my father, a devotee of conspiracy theories—he would speculate on the veracity of plots from his favorite television show, *The X-Files*, and when I'd tell him it was fiction, he'd say, "That's what they want you to believe"—was on a roll. As he doused his handkerchief with cologne before leaving for the office, he said, "Just keep in mind that you are in a country without a rule of law. They can do whatever they want, to whomever they want." Then he dropped the final bombshell. "But I wanted you to have a piece of information. In our old apartment building in Vedado, there is a false wooden ceiling in a hall closet that contains $200,000."

"Wait. What?!"

As he was literally out the door, holding what he called his "attaché," my father described how, before he left Cuba, he and his father had carefully fitted a plank of wood in the ceiling of the hall closet of my grandfather's apartment, filled it with stacks of Cuban pesos, and covered it with wallpaper.

I'd been traveling to Cuba for several years by then. I'd visited our old building several times and made friends with a woman named Consuelo who lived in a ground-floor apartment and ran an after-school program for neighborhood children. Later that day, as I made my way through Havana's passport control, baggage claim, and into the car of a loquacious neurologist named Saúl who had taken a week off from work to squire me around the island for a fee that exceeded six months of his salary, I thought about asking Consuelo to introduce me to the woman who lived in my grandfather's apartment. But what if the wallpaper was intact? What then? Would the money belong to me or someone else? Would that money even have value today? In the

late 1950s, the peso and dollar were of near-equal value. Now, currency in Cuba was a free-for-all. Both dollars and pesos circulated. A new currency, called the Cuban Convertible Peso, or CUC, had been introduced in 1994 to manage the influx of dollars that had started pouring in as a result of a revived tourist economy that was flourishing, in part, because of preservation.

Eusebio Leal Spengler, the Historian of Havana, had been promoting the UNESCO World Heritage Centro Historico as a cultural destination. Gone were the piles of trash and rubble that had clotted Old Havana's streets. In their place were new boutique hotels, restaurants, and small museums, not to mention cranes, cement mixers, and wooden scaffolding. Leal had a gift for spinning yarns that linked the smallest architectural detail—a fossil within limestone, a brushstroke on a mural—to the island's freighted history of occupations, foreign abuses, and current economic woes. Fidel Castro, whom he revered, had given him $1 million to restore Old Havana. The money was administered through a corporation called Habaguanex, S.A., which Leal himself controlled. It was in essence a capitalist venture within a communist economy, run like the country itself—through one man's autocratic will. Against the recommendation of his own architects and engineers, Leal had ordered the demolition of the above-grade cement parking lot in Plaza Vieja. As the experts had predicted, an eighteenth-century house collapsed due to the jackhammering. I had met Leal several times and interviewed him for an article in *Preservation* magazine. Of the building that collapsed, he said, *"No se puede hacer una tortilla sin romper huevos"* (To make an omelet, you have to break some eggs).

THAT YEAR, I WAS HEADED TO CUBA on behalf of an oddball project called "Send a Piana to Havana." The brainchild of a piano tuner named Ben Treuhaft, whose mother was the British author and well-known leftist political activist Jessica Mitford, "Send a Piana to Havana" aimed to fix pianos in Cuba and teach piano tuning to Cubans. Serial exoduses had caused a huge brain drain in technical professions. There were almost no trained piano tuners on an island whose lifeblood was music. My role in the project was to help find a safe method to protect the pianos from termites, as most wood in Cuba—the exceptions being local mahogany and cedar—is hyper-vulnerable to infestation. Russian-made pianos, the only ones that were brought in during the Soviet years, were made of soft woods that were especially tasty to the colonies of ant-like critters. The challenge was finding a chemical that could repel the insects over the long term without altering the tonal qualities of the sound boards. Or poisoning the pianists.

My cohort on this project was Dr. Raquel Carreras, a conservation scientist I'd met a few years earlier. I happened to walk up to introduce myself at the CENCREM while she was chatting with two colleagues about relationship woes. After we said our hellos, the women continued talking. One complained about a husband who'd left her for another woman and now continued to show up for afternoon trysts. The other worried about keeping her two lovers from finding out about each other. Without warning, Raquel cried out, "*Disfruta, niñas, sus bollos no vienen con contapingas!*" which translates roughly to "Enjoy life, girls, your vaginas don't come outfitted with dick counters."

The fact that she yelled this in front of me, a total stranger, made me like her instantly. Only later did I learn that she was a formidable scientist, a PhD in tropical wood identification whose many achievements included having performed the radio-carbon dating of the cross that was purportedly planted in the ground by Christopher Columbus on his first arrival in Cuba in 1492.

"This entire island belongs to the termites," Raquel told me, as we strategized how to tackle the infested pianos. Raquel had a long history of battling termites, wood borers, and other tropical pests. She'd had some limited success with tobacco and chili pepper juice on instruments at the Museo de la Musica (she explained to me how the nicotine alkaloid found in tobacco leaves impedes the process of neurotransmission in wood-boring beetles and termites), but treating working pianos—which she referred to as "those Russian pieces of shit"—was harder to do because we could not brush anything on the sound boards without damaging the tonal qualities of the instruments. I had brought down a bag of boric acid crystals, which kills termites by dehydration, and a type of triple-layered plastic that could be used to make a chamber for suffocating insects. The latter process, called *anoxia*, was a good way to eradicate pests without introducing poison to collections. The key was making sure you had an airtight chamber (even a tiny pinprick would render the treatment useless) and a method of consuming or replacing the oxygen.

In Cuba, as in most places, nitrogen gas was the preferred method. The trick was getting our hands on a tank, but through a combination of Raquel's ingenuity and some local buzz about "Send a Piana to Havana," we managed to *resolver* a nitrogen

tank, a term used by Cubans for getting what they needed. We had a blast trying to adapt garden hoses and some pilfered valves to get the bag to work. When it didn't, we switched to injecting boric acid and chili pepper tinctures into termite cavities. Our treatments were eventually a bit too makeshift to provide conclusive answers. But the fun we had working together made me realize how much I missed my old camaraderie with Robin.

AFTER A WEEK OF battling the termites, I left Havana for Trinidad, Cuba's second UNESCO World Heritage Site. The road down to this historic site winds along the Escambray Mountains, a cordillera that bisects the island and tumbles into the Caribbean. In 1993, when I made this trip for the first time, I was jolted by a gut-level awareness the minute I saw the verdigris foothills: *I've been here before; this is my landscape.* I said as much to A.B., who was driving a rental car, though it was not remotely possible, as the only person in my family who'd ever been to Trinidad was my father, as part of his cross-island trips to sell optical supplies. The flood of recognition nonetheless intensified as the mountains rolled past, and Cuban *campesinos*, known as *guajiros*, trotted by on horseback, machetes in hand. When the blue Caribbean appeared before our car and we turned along a coast where grey-green rivers spilled down from the verdant mountainside into the sea, I was certain that the trip was going to be important, though I had no idea how.

A.B. and I were headed down that time to meet Roberto Lopez Bastida, Trinidad's *conservador*. Known to everyone as

Macholo—a childhood nickname that perfectly described his masculine swagger—Lopez Bastida was the architect responsible for the preservation of Cuba's second UNESCO World Heritage site. Arriving at his office almost at sundown, A.B. and I said quick hellos and headed to our hotel, having arranged to meet the following day for a city tour. The next morning, A.B. changed his mind and told me he preferred to hang back at the beach, so I promised to return for a swim in the sea at three o'clock.

I met Lopez Bastida in the Plaza Mayor, the city's center. He was an experienced guide of his remarkable city, and he immediately began explaining that the town had been one of the first seven villas founded by Diego Velásquez in the early 1500s, and was the wealthiest in Cuba by the mid-nineteenth century, largely because of sugar and the illegal slave trade. In the mid-nineteenth century, the city's fortunes plunged because the local *azucareros*, or sugar barons, refused to mechanize their mills, leaving the city isolated for more than a century. "The road you came in on was built by Batista in 1956," he explained. "Before then, you could get here only by railroad from the north. Or by sea."

Insisting that I call him by his nickname, Macholo asked me about my work as he led me along the town's hilly cobbled streets. He was surprised to learn that I had been born in Cuba and had questions for me about coatings for wood and iron and showed me wall paintings in mansions that were powdering from exposure to humidity. As we talked, he took me into mansions that had been turned into museums, and private homes where people greeted him like a relative and let him go into their bedrooms to show me bronze beds with mother of pearl inlay

that had been imported from Italy, ceilings made of local Cuban hardwoods, tooled with delicate Mudéjar incisions, a type of Andalucian Islamic design produced by Christian artisans, and how the local adobe was a mix of mud, straw, and river stones that he told me came from the confluence of the Guaurabo River with the sea, "the very spot where Hernán Cortés left from to conquer Mexico."

Talk about materials as storytellers! Trinidad's adobe mansions were decorated with mahogany louvers, imported cabinets filled with Sévres and Meissen porcelains, and murals done by a Florentine artist brought to Cuba by the region's infamous sugar barons. Wandering for hours, we talked nonstop about conservation problems for artifacts and buildings. He ended the tour by taking me to the top of a five-story tower in a mansion for a panoramic view of the Caribbean and the blue-green Escambray.

Macholo stroked his thick dark mustache and stared at me. "When I first laid eyes on you, I thought you were American. But you're not," he said.

"I'm Cuban and American. But my ancestors are Eastern European Jews."

"Interesting," he said, lighting one of those aromatic *rubios* I had come to associate with Cuba. "My mother Lola's family was *Sefaradita*."

Clouds sat on the mountaintops. Rain was on its way. The wind coursed through the trees like a mad spirit. Macholo pointed out the bell tower of the Convento de San Francisco, the tallest in the region, and offered me a drag of the cigarette. I took it, even though I didn't smoke. It went to my head and made me dizzy.

"It is amazing to live in the city where you were born," I said.

"Not just the city. I live in the same house where I was born, the house my father bought when he married my mother."

"Do you ever think of going someplace else?"

He shook his head. "I don't even like staying overnight in Havana. But the country is changing. I'm not sure what comes next. I just hope I live to see it."

Though it was well past the time for me to head back to the hotel, Macholo insisted that a tour of Trinidad could not end without a visit to the city's oldest extant building, which had been built in 1723 and now served as a bar named La Canchánchara after its signature cocktail, a blend of *aguardiente* (raw rum), lime, and honey that had been invented by guerrilla *campesino* warriors, called *mambíses*, who fought in the nineteenth-century Cuban War of Independence (the third and last of three wars of liberation, starting with the Ten Years' War and the Little War). When we reached the front steps of the bar, it started raining. We huddled at a wrought iron table under the courtyard overhang, listening to a waterfall coursing down from the tiles as Macholo ordered us two drinks that came in small clay pots, called *jicaras*. The drink was potent, syrupy. "So, what does a beautiful *rubia cubana* like you restore in Los Angeles?" he asked.

A beautiful rubia cubana. I felt the drink go to my head. I was a local, like the cigarettes. "It's a young city, a place where nearly everyone has come from somewhere else."

"Like you," he said, locking his onyx eyes onto my blue ones. My skin began to tingle. Macholo dragged his chair closer to mine, and started to say, "Look, why don't we—"

But just then a man came up the steps, and when he saw Macholo called out, "*Compadre!* Congratulations on the medal!"

and slapped him on the shoulder. Macholo fired off a retort that I didn't understand and raised his glass. The men laughed.

"You won a medal?" I asked.

"It's figurative. My third wife, Mariluisa, and I just got back together after a separation. We're back in a honeymoon phase."

"Congratulations," I said, relieved as much as disappointed by the breaking of the spell. As he walked me back down to where I was parked, he took my arm, leaned in to my cheek, and finished what he had been about to say: "Why don't we spend a few hours alone down at the beach?"

"What about the medal?" I replied.

I DID NOT GO WITH HIM. Instead, we began writing to each other. In his beautiful architect's handwriting, Macholo wrote to me about his struggles to retain the past in a present that seemed to have no future, on believing in the future anyway, on helping neighbors fix their plumbing, keeping their roofs from caving in, and stopping them from removing the original decorated timbers and replacing them with concrete beams. The letters were sent back and forth through Nicaragua, where Macholo knew a pilot who flew to Trinidad once a month. I tried to copy his ardor in my own letters. But it was hopeless. My problems were personal. Minuscule by comparison.

We arranged to meet the following summer. I had Saúl the doctor drive me to Cienfuegos, a town founded in 1812 by French colonists who fled New Orleans after the Louisiana Purchase transferred their North American settlements to the United States. Our meeting point was the main town square, across from

an ornate theater where Enrico Caruso performed during a 1920s trip to Cuba. The façade was decorated with golden mosaics.

I waited and waited. Morning turned to afternoon. It was sweltering. I went into the theater. Inside, it had all of its original furnishings, including wooden chairs, iron grillwork, and an ornate ceiling mural. Outside, the plaza became bleached, a desert landscape rather than one paved with marble. I took refuge beneath trees that drooped white flowers. Across from me two little girls sat in a gazebo, kicking their legs and holding violin cases. Other children showed up, each carrying musical instruments. My skin erupted in heat bumps. Macholo had arranged for us to spend an afternoon at a beachfront hotel. Now I was having second thoughts. The heat and wait had vanquished my excitement. I'd been down this road before. I knew the gut-wrenching self-loathing that came later.

At dusk, Saúl drove me to Trinidad. Macholo's second ex-wife, a preservation architect named Nancy Benitez who was second in command at the Oficina del Conservador, came by the next morning to tell me that Macholo sent his regrets but he'd been called to a meeting in Santiago. Nancy took me on a tour of the plantations in the Valley of the Sugar Mills. At a site called San Isidro, she showed me where a sacred ceiba seedling sprouted from the foundation of the master's house, pushing out the roof timbers and collapsing the walls. "The Afro-Cuban orishas are taking vengeance on the sugar barons," Nancy said.

Saúl shook his head. "I had no idea such places existed in this country."

My trip after the "Send a Piana to Havana" project was going to be my fourth time in Trinidad. In recent months, Macholo had completely stopped writing to me. I tried calling— back then through a tortuous procedure that involved a third-party 800 number out of Canada; but the few times I happened to get through, his mother answered, put me on hold at a cost of $3.65 per minute, then came back and told me he was out. I had no idea why he had given me the total cold shoulder, but I decided to visit anyway. I wasn't about to lose my connection to that lovely historic town of which I'd grown so fond.

On our way to Trinidad, I asked Saúl to detour along the central highway to Cascajal, a tiny rural village where the nanny who had cared for me from the time I was born until we left Cuba lived. I'd been writing to Pilar since I had started going down to Cuba and we had met a few times before, but never in her hometown. She waited for me outside the small tin-roofed house she shared with her aging husband, beneath fruit trees bearing guava, sugar apple (*anón*), soursop (*guanábana*), and mango that were just beginning to flower. Pilar's once-curly black hair, a staple of our early family photographs, had turned a snowy white. She had ruddy, sunburned skin and black eyes that lit up when she saw me. "*Ay, mi Rosita!*" she cooed over and over as she led me by the arm to a wooden plank table piled with roast chicken, rice, black beans, salad, and fresh guava marmalade with thick slabs of white cheese made by a cousin. "She's been cooking since last night," said her husband as we sat to lunch.

Pilar seemed to adore me so much that it was a little overwhelming. She asked after my parents, as she always did, especially my

mother, for whom she had a soft spot, and regaled Saúl with stories about her, telling him about a time my parents and I drove out to Cascajal when I was two years old—my mother was so bothered by the heat of "*el campo*" that she insisted on bathing right then and there, using water that had been warmed in a metal pail. "Señora Hilda liked to show that she had once been poor and wasn't afraid to bathe without running water," she said with obvious pride and affection.

Saúl shared stories of his own as we feasted on the country meal, especially about the sorry state of hospitals in Cuba ("You know why Cubans are so healthy? Because they are committed to staying out of our hospitals!") and the sad fact that doctors like himself made twenty times their salary driving tourists around.

I chimed in and asked Pilar, "Do you know anything about my papa and *abuelo* storing money in a false wood ceiling?"

She shook her head, then pushed back her wooden chair. "Come outside. I want to show you something."

Once we were out of earshot, she whispered, "How well do you know *ese medico*?"

I was surprised. "Not that well, but he comes highly recommended by a colleague at the CENCREM."

She squeezed my arm. "*Ten cuidado lo que dices*" (Be careful what you say).

THE DRIVE FROM PILAR'S HOUSE to Trinidad took two hours. I had Saúl drop me off at Macholo's office before anyone else knew I had arrived, so I could surprise him before someone could claim that he was busy or out of town. When he saw me walk in,

he sprang to his feet, nonplussed, and quickly said, "Actually, I'm glad to see you. We've just discovered some old cannons buried in the sand out by the beach, and I think they're rusting." It seemed a strange and sudden revelation, but I was used to strange revelations in Cuba, and I was frankly willing to go anywhere he wanted as long as we had a few minutes to talk.

Though Macholo had an official government-issued jeep, he asked Saúl to drive us to the far end of the Ancon Peninsula, the seaside spit of land where I stayed with my husband on my first trip to the area. "Leave your purse in the car," Macholo said when we parked. He asked Saúl to stay behind and keep watch, then he started along the sand dunes, trudging in front of me in silence. Anguish thudded through me as I followed. *Where are you taking me? Why did you stop writing to me? What did I do or say?* Nearly half an hour later, I was seriously starting to worry what this was all about, when the fuse ends of the tilted iron cannons appeared in the sand dunes. Macholo whipped around suddenly and pulled me toward him. His mustache grazed my ear as he said: "State security came to see me. They encouraged me to get to know you, even accept an invitation to Los Angeles. That's why I stopped writing."

Six months after Macholo's confession, a conservation scientist who'd left Cuba on a work contract called me from Bogotá. "That doctor who drives you around came to see me when I got the invitation from the museum. He told me that if I wanted to get my exit visa, I had to ask around about you and report back on your activities."

I never called Saúl again. He tried tracking me down, but I avoided him. Later, when I told Raquel the story, I said: "It's not so much that I minded his keeping tabs on me, because I wasn't doing anything illegal. But he was charging me a fortune to drive me!"

"That's how these sons of bitches work," she said, laughing.

DESPITE THE SURVEILLANCE, I returned to Cuba every four to six months. I led groups of preservationists and art collectors who wanted to see the island "before it changes." I grew to detest this term. Cuba was already changing. As all places do. Nothing is ever static. Governments come and go, slowly or at the speed of coups d'état. Materials and buildings change as well; but as long as they remain standing, they retain their stories, their materials the words and phrases of those narratives. Wood beams cut from lush forests, tooled with Andalucian ornament. Walls of mud with stones and sand found at the confluence of a river used by Hernán Cortés to embark for Mexico. A ceiba's vengeance for the lives of Africans. Tall apartment houses with terrazzo floors. A false wood ceiling covered with wallpaper.

I MANAGED EVENTUALLY to check out that closet in my grandfather's apartment where my father said he hid the money. I got in after telling the current resident a cockamamie story about playing in there as a small child that sounded preposterous even to me. The wallpaper and false ceiling were of course

long gone. But in many other parts of Cuba, buildings bear the vestiges of ancient tales, of suffering at the hands of dictators and sugar barons, to be sure, but also of intrepid immigrants, virtuoso architects, designers, artisans, musicians, dancers. That place where I was born and that my parents left behind is forged from African, indigenous, Spanish, Chinese, French, North American, Ashkenazi, and Sephardic cultures. People who were fleeing from and coming toward. Builders, planters, innovators, tinkerers. One of these, an engineer named Ysrael Seinuk, who left in 1960 for New York "with nothing but my slide rule and my diploma from the University of Havana," later engineered the Lipstick and Condé Nast buildings and all of Donald Trump's eponymous towers. "Ysrael was so in love with me when I was fifteen!" gushed my mother when she read his obituary in *Time* magazine.

The conservation scientist did not return from Colombia. Eventually, Raquel left also. Macholo remained in Cuba. At the age of forty-five, a few years after marrying his fourth wife, he died of bacterial meningitis. He is buried in Trinidad's Cemeterio Viejo next to his ancestors.

Chapter Eleven

STEEL

I n conservation, as in health, prevention is everything. Just as it's better to eat well and get enough exercise than to, say, have cardiac bypass surgery, it's preferable to keep artworks safe from damage. This type of work, known as Preventive Conservation, is not glamorous. It's not mending a tear on a Picasso, repainting an outdoor sculpture, or stitching a frayed tapestry. It's humdrum work—washing outdoor sculptures and making sure sprinklers aren't hitting them. It's sweeping and dusting galleries, making boxes out of archival cardboard, monitoring relative humidity, crawling on your hands and knees to inspect insect traps, and making sure museum visitors don't touch objects with their sweaty hands.

Conservators are all about making sure nothing bad happens. And lots of bad can happen. Humidity that spikes out of control, cockling a watercolor. Drinks that spill, fingerprints that etch. Insects, always insects, hiding inside lacquer armoires, in the

spines of books, and in the warp and weft of carpets. Did you know that squirrels gnaw on lead because it tastes sweet and because it helps them grind down their fast-growing front teeth? Or that dog pee can change the color of bronzes?

And cats? Don't get me started on cats. When I opened my Los Angeles practice, a man brought me a 1940s Alexander Calder mobile, a rare example of the artist's work that used string instead of wire. Calder had made it for the man's mother. When she died, they packed it in a box. The cat jumped in before they put the lid on. The mobile was shredded almost beyond repair. Another cat managed to spring from a dining-room table onto an Aztec basalt corn-grinding metate, owned by a Mexican collector who kept it on a pedestal in her Key Biscayne condo. The metate flipped, landed on the marble floor, and was smashed to smithereens. The cat escaped unscathed.

If you are a collector and have a cat, chances are that an artwork will get damaged. But some injury to art can't be anticipated. In 2002, the pedestal beneath the Metropolitan Museum's fifteenth-century *Adam* by Venetian master Lombardo Tullio famously collapsed, shattering the marble. The repair took a decade and involved a cadre of conservators, engineers, and technical specialists. The *New York Times* reported on the process, calling it "a watershed for the Metropolitan," and "a radical approach to conservation."

Treatments of this virtuosity—rescuing Notre Dame after the fire, uncovering sixth-century biblical mosaics in an ancient synagogue, stabilizing cave murals in China and pyramids in Guatemala—lend our obscure profession glamor and cache. But most of what we do—what I've done in my career—is mitigate potential damage. Conservators are not control freaks, but we're

definitely control enthusiasts. When I'm called in to inspect an artwork in a client's house or a museum collection or a group of outdoor sculptures on a grassy median in West Hollywood, I am alert to what could happen as much as what already has. It's about looking into the future, seeing the next hurricane, earthquake, storm surge, fire, burst pipe, closetful of insects, or car accident. (Also, the telltale tricycle that explains why there are smeary fingerprints on grandpa's Yayoi Kusama pumpkin.) Lots of people now discuss disaster preparation; conservators dream in disaster technicolor. It is a profession in which it helps to have the psyche of a fleeing exile, or someone whose parent can flash like a wildfire. All of us are like this. As quasi-scientists, we know that entropy is always around the next corner.

It is strange, then, that I did not see disaster coming with the ongoing sale of my private practice to Robin. The events happened so fast and under such duress that the sequence escapes memory. There are, of course, two versions to the story. Robin's casts me as insensitive and unconcerned with her struggles to keep the practice going while I was running around in Cuba. Mine is that she just couldn't do the hard work of juggling the conservation work with business management. Our once robust bank account dwindled so fast that within six months of her taking over we had trouble meeting the payroll. To keep the work moving along, she hired her artist friend to help out. Then one day, when I had just come back from Cuba, she said: "This is not working for me. I don't want it."

A string of accusations ran through my mind. I might have said some out loud. They ran along the lines of: *Can you see now how hard it is to run a business, how much I have had to juggle, how unfairly you have treated me by always acting as if I were the enemy*

simply because I'm the owner? I knew, in part, that we had not worked out because I had not been paying attention. But the time for repair had long passed. I was done with running a business and dealing with employees.

I called around to colleagues and friends, looking for someone to take the practice off my hands. The one solid offer I got was from someone I had met when I had worked at the Los Angeles County Museum of Art. Trudie Holmes was a mother of two daughters; she had never attended conservation graduate school but had spent about fifteen years interning at a local museum part-time. After the Northridge earthquake, there had been so much work for conservators that even with her limited training, she had managed to open a small private practice. I had always liked her very much and thought she'd be a good partner, as Robin had once been. Even better, Trudie came from a wealthy Arizona family and had the cash to buy me out.

Though the wealth was her own, during our negotiations Trudie kept bringing up her husband's opinion about everything we were doing. She'd say: "Mike thinks I should only buy 60 percent of the practice. Mike insists that you sign a contract to work for me for five years." Mike's opinions were solid, but I found that "Mike says" and "Mike insists" deference an annoying throwback to the way my mother would always say, "Papi thinks you should do this," when she wanted to lend weight to her words, even though she was happy to trample my father's opinions whenever she felt like it.

I found it a little disconcerting to hear someone of my generation using the same ploy and wanted to ask Trudie, "Do you think Mike tells his bosses at work what you think?" but I held back. I needed this deal to go through. My own husband had

serious doubts about Trudie's experience, let alone gravitas as a professional, but he wasn't about to get in my way. Maybe he should have.

My parents, meanwhile, were unequivocally against the sale. "You're going to give up being a boss to become someone's employee? Someone who has less experience and knowledge than you do?" asked my mother.

My father had more practical advice. "If you're going to sell, just get rid of the whole thing. Sixty percent makes no sense."

"I don't have that choice, Papi."

"Fine, Rosa, but you don't have to be so belligerent!" my father said.

My father had recently become enamored of the word *belligerent*. Where he had learned it was anyone's guess, probably television, where both my parents picked up some of their most interesting vocabulary. My mother, for example, loved the expression "not cutting your nose to spite your face," though she transposed it to, "I don't want to cut myself to spite my nose." I never corrected her when she malapropped. I personally enjoyed the way both my parents savored their adopted language, even while retaining Spanish as the primary language of their home. They could twist and mangle words and phrases, or invent translations of words that came directly from the Spanish, like the word *accomplexed*, which does not exist in English, but comes from the Spanish *acomplejado*—someone with a personal hang-up. In my father's mind, my mother and I were both *accomplexed*. He said it was the reason I was walking out on a healthy private practice for no good reason. "You're too *accomplexed* to know what's good for you," he said. Boy, was he right.

The day Trudie strode into our studio, she was a completely different person than the one I'd known. Gone was the perky, deferential, part-time intern who had befriended me years earlier. Gathering the staff for a meeting, she announced, "I'm the new boss now, and things are going to change around here as I set new rules and procedures." She actually used the word *boss*. The staff exchanged furtive glances. No one would make eye contact with me. Robin's face reddened, and though I was a bit appalled myself, I chuckled internally: *You thought I was bad? Now get ready for what's coming.*

Though Trudie's husband, Mike, was always in the background pulling strings, she nonetheless worked hard to get her arms around our growing practice. I had not expected such diligence from someone I had really considered more of a dilettante than a true professional. As someone who was constantly worried about what others thought of me, I couldn't help being impressed by her facile self-confidence and lack of concern for the opinion of others. I had been giving public lectures for years, but the first time Trudie and I shared a podium, she winged her presentation, and still managed to come off pretty knowledgeable and poised. But that type of misplaced confidence can be a dangerous thing in conservation and it made me a little nervous. It drove Robin up the wall, and though Trudie offered Robin a generous raise and profit-sharing arrangement, I could feel Robin's resignation coming. What I did not see coming was a lawsuit, filed in small claims court, by Robin's artist friend for the salary Robin had failed to pay her. I was furious about this and wanted to call both of them and tell them off. My father, an expert in lawsuits, said: "Don't even think of it. You're legal adversaries."

"I've put her in God's hands," my mother added, her favorite method of wishing someone ill without doing so directly (it's bad juju). Unfortunately, because I was still the titular owner of the firm when Robin had hired her friend, the judge ruled against me. The total back pay came to roughly $5,000. Not the end of the world. Then Trudie and Mike called me on the phone together. "Because this all happened before we bought the business, it's your responsibility to pay her," he informed me.

"Or you can give us another 10 percent of the shares," she chirped.

"Do it," said my father when I called for his advice.

"Another 10 percent is more than twice the price of what I owe!"

"So what? Your shares are meaningless. You'll never see a penny of profit."

THERE ARE MANY ASPECTS OF our field that offer guidance for untangling life's messes. It would take me years to see this. Right then, as I was living out one of the most potent of those lessons, I was too dug in to my position to notice that outdoor sculpture conservation, which I happened to be spending a lot of time doing, offered such a framework. The way I saw it, Robin had treated me terribly; Trudie was shaping up to be even worse. I built a case around them while my mother's voice burbled in my head, telling me that everything was happening because I had been running back and forth to Cuba. But the truth was that I simply hadn't wanted to do the maintenance for either of these two relationships. Like collectors who tell me, "The gallery said

the sculpture is maintenance-free," I avoided tending to each of their needs the way I expected them to do for me. I failed to pay attention to what was happening.

I did the same thing with my marriage. A.B. and I had stopped fighting, but our joint fabric was thinning—a gauzy shirt that had been washed too many times. Soon our son would be off to college. I folded inward, not admitting how unmoored I was over having an empty nest to come home to after weeks in Cuba. Just as my husband and I had never once discussed our lost babies, so we never explicitly sat down to talk about "us" as we frayed beyond repair. We each went into our own corners and waited for the inevitable.

Most of us spend lots of time designing our own unhappiness. But who can ever see, within the quagmire of their own distorted sentiments and foolish actions, that things just fail because they are designed improperly? We're born into a family that doesn't love us the way they should. We make our bed with someone who is tethered to her own distresses, which might have nothing to do with us, but nonetheless makes for a troubled outcome. There are hundreds, if not thousands, of perfect storms that cause deterioration of the personal: illness, poverty, untimely deaths, deceptions, exile, persecution, loss of country. Almost nothing comes without intrinsic flaws. It is a law of nature. Some artists nowadays strive for perfect finishes—mirrored surfaces without a scratch, a bubble. They are practically impossible to maintain. Proper care can go a long way toward alleviating problems, but not always. As a wife, colleague, and business owner, I was blind to all of this. As a conservator of outdoor sculpture, it was all I considered.

BEFORE THE TWENTIETH CENTURY, public outdoor sculptures were mainly made of bronze, marble, and granite. Most were statues of men—for instance, politicians and military figures (Confederate monuments being the most glaring example)—used to promote unsavory political and social ideologies. The style of public sculpture changed in the 1960s, when President Kennedy created an Ad Hoc Committee on Federal Office Space that encouraged contemporary architecture for new federal buildings, including works by living American artists in their designs. Since the early 1970s, national public art initiatives, like the General Service Administration's Art in Architecture Program and the National Endowment for the Arts, mandate that a percentage of construction for new buildings (usually between 0.5 and 2 percent) be set aside for commissions by living artists. Public sculptures by powerhouse artists like Oldenburg, Calder, Tony Smith, Ellsworth Kelly, Louise Nevelson, and Alexander Liberman, to name a few, began displaying modern, abstract aesthetics that were visual game changers in public spaces. States, counties, and cities soon had their own public art programs.

But within years of installation, many of these works, especially those made out of steel, began to deteriorate. Alfred Lippincott, whose firm Lippincott, LLC, made many of the largest pieces, recalls problems of water pooling inside sculptures, causing rust to bleed through welds. Paints faded faster than expected, and the size of the artworks made them difficult to care for without cranes, street closures, scaffolding—all logistic nightmares. The worst problems were with COR-TEN steel, an alloy

patented by U. S. Steel that became trendy with artists as well as architects for its ability to form a velvety terracotta-colored patina after several years of weathering. Unfortunately, this only happened when the steel was able to dry completely, which was impossible on the shaded portions of the sculptures, on their undersides, where leaves collected, or, most critically, at foundations that were sunk underground.

"We started providing maintenance manuals," says Lippincott, "but they'd get filed in a drawer and no one would look at them again." Pieces rusted and peeled. Add graffiti to the mix, and public art agencies, who had the best intentions for beautifying urban places, suddenly saw commissioned works looking like the definition of urban blight.

Here's what one learns quickly when considering the life span of outdoor sculpture: Longevity begins with good construction and placement. Then comes upkeep. There is no way around this. You can't use COR-TEN steel in places where it will stay wet. You can't expect a shiny surface to remain that way without regular polishing. You can't set sculptures under trees without expecting stains from leaves and birds, or in fountains with hyper-chlorinated water (to keep people from getting bacterial infections), or in the path of sprinklers. Artworks based on electronics, video, neon, and light fixtures—what we refer to in the field as Time-Based Media—have to be calibrated constantly, and migrated to new platforms before the old ones (remember videotape, cassettes, floppy discs?) become obsolete. It takes vigilance and specialized knowledge.

It is the same with marriages and partnerships. One has to stand before the gritty truths and deal with what is wrong. Wipe off the dirt. Grind off the rust. See what is happening.

ONE DAY IN 2003, as the requisite five years of working for
Trudie were coming to an end, I found myself in Old Havana
with a group of architects. It was one of the last trips I would
take before George W. Bush clamped down on cultural travel to
the island. It was a cold, damp December morning, a few years
after the destruction of the World Trade Center towers. On a
break from touring, I slipped off to have coffee with my friend
Humberto Solás, the celebrated Cuban film director. Stratus
clouds hung low over the open courtyard, threatening *un norte,* a
nor'easter. We were bundled in coats and scarves, he smoking an
aromatic *rubio.*

I'd been writing about Cuba, penning short stories and essays.
"What's next on the creative horizon?" he asked.

I had been thinking of taking a stab at a novel. I wanted to set
it at the Tropicana Nightclub, that 1950s pinnacle of Cuban mod-
ernism. A few years earlier, CNN had featured the Tropicana in
a January 4, 2000, report of quintessential New Year's Eve night-
spots of the last millennium. Like many Cubans of a certain gen-
eration, my parents had loved the Tropicana for its music, shows,
and dancing. I loved it for its thin-shell concrete architecture.

I told Humberto and he nodded sagely. Then he pointed
toward the corner of the courtyard. "That's an interesting coinci-
dence, because that man over there is related to the original own-
er's wife."

"My aunt hates me because I'm still here in Cuba," the man
said after we were introduced, "but if you can get her to speak
to you, maybe you and I can write a screenplay together." He
presented me with a phone number that I expected would be in

Miami. Instead the area code was 323—the same as my own area code in Los Angeles.

Following the thread of serendipity, I drove to Glendale in northern Los Angeles County to meet Ofelia Fox several weeks later. A few years older than my parents, she had been waiting—literally, for she was deeply spiritual—for someone to "appear on my doorstep" to help her write about the nightclub that defined Havana in the 1950s. I realized that the true story of the place known as the "Paradise under the stars" was far more interesting than anything I could conjure.

We started meeting regularly at her house. With Fox News blaring in the background—she was a staunch Republican anti-communist—Ofelia and I talked and drank martinis or boilermakers at her fully stocked bar. Most nights she drank me under the table. At midnight I would take a nap while she and her housemate, Rosa Sanchez, ate dinner on cabaret time. Rosa hovered, interrupting and trying to steer my questions away from anything she sensed Ofelia didn't want to talk about, like Tropicana's link to mobsters, and most especially her and Ofelia's relationship, which was clearly one of long-term lovers. Like with an artist's interview, I tried to parse out the truth from lies as Rosa and Ofelia worked hard to make a big deal of how deeply Ofelia had been in love with her husband, Martín.

The story of the nightclub was buried in that detail. It was the story of Cuba itself, which was complicated, layered, like a stubborn coating that refuses to yield to solvents. It masked the truth about Ofelia and Martin's relationship. She had loved him, but she had also always loved women. Martín knew everything—it was an open secret, and part of their family arrangement. She never said that last part to me. But it was as plain as the fact that

the Tropicana represented all the lavish excesses of Cuba in the 1950s, but it was also a bastion of dance, music, and humor, a nightspot that was utterly beloved by everyone who performed there, including Nat King Cole, Celia Cruz, Olga Guillot, and Carmen Miranda. Slowly but surely, one boilermaker at a time, Ofelia and Rosa revealed their story to me. They introduced me to their friends. They would deposit details in my hand like jewels, waiting for me to react. When I finally gained enough of their confidence for Ofelia to confide in me about her and Rosa, she said: "People can be more than one thing. I needed time to know that you could handle that."

Places and objects can also be more than one thing. Outdoor sculpture can be both robust and fragile. Even when it's made of steel, rain and salt can wreck an artwork if it's not designed properly. Cuba itself, that vibrant cultural melting pot, had always been plagued by political instability, not to mention racism. But it had given my beleaguered Eastern European grandparents a home when the United States refused to let them in. And its five hundred years of historic buildings—all built with the profits of rampant capitalism—now remained standing only because real estate development had been halted by communism. Ofelia and Rosa, whose love for each other and for the memory of the Tropicana, was built on a dichotomy, scoffed at that last detail. They challenged me about traveling to Cuba as I did, "When all it does is help the Castro regime." To me the answer is simple: Cuba's architecture does not belong to Castro or the Communist Party or any one government. It is the legacy of all Cubans.

When Ofelia and I sold the Tropicana book proposal, I decided to pull back from private practice. As my father had

predicted, my shares yielded no profits. But then our firm was asked to undertake a project to conserve a sixty-panel mural in Inglewood, California, that was the largest WPA artwork west of the Mississippi River. Designed by Helen Lundeberg, the *History of Transportation* was made of petrachrome, a pictorial material similar to terrazzo.

The project had a range of issues, most notably a thick mat of graffiti that obscured large sections of the mural. The outer, thicker layers could be removed with paint strippers and pressurized hot water. But the bottom layers had permeated the porous surface, leaving a ghost of pigment within the matrix. We had to find a solution to removing them, because graffiti on a surface invites more graffiti. It's an interesting conundrum: Something unwanted attracting more of itself. It felt like a metaphor for my entire professional and personal life. Unwelcome bits were embedded into me and they bound me to bad situations. I kept repeating patterns of antagonism and disappointment. It came from me. It had to.

The agency that commissioned us to do the mural project wanted me to serve as the project lead. To say that Trudie was peeved would be a major understatement. She was the major shareholder and titular owner of the firm; the limelight was hers to have. I should have stepped out of the way and let her bask in the glory. Instead, I stuck it to her, using my leverage to make sure that the agency insisted I had to be the project lead. I also used it to muscle a higher salary for myself.

"Nice work," my father said.

Linda thought differently. "Weren't you on your way out? Can't you just let go?"

IT WAS AROUND THAT SAME TIME that my mother called one day, her voice careening into piercing octaves. "It's happened again! Your father was fired. They're accusing him of horrible acts."

"What, Mami?"

"I can't even bear to say it!"

It took time to get the information out of her. The ophthalmologist my father worked for was imperious, wealthy, someone who always had to be right. My brother had warned my father when he took the job: Keep your head down, be agreeable. If the guy says the sky is orange, just nod and say "and what a lovely shade." My father didn't have that in him. Knowing that my father had already fought and won an age-discrimination lawsuit, the ophthalmologist arranged for several employees to accuse him of harassment. In court, it came out that there were no prior accusations, no warnings, no corroboration by others, no history of anything untoward. My father was a sweet and courtly gentleman, but he could make distasteful statements about women in business, that we were vicious, backbiting, *belligerent*, always trying to prove our superiority. Did this translate to something worse? It's hard to imagine, but then again, many trusting women have maintained their father's, brother's, husband's, innocence, and I feared I could not be sure. All I knew then was that my father wept openly at the injustice of it all. Why did so much trouble always befall him? Eventually, the court ruled in his favor and my father won his second wrongful termination lawsuit. He got paid—but only the few thousand dollars that remained in his

contract, even though the staff who had accused him later con-
fessed that they'd been offered promotions.

This time my parents were finally forced to sell their treasured
Aventura condo. They found a cheaper place at the Jockey Club,
one of Miami's first gated developments. In 1970, when it was
built, the complex's clubhouse had been one of the city's most
happening nightspots, where sports stars caroused alongside
celebrities like Jackie Gleason, Burt Reynolds, and Eva Gabor,
and the cocaine and champagne flowed until dawn. The club-
house was now shuttered, moldering, rats and iguanas scurrying
out from between its warped louvered windows. Approaching
seventy years of age, my parents saw their earning years slipping
away. Their friends were taking annual cruises, and they were
pinching pennies. The only place that would hire my father was
Walmart. He drove forty miles in each direction to work as an
optician for seventeen dollars an hour.

The Jockey Club was a bit long in the tooth, but their apart-
ment had a stunning view. From their balcony, the bay could be
frothy green, or violent and grey, or glassy and immobile in the
mornings, with rose and coral cumulus clouds sieving the sun-
rise, the ashy dark wood of the run-down dock a synagogue of
squawking pelicans and seagulls. I liked sitting out there and
watching the thunderheads release a rippling pewter curtain that
veiled the cruise ship harbor to the south, the eastern slender
ridge that is Miami Beach, and the islands that Christo and
Jeanne-Claude had once wrapped in pink plastic.

Most nights my father came home after dark from Walmart.
He would call from the car to let my mother know he was on his
way. She would check the kitchen wall clock constantly. When

he arrived, she had his dinner ready on the granite kitchen counter, a paper towel as place mat, the way he liked. They'd eat and talk about the optical department, his manager, the customers. My father now lived in perpetual fear of displeasing his superiors. At home he complained about the power of major corporations, how it wasn't fair that companies like Walmart made such huge profits but paid workers so little and gave them so little recourse if they were treated unfairly.

"Papi, you're sounding like a socialist," I said one day.

"That's crazy talk," he replied. He leaned back in his recliner and closed his eyes.

PART
FOUR

Chapter Twelve

GRAFFITI

n 1964, shortly after my family moved into our second apartment in the United States, a Category 2 hurricane made direct landfall in Miami. I recall the preparations: My father, Felix, and our neighbor taping up jalousie windows; my mother packing coolers with ice, drinks, and sandwiches. Hurricanes always seem to hit hardest at night, and we all stayed up waiting for the onslaught by the green and red glow of teardrop-shaped hurricane lamps. My parents and their neighbors spent the hours playing poker and listening to our neighbor's off-color stories about his service in the Korean War. We kids gathered on the floor around board games and paint-by-number kits, eating cookies and Cheetos.

When the eye passed over us, the roar of the storm's harshest winds abruptly dying down, my father peeked outside and said, "All right, kids, let's go gather coconuts!" We filed out of the

building, wearing sneakers and knee-high socks under our paja-
mas. Each of us held a flashlight to scour the grass and street for
fallen fruit. We were not to touch anything, just point. The dads
would do the picking up. It was exhilarating fun. And dangerous
as hell, given the possibility of downed power lines or snakes and
alligators, not to mention the eyewall suddenly crashing back
over us with its monster winds. But nothing bad happened. Not
that I recall.

Except that sometimes I wonder if my own memories are real.
Was it possible that my father behaved so irresponsibly? That my
mother allowed it? My recollections can be lopsided when it
comes to happy times. I hoard fragments the way my young son
used to collect baseball cards. Gathering coconuts in the eye of a
hurricane. Getting a dog—a German shepherd that we named
Yafa, *beauty* in Hebrew. My mother was always annoyed at the
dog, hitting her with a newspaper. I don't remember what hap-
pened to that dog, but later we got another dog, an Irish setter
that my parents let me name Shimon after one of the most erratic
rabbis at the Hebrew Academy, a man who'd lost a few fingers
while fighting the British in Palestine. Shimon was as dumb as a
rock, but beautiful. My mother told me that he ran away, but later
they confessed to giving him away because my brother was
asthmatic.

I remember dissolving into tear-strewn laughter as my
mother sang love songs translated from Spanish to Yiddish in
the car when she was in a good mood. A virtuoso UN inter-
preter she was, belting out *"Heyt nakhmittag ha bikh gezen as es
regn, ikh hab gezen vi mentshn loyfn, aun du bist nisht geven"* in
time to Eydie Gormé's crooning of "Esta Tarde vi Llover" by

Mexican composer Armando Manzanero on the 8-track tape player. My parents dancing—they were stupendous *salseros*, oozing so much sexuality that I'd be forced to look away. My little brother, as adorable as he was irascible. The swimming pool my parents built when he was six, where they snuck off privately to swim when everyone was sleeping, and the time my son, seven or eight years old, caught my mother sneaking a cigarette as she fried potato latkes, and she hurried to slip her hand behind her back, while he said, "Grandma, why is there smoke coming out of your mouth and from behind your head?"

How we laughed and laughed at that one. There was lots of banter in between the arguments. Both of my parents had the storytelling timing of stand-up comics. My mother was a gifted cook, though her repertoire was limited to a few dishes that toggled between Cuban and Ashkenazi, all of them learned from Blanca, her mother-in-law. On Jewish holidays, she made brisket, potatoes with onions, chicken soup with malanga, plantains, and boniato (the Cuban sweet potato identified by its dry, white flesh), sugary sweet noodle kugel packed with apples and raisins, matzo farfel (no matter what holiday), and sweet potato pie with canned pineapple and marshmallows, a nod to her adopted country. Because my father loved it, she made *kindli*, a Hungarian, walnut-filled, log pastry that involved hours of kneading, rolling, and grinding.

Those joyous moments were like stepping stones over a sea of flames. I never knew how long they'd last, yet they would always reappear when I least expected them. I learned to treasure them, bask in the love and laughter. My mother's rage quivered right below the surface. When it burst out, mauling,

shredding, screeching, she sometimes had enough presence of mind to slam into her room, turn off the lights, and crawl beneath the covers. Tears, sleep, and time always sent the demon back into its cave. She knew herself, I'll give her that much.

"She had a rough childhood," my father once said to me in such a moment. "All I ever wanted was to make her happy."

A VERSION OF THOSE SAME WORDS were spoken by my husband, A.B., when we finally made the decision to separate. We sat across from each other in a soul food diner in South Los Angeles, our swollen hearts laid on the table. "I saw how wounded you were," he said. "I wanted you to be happy. And you never were. I wasn't happy either, but I didn't want to upset you more than you already were."

He didn't say that to harm me. But it still felt like a sucker punch, and even though it was clear that in a marriage nothing is solely the fault of one person, I could not help but lament the fact that I, with all my education, all my years of therapy, wound up as laceratingly temperamental as my mother. My husband was gracious enough to acknowledge that I had done a good job of shielding our son from my temper. Still, it was almost impossible to fathom that we'd wasted nearly twenty-five years with neither of us sitting down and forcing the other to "shit or get off the pot," as my mother liked to wisecrack. Instead, we turned our backs on the problem, hoping it would go away. I'd been spending several months a year in Cuba or Miami. To cope with my absence or avoid me when I was home, my husband, in turn, signed up for a Japanese martial arts class that met on Saturday

nights. It was no way to live, yet neither of us had possessed the courage to confront the other.

When I finally took action, it was only because I'd met somebody else. Todd was a film director from New York, the friend of a friend I'd met several months earlier. I knew that my partner of a quarter century—my son's father—deserved better than me sneaking out this back door, but I was too weak to extricate myself without someone else to lean on.

Linda, who had been married, divorced, and now remarried to someone with whom she was deliriously happy, said to me: "Divorce is like stepping into a river of shit. But if you can slog through it, make it to the other side, you will surprise yourself."

I was terrified. But I moved forward anyway. I can't say I was brave, because I wasn't. I had a new relationship with someone who was also leaving a marriage of twenty-five years. Todd seemed more sure of what we were doing than I was. "I don't know if this will work out between us, but let's just use this opportunity to let our partners go." It sounded like a facile way to describe what we were doing. A.B. had done everything he could to patch the fissures in my heart, and I was busy convincing myself that the reason I was leaving was this new, hopefully true, love. For that person to casually say that perhaps we were just one another's transitional objects was not the narrative I wanted to hear. But, of course, he was right. A.B. and I had stopped working years ago. Todd and I could not predict the future. But I had a feeling in my gut that, one way or the other, this was the right move, no matter how it unfolded. I moved out. A.B. and I wept and vowed to remain amicable.

Still, history is a hard thing to shake. Though I was the one who had ultimately chosen to end the marriage, once I had left,

I could hardly stand to stay away. My son had taken a leave from college and was living at our longtime family home. Several nights a week, I'd come back home to watch television with the two of them—husband and son—then I'd wrench myself away again. It was crazy-making for everyone.

The back-and-forth came to an end only when I finally left Los Angeles. I won a yearlong fellowship at the American Academy in Rome, my first time ever winning anything. One applies to the Academy to work on a specific project. My proposal's title was "A Comprehensive History of Vandalism."

THE *NEW OXFORD AMERICAN DICTIONARY* defines vandalism as "a deliberate, unauthorized act that is intentional and done in order to alter, make a mark in, or purposely damage art, architecture, or public places." Public art conservators are experts in this sort of thing; we're always seeing artworks that are scratched, gouged, sprayed with paint, and written on with magic markers, and we're always being asked to recommend materials that are "vandalism-proof" for new commissions. As I spent more and more time working in this field of conservation, I began to give a lot of thought to the differences and similarities between the mischief of graffiti and the more violent types of damage to artworks. Were there common threads between, say, the colorful spray-painted graffiti markings that obliterated the *History of Transportation* mural and the hammer blows delivered by a delusional visitor to Michelangelo's *Pieta* in 1972? What about a link between the toppling of statues of dictators (we had not yet witnessed the exhilarating, wholesale defacement and destruction of

Confederate statues) and the slashing of paintings? Rembrandt's
The Night Watch had been knifed twice—in 1911 and 1975—and
doused with acid by a psychiatric patient in 1990. Barnett
Newman's abstract canvases had been sliced on three separate
occasions—in 1982 at Berlin's Nationalgalerie Museum and
twice later at Stedelijk Museum Amsterdam. What was that
about? Why Barnett Newman? Even though the Taliban's 2003
detonation of the monumental, sixth-century Bamiyan Buddhas,
the wild smashing of Jewish-owned stores and synagogues during
the 1938 German pogrom called Kristallnacht, and the 1993
bombing of sixteenth-century Ottoman-Islamic Mostar Bridge
in Bosnia-Herzegovina by the Croatian military were authorized
acts, did they not also qualify as vandalism? Although I didn't
give voice to this in my proposal, I also wondered how much the
shredding of a marriage had to do with vandalism.

ON MY WAY TO ROME, I spent a month in Miami. I had been
asked to perform a survey of garden statuary at Vizcaya Museum
& Gardens, an ornate historic mansion that was one of the city's
major cultural attractions. Designed and built between 1914 and
1918 for James Deering, the heir to the International Harvester
fortune, Vizcaya has a main house decorated with European
sculpture and furnishings, and lavish gardens filled with grottos,
fountains, and gazebos made of local coral stone, as well as
eighteenth-century Italian limestone sculptures. In the 1990s, I
had visited with their in-house restorer, a Florentine who showed
me around with a perfunctory air and made it clear that he
wanted nothing to do with me. Now guided by a new director

named Dr. Joel Hoffman, who had a professional museum back-
ground, the museum had recently obtained a grant to conserve its
outdoor sculpture collection. A stipulation of the grant was that
someone had to first survey the conditions of each artwork, but
that surveyor could not bid the actual hands-on work. Which
was where I came in.

August is no time to work outdoors in the subtropics. The sun
gains force throughout the day, the air smothering you like a wet
wool blanket by early afternoon. Coolers filled with iced drinks,
big brimmed hats, and loose, long-sleeved shirts were as much
part of our tool kits as clipboards, measuring tapes, and cameras.
Despite the harsh conditions, I was excited to have a new per-
spective on the hometown I had fled years earlier when it had
almost no museums or cultural institutions of note. Now Miami
was an arts capital, fueled largely by Art Basel Miami Beach, an
international event that took place each December and attracted
artists and collectors from around the world. South Beach, the
once run-down neighborhood where our family lived when we
arrived from Cuba, now pulsed nightly with club music, flashing
neon, and celebrity sightings. The backdrop for all of the artistic
activity and economic revitalization was the restored Miami Art
Deco District (officially named the Miami Beach Architectural
District)—a National Register of Historic Places–designated
area that included among its many buildings the apartment house
we had lived in when we first arrived from Cuba.

Every morning while I worked at Vizcaya, I woke up in the
frigid air-conditioned air of my parents' second bedroom, my
mother's voice foretelling the tenor of the day. Was that an angry
mutter, a barked order? Or was my mother whispering cozily to

my father at the granite breakfast counter, their spoons clinking against *café con leche* cups, pages of the *Miami Herald* softly flapping. My mother had retired from her last job at an optical store because of problems with her knees. She'd already had one replaced, and when I'd come to help she spent the day refusing to take painkillers, because she was "not going to become a drug addict!" then moaning all day long about "the agony." As the day of my departure neared, she asked, "How long are you supposed to be away?"

"Eleven months."

"I might have to have my other knee replaced before then."

I couldn't believe she was saying this. "It's elective surgery. Can't it wait?"

"It's not you who can hardly walk! Fine, don't help out. Do what you want."

She was goading me to say, "I'll come back if you need surgery." I did not.

I caught my father staring at me. When he hooked my attention, he closed his eyes and lightly shook his head as if to say, "I can't take this." Each night as we sat together in their living room, me on the couch, them on recliners, watching *Dancing with the Stars* or *Law & Order: Special Victims Unit*, my father would pepper me with questions during the commercials: *What's the time difference to Rome* (six hours); *Who's going with you* (my new boyfriend was going to meet me intermittently, but I didn't share much about him); *How will we reach you* (I taught them to use Skype).

"I don't know how I'll manage without you," he said one day when my mother was out.

"It's only eleven months."

"Yes, but what if she decides to have that surgery before you return . . ." He sighed and let his voice trail off.

"Make her schedule it for next summer, when I return."

"If you return," he said.

"What do you mean *if* ?"

He waved me off. "There's no making her to do anything. You know that."

MY FATHER KNEW ME WELL. Escape was on my mind. No longer tethered to a marriage or a business, Europe beckoned, Rome especially. Although Rome was more or less the center of the conservation world—it was where one of the first conservation training programs had been established in 1939, and where UNESCO's International Centre for the Study of the Preservation and Restoration of Cultural Property, known as ICCROM, had its offices—I had not spent more than a day there before. I'd kept the city at arm's length, sensing that it was a place that begged for time—a lifetime, as the saying went. I had lived in so many different places that I'd come to trust my instincts about cities, and it was now the right time in my life for Rome.

Like Vizcaya, the American Academy in Rome was built during the Gilded Age, a term coined by Mark Twain to describe the late-nineteenth-century American period of expansive economic growth that led to the amassing of enormous fortunes by industrialists like William K. Vanderbilt, John D. Rockefeller Jr., J. P. Morgan, and architect Charles McKim—all founders of the Academy. The goal of these men was to provide time and space

for architects, artists, and scholars to study the classical master-pieces of Europe, and the list of former Academy Fellows was a veritable who's who of mainstream (mostly male and white) American culture that included Paul Chalfin, the architect and designer of Vizcaya, and none other than my treasured mentor, Joachim Gaehde. Another former Fellow was Ana Mendieta, a Cuban-born feminist sculptor and performance artist, who had left Cuba as a child, and whose formidable works had referenced her own body and the island's landscape. Tragically killed two years after her 1983 fellowship (the sculptor Carl Andre, her hus-band, was acquitted of pushing her out of a window on grounds of reasonable doubt), Mendieta had been returning to Cuba reg-ularly just before she went to Rome.

On a stifling September morning in 2008 when I landed at the Rome-Fiumicino International Airport "Leonardo da Vinci," I was also on the heels of having spent years traveling to Cuba, although Cuba seemed to figure little in my Rome prize project. Being a native Spanish speaker nonetheless made it easy for me to learn basic Italian before I left, and by the time I got to Rome my accent was good enough to falsely telegraph a fluency that gave my taxi driver the green light to begin chattering about the upcoming United States presidential election.

"*Piu piano, per favore*," I begged, as he zoomed at breakneck speed along the highways and the narrow hilly roadways framed by ancient vine-choked walls. I caught the words "Obama," "Sarah Palin," and a blended word that sounded like both McCain and Biden, marveling at trees that looked like they were drawn by Dr. Seuss, buildings that all seemed to be color coordi-nated in a palette ranging from creamy white to terracotta, and a massive marble fountain that spilled aqua water toward a

panoramic view of the historic city with the Apennine Mountains behind. By the time the driver screeched to a stop in front of the Academy's spiked iron gates, I understood more or less that Italians (and *tutto il mondo*) were hopeful that America would make the right choice and elect Barack Obama.

"*Estoy de acuerdo*," I responded in Spanish.

MY ROOM ON THE SECOND FLOOR of the Academy's main limestone and stucco building had a view of a manicured garden dotted with more of those Dr. Seuss trees that I soon learned were Italian umbrella pines, a species native to the Mediterranean. Everything else—cypress, orange, lemon, oleander, lavender—reminded me of California. Tired and a bit nostalgic, I wandered toward my studio, which faced the front of the building. It was accessed by tall wooden doors and was big enough to park a bus inside. I had two long work tables, a small desk, a futon sofa, an armchair, and a bulletin board that ran the length of the room on which to pin—what? Drawings? Architectural plans? I unfurled a giant map of Rome and stuck it to the corkboard. Work had begun.

That evening I got my first taste of dining among venerated scholars and artists. Most were from the Northeast and taught at major universities. Wine flowed freely and conversations tilted toward Pliny, Seneca, the Papal Schism, and Latin poetry during the Flavian period. I had no idea what any of those were. People talked about the New York art world, writing for *Artforum*, the *New Yorker*. My vandalism project was preposterously broad by any academic standard, and more than one person raised an

eyebrow when I tried to explain it. But that first night I met a professor from Washington and Lee University who studied the graffiti of Pompeii, and we arranged to meet for coffee.

Downstairs in the marble hallway there were sign-up sheets for tours of the Roman Forum, San Clemente, Subiaco, and the Necropolises of Cerveteri and Tarquinia. Except for the first, I'd never heard of any of those places. My fellow Fellows knew all sorts of things I didn't—for example, that there was a pyramid a few miles downhill, and beside it a Protestant cemetery where Keats, Shelley, and the American sculptor Chauncey B. Ives, whose sculptures I had worked on at the Met and in Atlanta, were buried. We were encouraged to request *permesi* to visit private libraries, catacombs, *ninfeos* that weren't open to the public, even climb the spiral column of Marcus Aurelius, but I was like the fourth child in the Passover Haggadah—the one who did not even know what to ask.

Days passed. I had coffee with the expert on graffiti. Professor Rebecca Benefiel explained to me how ancient unauthorized writings showed us how similar people are over time. At Pompeii some of these writings are funny and salacious: *Myrtis, you do great blowjobs. Virgula to her Tertius: You are one horny lad! Lucius painted this. I've caught a cold.* Outside of a brothel: *Here Harpocras has had a good fuck with Drauca for a denarius.* And in the gladiator's barracks: *Celadus the Thracier makes the girls moan!* Ancient graffiti, Dr. Benefiel explained, is the only place where one can read the words of people who did not have agency or power, for example women and enslaved people.

I took notes and pinned them to my corkboard. I set drawing paper on my long table and tried my hand at sketching for the first time in almost forty years. The world economy was imploding.

Banks were dissolving, homes foreclosed, Fannie Mae and Freddie Mac collapsing like buildings in Old Havana after a rainstorm. At dinners, which were run by protégées of Alice Waters, and where, predictably, I drank more wine and ate more *cacio e pepe* than was good for me, conversations often steered toward the American election. Everyone had sent for absentee ballots and most of us hoped for Obama's win. An idea was floated to put up a sign with his name spelled out in each of the central street-facing windows, and my window would hold the central A in OBAMA.

At the Basilica of San Clemente, a three-level church that began as a Roman temple, then an early Christian church, then the current eleventh-century Basilica, I started noticing the scratched and penned names on the murals. Afterward, I saw such markings at Orvieto and Siena cathedrals, in minor chapels hidden in alleys. The layering of Christianity onto the Roman temples could be construed as a form of vandalism. One culture annihilating another, as the Spanish did to the indigenous peoples of the Americas. I could not tell yet if this fit together with the paint slapped onto stone and stucco, or the googly eyeballs drawn on the Piazza del Popolo sphinxes, or the magic-marker, muscled arms and erect penises (complete with scrotum sacks sporting spiky hairs) doodled onto marble busts of long-forgotten statesmen in Garibaldi Park, a stone's throw from the Academy, but I let my mind wander and spool, exactly what this year was all about.

As a Rome Prize Fellow, I was accorded access to the ICCROM library, located downhill from the Janiculum in a cobbled corner of Trastevere. There I read about the Allied bombing

of Dresden, about the links between genocide and cultural destruction among Nazis, Stalinists, and the Khmer Rouge. The deliberate destruction of a country's heritage has been considered an international war crime since 1954. I pored through rare books documenting the Italian government's preparations for protecting monuments from bombing in World Wars I and II and saw photos of sandbags around Michelangelo's *David* in Florence and Bernini's *Ecstasy of Saint Teresa* wrapped in burlap.

But what connected all of this? I took long walks in the parks and along the river looking for threads of commonality between the bawdy wall writings of slaves and women, Buddhas bombed into oblivion, slashed paintings, arches that had the names of emperors gouged out, and spray-painted graffiti. I thought about A.B., now my ex, and all the damage that I'd caused him. But that was inadvertent damage; vandalism is intentional, even when it's not pernicious. I never wanted to cause A.B. or anybody—not Stella, Trudie, and especially not Robin—any harm. I suppose that neither did my mother with her scorched-earth rages. It nonetheless felt awful to have taken archaeology away from A.B., the profession that he loved, then leave him for someone else and find myself relishing Rome, a city that by all accounts an archaeologist deserved more than I did. Fortunately, he was already in a great new relationship, and it hurt as much as made me happy, when he talked about it during our infrequent phone calls. I spoke with my son every week, and he sounded happy and relieved that his parents had "finally done what I've been expecting for a long time." As we made plans for him to visit Rome over the holidays, I wondered: *How do damaged items become whole again? How much destruction is necessary in a cycle of true repair?*

The world was inexorably careening toward economic free fall. The news cycles said it was part of a "correction." How much needed to be lost before we could be found?

The tourists left and Todd arrived from Los Angeles. Every evening we walked to the Tiber to watch flocks of starlings swoop and swirl a calligraphic pattern on the clouds. Todd had created a wildly successful children's television show and now wrote books, plays, and films for young audiences. He had a calm demeanor that receded to the background at a place full of ambition like the Academy. No one really got him, but he wasn't fazed by this; he hadn't even gone to college. I had never encountered someone so comfortable in his shoes, someone less interested in the opinion of so-called tastemakers and academics than in his audience of teenagers and two-to-five-year-olds. Still, I remained worried about his statement that we were transitory objects for each other, and churned scenarios of chaos, wondering whether the law of karma required this relationship to crater. I had hurt my husband, ergo, it was logical that I should be hurt by Todd. And yet here he was, enjoying Rome with me, making friends with a scrappy and eccentric "fellow-traveler," as spouses and accompanying parties were called—a French documentarian and restaurateur named Stefan.

AT MIDNIGHT ON NOVEMBER 5, 2008—6:00 p.m. Eastern Standard Time—we Fellows and our fellow travelers gathered in the grand salon before a grainy, analog television. With several little girls in pajamas among us, and one gregarious toddler who kept blocking the screen, we waited for the election results. The

predictions were good, but we were jittery. We snacked on dense, small donut-shaped crackers called *tarallini* and drank tea, whiskey, and a Brunello di Montalcino someone had reserved for the occasion. At 5:00 a.m. Rome time, CNN called it. The United States had its first Black president, a man of obvious integrity. We cheered and wept and most of us hung around until just before 6:00 a.m. local time, when Obama delivered his victory speech in Grant Park, Chicago. The following day, random Italians on the street seemed to be smiling at me. The barista at the local place where Todd went for his daily *doppio machiato* greeted him with, *"Auguri, ragazzo!"*

THANKSGIVING CAME. Before the Academy's lunchtime feast, Todd and I walked to the Pantheon with his daughter. She was visiting from Madrid, where she was taking third-year law school classes. The day was damp and blustery, the city nearly empty of tourists. I walked ahead to give them space and she talked nonstop—bright, kind, generous conversation with her dad. Rome felt magical with this lovely young woman and her attentive father strolling behind me. *Why shouldn't this work out for me?* I wondered. Without the throngs, you could hear rain pattering on the cobblestones, the roar of the rapids below Tiber Island. I heard Todd saying to his daughter, "Rome is covered in graffiti, but without it, the place would look like a Hollywood back lot."

Inside the Pantheon, we were only a handful of people. Rain misted through the oculus, puddling onto the marble floor, the only human sound the soft patter of Todd's daughter. The Pantheon is Rome's best-preserved ancient monument. Built of

concrete that uses increasingly lighter weight aggregate in each ascending tier, it has a dome that, at 141 feet, still holds the world record for being the largest ever made of unreinforced concrete.

We walked next to Piazza de la Minerva, where an Egyptian obelisk rose from an elephant sculpture by Gian Lorenzo Bernini. The nearby church Santa Maria sopra Minerva had a sculpture by Michelangelo; others in the neighborhood had Caravaggios. Noticing that none of those walls were graffitied, I snapped out of my pleasant reverie and started churning with worry: *Please, please let me come up with a unifying theory that coalesces what I'm seeing. Please don't let me waste this year and have nothing to show for it.*

Later that afternoon, over martinis and prosecco, Todd's daughter asked him, "Hey, Dad, what's up with your Western?"

The Western was an idea Todd had for a movie. It was a classic story of good versus evil, the twist being that the hero was a teenage girl. Todd shook his head. "I don't stand a chance to get that movie made without it being a book first."

In bed that night, I said, "Want me to try writing the Western?"

Though it was dark, I heard the pleasure in his voice: "Sure, why not?"

MORNINGS IN MY STUDIO on the highest hill of Rome now started in the craggy Bighorn Mountains of Wyoming in a fictional town I christened Mariposa Creek. A place of lodgepole pine and aspen forests, icy rivers, granite, and no works of art or architecture. There is plenty of violence here, but no vandalism. I

researched 1880s Winchesters and Colts, and carved out log buildings, a creek bed, a whitewashed schoolhouse. The heroine became a Cuban girl from Trinidad, an immigrant in search of home within the vast continent that had adopted her. Snow fell, woodfires burned, a stagecoach thundered downhill, leather snapped, and wood wheels rattled. I loved the process of getting into someone else's head, a different skin, conjuring their thoughts and feelings, especially those whose hearts were dark and hell-bent on causing harm. Most days it leveled out the dread of staring at my walls and coming up with no cohesive theory about vandalism.

Right before lunch each day, I left the mountains of Wyoming and Skyped Miami. It would be challah and *café con leche* time, my parents in their bathrobes, the seagulls on the derelict dock squawking loud enough to hear on the Janiculum. My parents always had reports of problems they were having with their neighbors, with my father's job, my brother who they claimed did not call enough, but I always managed to regale them with stories they'd find interesting—about the Jewish catacombs, a synagogue that served a community that was neither Ashkenazi nor Sephardic (it was its own thing—Italki Judaism), and bore the bullet holes of a 1982 terrorist shooting on a Jewish holiday that left a toddler dead and thirty-seven others injured. I showed my father, who adored sweets, mouthwatering pictures of *cassata siciliana* and *corneti* filled with custard, and told them both about buttery leather gloves in chic boutiques on streets with melodic names like Via del Gobberno Vecchio. My father reminisced about his days traveling to Milan for optical conventions. "Do they still refuse to serve you cappuccino in the afternoons?" my mother asked incongruously. She always had some throwback

thought to a time past, as if the world never changed. They were happy that Obama was elected. My father looked tired.

ONE RAINY DAY IN EARLY DECEMBER, I headed to the Palatine Museum, to see a graffito purported to be the first image of Christ on the cross. I climbed the steep hill carefully, folded my umbrella, and began to search for the image. I found it in a corner of the museum—a small plaster fragment not much bigger than a dinner plate. On it were two scratched stick people—one standing with an upraised arm, another crucified while wearing the head of a donkey. The sardonic inscription read, "Alexamenos worships his god."

This first image of Christ on the cross, depicted pejoratively—after all, the donkey's head was there to suggest *"your crucified god, Alexamenos, is nothing but an ass"*—took me back to that darkened hall in college where illicit Christian artworks changed the direction of my life. A time when practicing Christianity was punishable by death. The first image of Jesus on the cross, the worshipper mocked, the mark of it a whisper on a piece of plaster in a little-visited museum. I stepped back out into the cold December morning, where the rain had ended, giving way to sunshine. Cloud blooms filled the sky, looking like smoke signals behind the Colosseum.

I trekked back up to the Academy, all the monuments appearing sluiced by rain, their marble sparkling as I panted past them. Back in my studio, I sat and took notes, though I did not know where this was going. I wrote first about mark-making, the tools one uses, the way pencils, crayons, spray paints, awls,

and hammers impact substrates differently. Then about words—sarcasm about Alexamenos, and I recalled a graffito from Havana in the 1950s that read *¡Abajo Batista!* in clear red scrawl that had been obviously retouched and protected in a country where graffiti is no longer tolerated. I'd been reading Primo Levi's memoir *The Periodic Table* and suddenly I thought about his links between chemistry, materials, damage, and suffering. Nothing that I had endured or that my mother had endured came close to Levi's trauma. Nonetheless, in his words, "It seemed to me that I would be purified if I told its story," I found a starting point.

As Christmas drew near, the Fellows visited a monastery to St. Benedict in a town north of Rome called Subiaco. The walls were covered in murals, and one of these, an image of the Virgin Mary from 1160, was gouged with names, dates, and orations that nearly obliterated her face. The piece looked terribly damaged, but those scratches were devotional, lending layers of love on what was otherwise a commonplace wall painting. Vandalism was a fingerprint of authenticity, much like trauma to personality. The broken blocks of a Buddha, the shredded pages of a Hebrew bible are rendered special by the ordeals they have gone through. My mother came to mind. Her ravages were simple marks of who she is. Things attacked are things beloved. The Mostar Bridge, Bamiyan Buddhas, and Barnett Newman's gashed canvases. I felt a tenderness for her, for myself, and for my marriage, with all its scars.

One morning, a few days before Hanukkah began—it was one of those rare years when the Jewish and Christian holidays coincided—during my midday Skype call to Miami, my mother announced, "I've scheduled knee surgery for February."

On the screen, my father's face bore a look I'd never seen before. It was a muted, beatific countenance—the tender sorrow

of the Virgin Mary in *Annunciation* paintings by da Vinci and Fra Angelico. A look that telegraphed acceptance, inner prescience, a knowledge that the future held awful, providential certainties. A face ravaged by scrawls.

"I'll come back for a week," I conceded. "Once Mom's home from the hospital."

A smile feathered the corner of his lips. "*Gracias*, Rosinke. I told your mother that she has to take the painkillers this time. Otherwise, I'll leave the house."

DISASTER

landed in Miami four days after my mother's surgery. She was home, up and about on her walker, swaddled in a thick bathrobe. "I took the painkillers, but I don't need them anymore," she announced. I glanced at my father. He closed his eyes and sighed. My mother had a day nurse, paid for by home healthcare insurance that she and my father had the prescience to buy when they were in their sixties. I spent a lot of time sitting around and watching television. When my father came home, I served his dinner. But apart from that one task, I was not needed. I was annoyed to have left Rome for nothing.

One day, I called Vizcaya while my mother slept. The curator asked me to stop by and inspect damage caused years earlier by hurricanes Katrina and Wilma. Both storms had struck in 2005, and though staff had installed Kevlar screens over the mansion's doors, rolled up carpets, and sandbagged parts of the

interior and gardens, the ocean surges had flooded the mansion's
basement-level rooms. Stained glass windows had fractured,
painted wooden frames had swelled and cracked, and corrosion
bloomed on every banister, window frame, and doorknob. On the
second floor, the window of a sitting room had opened in a wind
gust, spraying salt onto lamps, sculpture, furniture, and silk wall
coverings.

Much as I hated to admit it, I felt fortunate for the damage.
My year in Rome was coming to an end, and there were few jobs
in conservation, the recession having gutted museums across the
United States. Foreclosures remained on the rise and the stock
market was ricocheting up and down. I called Amy Green and
delicately asked if I could join her and her partner in their firm.
Her response was tepid, spongy. I could tell she did not want to
say they didn't want me, but they obviously didn't.

BACK IN ROME, SPRING ARRIVED, bathing the city's marble
with a luminous, romantic light. Todd and I traveled to Budapest,
where so many people we met claimed to have hidden Jews during
the war that we wondered how it was possible that so many were
nonetheless deported to Auschwitz. We later spent ten days driv-
ing through Sicily, visiting Segesta, that most well-preserved of
Greek temples, and Piazza Armerina, where a Roman-era villa
had mosaic floors depicting bikini-clad girls playing volleyball.
We feasted on tiny rice balls called *arancini* and cups of *granita
de mandorla*, a snow cone made of almond milk.

My brother, with whom I was only just starting to grow close
given our thirteen-year age difference that seemed so immense

when we were younger, came to visit with his wife and two teen-aged children. Todd and I took them to Naples, where pizza had been born (my nephew was particularly enamored of a variety served with French fries on top) and where every saint's day was commemorated with its own bespoke pastry filled with custard, meringue, or chocolate ganache.

As the last days of the fellowship approach, I surprised myself by actually completing a first draft of the Western. I also developed a coherent approach to understanding vandalism, which turned into an outline for a book that was neither popular nor academic enough to interest any publisher. The golden hours in a garden lined with lavender, where everyone around me was similarly engulfed in creative thinking, were almost over. It was time to say goodbye and head back to the real world.

For me, that world consisted once again of private conservation practice. It was my fourth such venture, a letdown after Rome and, once again, inevitable. Entrepreneurship had begun to feel like a mantel passed down from my pushcart-peddler, importer-exporter ancestors. Years earlier, a santera I had met in Cuba through Raquel Carreras told me, "Your forte is the business of the art world, not the creative part." Dinorah Castellanos read the wishes of the *santos* through a configuration of cowrie shells. Both the *santos*, and a spirit being she channeled with a nine-card Spanish tarot spread, held that I was wired for business, not creative work. I didn't like this prophesy, but on a different visit Dinorah had foretold that I would meet *un hombre canoso*—a white-haired man, which sent me into a paroxysm of protest. Then I met Todd, who is white-haired. "The dog has four legs but only one path," Dinorah explained matter-of-factly as she chain-smoked thin cigars and drank thimble-sized cups of

sugary coffee. "You can't keep trying to go in all directions. Follow your destiny. Believe me, it's going to pay off."

PRIVATE CONSERVATION PRACTICES can be solo endeavors, but architecture and sculpture conservation are team sports that require ladders, power-washers, compressors, propane torches, and scaffolding. The first person I hired to assist me was Dinorah's son, a chemist named Ignacio Del Valle. Ignacio had won *el bombo*—as Cubans call the US immigration lottery—but had arrived just in time for the recession. He had been getting by on odd jobs, like pouring concrete and helping a cousin "move products" from Miami to New Jersey.

"What sort of products?" I asked.

He shrugged and flashed me a full-lipped smile. "Things a person doesn't talk about."

"Let me be very clear. In my line of work, nothing illegal can ever—"

"*Oye, sin problema*," he interrupted. "I've been doing what I do because *hay que vivir*" (A person's gotta live). "But if you hire me, I'll be clean as a choirboy."

IGNACIO WAS GREAT WITH HIS HANDS and a skilled problem solver. At Vizcaya, he deftly removed old concrete fills and rusted rebar from a seawater-soaked marble staircase. Because of his chemistry background, he was comfortable testing water for chlorides with silver nitrate, mixing adhesives by weight to

volume, and managing the optimal dwell time of cleaning products.

"You'd make a great conservator," I said, as he tapped away at discolored fills in a patchwork marble floor, which is hard to do without scratching the original materials.

"Me? Nah. I'm a hands-on guy."

"Seriously. You're gifted at this line of work."

He looked up from where he was sitting, wiped his forehead, flashed me the smile that made him catnip to three warring girlfriends. "The only reason we Cubans can't fly is because we don't have wings."

IN LOS ANGELES, Todd and I rented a two-story Spanish Mediterranean house in the mid-Wilshire neighborhood where I had lived since 1991. Even after three decades, Los Angeles still felt like a temporary way station. I'd never gotten used to the dryness, the cloudless skies, and the roiling, murky, scary ocean that is as cold as a daiquiri. I had so much baggage here, so many ruined relationships, so little community since I had split with Robin. But I had raised a son here, lost twins, built a business, sold it. I never would have met the widow of the Tropicana Nightclub had I lived anywhere else. I was familiar with the city's neighborhoods, freeways, quirks, and artists— Baldessari, Saar, Ruscha, McCracken, Irwin, Bengston, Bradford, Valentine. I spent decades becoming skilled at the specific fabric that made up the city's architecture—cast stone, terracotta, petrachrome, terrazzo, California tile, and magnesite, a type of low-cost 1920s flooring. Thirty years was a long time to

live somewhere and not think of it as home. I realized, extraordinarily, that three generations of my family—beginning with my grandfather Bumi's arrival in 1926 and ending with his departure in 1964—had only lived in Cuba for about the same time that I had been in Los Angeles.

I settled into a peripatetic existence, traveling every six weeks between the studios in Miami and Los Angeles. Todd preferred Los Angeles, and through him, I began to see this sprawling place as one of mystery and discovery, of canyons and secret staircases, where you can spot coyotes, hawks, and hummingbirds in urban neighborhoods. Todd and I drove to beaches tucked behind Malibu cliffs, and went on tours of mid-century modern neighborhoods. In Rome, Todd and the French restaurateur had shopped for food at local markets, cooking up batches of clams and fish, plates of black kale and endive shoots, called *puntarelle*, and learning how to boil pasta for exactly the right amount of time. He found the same joy in Los Angeles's far-flung farmers markets and I was well fed, if a bit elbowed out of the kitchen. I argued with him for it, but my mother offered wise words: "Are you nuts? Let him cook!"

Nothing is wrong, I told myself. *Todd is good. We're good. Los Angeles is good. My business is thriving.* Fear brimmed over anyway. Some nights I lay awake, waiting for the other shoe to drop. Some days, I lashed out at him about leaving the water running in the kitchen sink ("We live in a desert! Can't you get that through your head?") or about always coming home late when we had someplace to go. "Let me know when the Mean One goes back into her den," Todd would remark, which made me angrier, until I let it wash away. Our love bloomed slowly, like wildflowers rather than a showy bird of paradise. Over Thanksgiving, we

visited his mother in Berks County, fifty miles from Philadelphia. I drove an hour to see Linda, and we sat around her fire drinking hot chocolate, talking about second chances.

MY WORK TRIPS TO MIAMI became easy ways to see my parents. I was busy; I could only come for dinner. I slept in my own place now, a badly renovated flip house in a neighborhood called Buenavista. One night, as we sat to dinner, my father said, "I've got something for you." He shuffled to their bedroom and returned with a double-pointed, plastic, orange hammer that had a razor blade fitted into its handle. "Keep this in your car. It's for breaking your window and cutting your seat belt."

"What do I need that for?"

"If your car falls into a canal."

I laughed out loud and he grew annoyed. "It happens all the time! We have hundreds of canals in Florida. But fine. Don't take it. Do what you want."

I took the hammer and thanked him for looking out for me, realizing that the conversation was about safety, about feeling secure. My parents did not feel secure. Now nearing eighty, my father was fatigued by long days of standing on his feet in Walmart's optical department. His feet burned with neuropathy. He needed to retire, but they had no savings. Social Security would not cover their expenses.

My brother and I had a meeting with them and offered to help out. My father stared into the distance. I could tell that the idea of being indebted to his children was intolerable. He took gabapentin for his neuropathy. A doctor prescribed a fentanyl patch

for arthritis. My mother started finding bottles of Ativan hidden in drawers. Alarmed, she called me. "What if he falls asleep on his way home from work? What if he kills someone on the expressway? I'd go back to work myself if I could get a job," she'd cry, then quickly shift gears and erupt, "Why *should* I work? I've been working since I was five years old, scrubbing tables in an orphanage!"

They argued regularly about topics as benign as Michelle Obama's sleeveless dresses. "It's not dignified to see the First Lady's armpits!" my father flashed.

"Who sees her armpits? And with that body, she could show her ass and it would be fine!" my mother shot back.

When we were alone, my mother listed the ways he'd failed her, always starting with that old recrimination that his father would not let them take their money out of Cuba. Then it would be the plastic lens factory. A flea market stand. A sunglass place at Aventura's Loehmann's Plaza. That North Miami store my father opened with the money that he borrowed from me. When it flopped, he started drinking. He kept a gallon jug of vodka in a closet. My brother would smell it on his breath when he came to the store. My mother found out. "You're a drunk! And I hate drunks!" though she always claimed that the person that she'd loved most in the world was her father, an unremitting alcoholic. My father's bout with vodka did not last more than a month. Nowadays, fentanyl, Valium, Ativan were his tools for coping with the pain and sorrow. "You're a drug addict! I hate addicts!" my mother would cry. "No wonder we don't have any money!"

My stomach would roil as I sat there, wondering what I was supposed to do. It was a throwback to my childhood, bearing witness to their self-inflicted misery.

"We don't have any money because she can't keep a nickel in her pocket," my father would whisper when he was sure she was out of earshot. "If I made a hundred dollars, she spent a hundred and twenty."

"What are you two talking about?" my mother would demand, returning to her recliner.

My father would sit there, stone-faced.

"Just my work," I'd say.

"What about it?"

I never had to think too hard to come up with a story. "We just got hired to fix the cast stone façade frieze at the Wolfsonian museum."

"Now you're working in Washington?"

"Wolfsonian, not Smithsonian. It's a museum at 10th and Washington. Near where we used to live on Drexel."

"What could possibly need restoring there?"

I explained about the art deco district, and the fragments of cast stone that were raining down from the façade.

"Sounds like a big job. How much money will you make?"

Never having been sure what it was I did, my parents were amazed that people paid us tens of thousands to do it. They liked the fact that this work gave me visibility. I'd show up on the news or in the *Herald*, talking about protocols for cleaning off the layers of graffiti from the Miami Marine Stadium. "It's the most significant building by a Cuban architect outside of Cuba," I'd say.

My father would shrink under the weight of what could have been. I'd feel like an idiot and change the subject, gifting them stories about the mansions that I worked on in Palm Beach and Indian Creek Island, a local private community where football

star Tom Brady lived (and where Jared and Ivanka Kushner recently plunked down $24 million for a 1.3-acre estate). Without breaking nondisclosure agreements, I told them about yachts with baby yachts and pairs of jet skis parked along hundred-foot docks, swimming pools the size of tennis courts, Picassos and Rodins (the few artists' names they recognized), and panoramic ocean views from high-floor condos. Their plainspoken opinions cleared my head to certain truths about the art world, like when I told them about an imperious hedge-fund manager who had delayed cleaning splatters of pool water from a $3 million polished bronze sculpture, though time was of the essence, and my mother said: "They were probably hoping to claim a total loss," or when I complained that people would spend thousands having their fancy cars cleaned and waxed but not their outdoor sculptures, and my father remarked, "Probably the people who sold them the sculptures purposely didn't tell them they'd have to spend money on maintenance." This got me to start asking at art fairs: "Can this sculpture go outdoors? How many times a year does it need maintenance?" The range of responses was interesting, to say the least.

I WAS TRAVELING A LOT FOR WORK, and one middle of the night in a Honolulu hotel room, I dreamed about A.B. I called his name; he couldn't hear me. I bolted upright, my head throbbing, with the opening of Elizabeth Bishop's poem "One Art" in my mind: *The art of losing isn't hard to master; / so many things seem filled with the intent / to be lost that their loss is no disaster.*

I threw the curtains open. Waikiki twinkled against the dark slope of Diamond Head. I slipped back under the covers and dialed Linda. It was 8:30 a.m. in Philadelphia. "What have I done? I've made a terrible mistake. I acted rashly, stupidly, left the kindest, wisest, funniest, and most loving man ever. I've got a great relationship with Todd, but it is wrong, it started wrong, it has no chance of working, it's built on a bad foundation."

"Calm down," said my wise friend. "The middle of the night is no time to reflect on what you're doing or have done."

The next morning, I headed to a downtown Honolulu bank to inspect a badly damaged sculpture by Tony Rosenthal. Intended to be a highly polished disc, the artwork was now covered in gold paint and its surface plates were bulging and shedding fragments of rusted steel armature. This was going to be a complicated treatment with many layered steps that had to be worked out in sequence, so my colleague on the project—a local artist and welder named Michael Jones—suggested we sit and make notes over Thai iced coffees in our favorite café across the plaza. We walked over and saw a crowd gathered outside, glued to images on the café's television of crushed houses, people running and wailing, a roofless cathedral dangling stained glass windows, and a listing presidential palace. A 7.0 earthquake had leveled western Haiti. The death toll crawled along the bottom of the screen: ten thousand, twenty thousand, predictions of a hundred thousand. Miami had half a million Haitian residents. I called my parents. "*Los muchachos* are frantic. They can't reach their families," my mother said of the Jockey Club's valet parkers, front desk attendants, and mechanical engineering staff. The next day, all the news was about Haiti. Honolulu, a seismic island,

throbbed with the weight of devastation at a place of nearly the same latitude.

I returned to Los Angeles to work at the Huntington, a museum and botanical garden whose marble mausoleum was leaching salts. Salts comprise a slow-motion disaster, more akin to the ongoing poverty and corruption that countries like Haiti and Cuba endure than the abrupt slap of a natural disaster. I scraped off a sample of the salts, placed them in a plastic cup, and gave them to a conservation scientist who would examine them under a scanning electron microscope. Haiti's crushing woes faded in and out of the news cycle. Cholera broke out in the tent cities. There was no clean water, no way to land planes at the airport. Aid was being air-dropped; doctors were performing surgery on ships docked in the harbor.

Though it seemed unimaginable that someone would be paying attention to saving cultural items at a time of so much human devastation, a rescue plan had been put in place by the Smithsonian, the Haiti Ministry of Culture, and Blue Shield International, an "independent, neutral, non-governmental, non-profit, international organization which strives to protect heritage during armed conflicts and disasters across the world." Overseen by Dr. Richard Kurin, the Smithsonian's undersecretary for history, art, and culture, the Haiti Cultural Recovery Program was being managed by Olsen Jean Julien, a Haitian preservation architect and former minister of culture. The conservation team was being headed by a fluent French-speaking objects conservator whose most recent job was at the Smithsonian National Museum of African Art. She reached out to ask me and a paintings conservator named Viviana Dominguez if we could help with the rescue of murals that had collapsed along with the

Episcopal cathedral. Painted in the 1950s by the island's most revered contemporary artists, the original fourteen murals were among the most treasured artworks in the country.

On a hot morning a few months later, Viviana and I headed to Haiti, vaccinated against typhus, typhoid, and hepatitis, sprayed liberally with mosquito repellent to avoid dengue fever, and taking malaria pills that made me woozy as our driver fought the snarled traffic in the capital. We went directly from the airport to the collapsed cathedral. There were crowds everywhere—walking, hitching rides, carrying baskets, hauling carts. Most roads were lined with rubble. Blue tarps covered almost every rooftop. Viviana and I had packed everything we could think of bringing for the testing, but it was a stab in the dark; we weren't even sure what the murals looked like.

Built in 1924, on the site of an 1860s church that had been founded by African American Episcopalians fleeing slavery, Holy Trinity Cathedral looked like it had been bombed. The checkerboard floor of what had been the church's central nave was piled with palm-sized painted fragments. Scattered amid limestone rubble, these remnants, and others dangling on the walls, were what was left of fourteen murals painted in the 1940s and 1950s. The artworks were beloved for representing the stories of Jesus's life using only Haitian people, landscapes, rivers, and buildings.

We were met at the site by a team of five people, led by Olsen. Elaborate wooden scaffolding shored each of the three murals that were still attached to the walls. They included: a three-walled *Last Supper* by Philome Obin, Haiti's most highly regarded painter of all time; a *Procession* by artist Préfète Duffaut that incorporated cheerful imagery from the historic town of Jacmel; and a *Baptism* by Castera Bazile, the only one of three remaining

masterpieces by this artist to survive the earthquake. The murals were gorgeously vibrant, but their paints, which were intended for indoors, were already fading due to sun and rain. The walls appeared to be made of barely-held-together rubble. Viviana and I exchanged worried glances. We'd said yes immediately to the request, but now we weren't so sure what we were going to do. We climbed the scaffolding to get a closer look at the *Last Supper*. The paint was on an uneven coat of mortar that in places was thinner than a thumbnail. Mosquitoes attacked our hands and faces as we tried to take measurements. The blue paint of the background powdered with our touch.

Back in our hotel room we strategized. The main issue was the fragile mortar. How would we detach it from the wall without its shattering? There were other complications: how to get the powdering paint stabilized; how to get the fragments down the scaffolding; what materials and tools to bring from Miami. The city was as dangerously unstable as the cathedral's rubble walls. We were instructed not to leave the compound under any circumstances without an escort. There was no place to go anyway; six months after the earthquake, few businesses were open, and many people were living in tents, most without running water and electricity. We learned that morning that someone who was supposed to meet with us could not because his wife had been kidnapped.

I'm not one to shy away from complicated treatments, but I felt like I had bitten off more than I could chew. I was glum, distracted, and felt ridiculous about coming to a country with so many dire issues to rescue murals. Viviana did not share my angst. Born and raised in Buenos Aires, she was used to political and economic crises, and she kept her mind on the work, looking

for simple solutions, low-hanging fruit. At one point, she posited that we try using the strappo technique, an outmoded method of gluing canvas to the image and pulling only the paint layer off the walls. I shot back testily, "That's a dumb suggestion," then immediately regretted my outburst. "I'm sorry; don't know why this is getting to me," I said to her later that night.

She shrugged and said, "We're here to problem-solve, so let's just figure this out." The next day, our last on-site, I cautiously asked an architect affiliated with the project what local opinions were about spending money that is urgently needed for human survival on rescuing these murals.

She folded her arms and gave me a withering stare. "We have lost everything except our culture. We have to save whatever we can."

The salvage work began in mid-July. Five Haitian artists were hired to assist us. Junior, Frankie, Michel, Emanuel, and Snyder spoke only French and Kreyòl (Creole); Viviana and I spoke only English and Spanish. Viviana prepared dictionary diagrams to help us understand one another. Using the heavy cracks as natural separation lines and specialized chisels we had fabricated in Miami, we began to separate the murals from the wall. Having more time to travel to Haiti, Viviana became the project supervisor, whereas I came in to offer technical advice about the mortar. Slowly but surely the murals were released from their precarious walls, then stabilized, photographed, marked on a hand-drawn template, and packed for future installation in a new cathedral. Haiti proved to be a constant exercise in what is possible if one keeps at it.

When the work came to an end, the best of the technicians—a man who, like Ignacio, showed great promise in the field of

conservation—was invited to attend the American Institute for
Conservation conference. After the week in Albuquerque,
Emanuel decided not to go back to Port-au-Prince. The project's
leadership became outraged. "This hurts our team's reputation.
We're supposed to be training people to work in Haiti, not giving
them paths to come to the United States," someone told me. I got
it. Really, I did. But those words could only be uttered by those
who'd never had to flee their country. And in what universe could
I, a Cuban American whose family had been offered every advantage
when we arrived here, concur with such an argument?

Emanuel laid low for almost two years. Finally, he called me.

"What took you so long?" I asked.

"I didn't have a work permit."

"But now you do?"

"Yes, finally."

"Then come on over."

WHEN MY FATHER'S FEET finally gave out and he retired from
Walmart, he spent most days watching television. His favorites
were sci-fi and disaster movies. My mother hated them, so he
would watch them when she went out to play bingo or mah-jongg.
One afternoon I arrived at the tail end of *The Impossible*, a harrowing
film about one family's survival of the deadly 2004 Indian
Ocean tsunami.

As the credits rolled, my father said, "Disasters are good for
your business, aren't they?"

It sounded terrible, but he happened to be right.

"Which is best, a hurricane, earthquake, or fire?"

I'd actually given thought to this before. "Earthquakes are both the most abrupt and hardest to prepare for, but they can also be the most straightforward because much of what we deal with is breakage. The winds and storm surges of hurricanes break things also, but they'll add oily water, mold, muck, and dead animals into the mix. Also, they come all the time."

"And fires?"

I nodded, leaning into my didactic persona. "If a work or house is in the direct path of flames, it's usually gone or charred beyond repair. But if it's only covered with soot, you can usually get it fully clean."

"Interesting," he said, and yawned.

"Disasters are our new reality in conservation," I continued. "Nowadays out West, we deal with wildfires all year long. Hurricanes are getting bigger, slower, stronger. They're even hitting places like New York." I started telling my father about Superstorm Sandy and the floods in subways, fabrication studios, and museums. "There is a real risk," I said, "of a place like Venice, Italy, inundating by the year 2100." I continued with an ominous description of a new South Florida reality, which is that sea level rise is likely to contaminate the region's underground aquifer, threatening not only the Everglades and barrier islands, but the limestone bedrock upon which the entire region is constructed. And then, I heard him snoring. I let my sentence peter out. The silence woke him up.

He yawned and said, "My whole life has been a disaster."

My heart swelled with sorrow. Many times before I'd tried to tell him that I knew how much he lost, how much he gave up in

an effort to shield all of us from chaos. "You tried your best, Papi. I'm grateful for all of it."

He closed his eyes and shook his head. "I was a terrible father; you said so yourself in that letter."

Before I could respond, we heard a key in the lock, and my mother bounded in from mah-jongg. "I won six bucks and change! Not bad for a day's work. So, what are you two talking about?"

Chapter Fourteen

MOSAIC

O n a balmy winter night, Trinidad's Plaza Mayor teemed with tourists and competing music that wafted out from inside a restaurant and down from an outdoor discotheque. The restaurant was in the former mansion of a nineteenth-century sugar baron, and I was there as the study leader for a group of preservation aficionados from Los Angeles. The group was in a great mood, drinking frothy daiquiris and dining on roast pork, lobster, fried plantains, rice, and beans. They had been loving Cuba—"It's nothing like what I expected," many said, a statement that was true in ways too layered to unravel. These days much ink was devoted in the press to Cuba, but people were always surprised when they came down and actually saw the five hundred years of continuous architectural history in states of semi-ruin or heard the trumpet scales played behind walls of tile ringed with banana trees and the people's bluster and laughter, their expectation and worry about the future. I always thought

about Macholo on these trips, the way he'd hoped to live to see his country change. It was finally actually changing in a real way. Castro was on his deathbed and Raúl Castro and Barack Obama had just met and shaken hands at the 2015 Summit of the Americas. The press went nuts. So did right-wing US politicians and the most die-hard communists within the Cuban government. Despite the naysaying of opposing minorities, embassies would soon reopen in Washington and Havana. In March 2016, when Obama visited the island—the first US president to do so since Calvin Coolidge in 1928—he and the First Lady would be trailed by throngs and treated like rock stars.

Many of my Cuban-born American friends were now repatriating to the island, reclaiming their birthrights. Most did it in order to be eligible to purchase property. In decades past, you occupied your residence and it was yours, but you weren't allowed to sell it, only to pass it down to a family member or someone who lived with you. Real estate transactions were done in complicated exchange sequences known as *permutas*. Now you could openly plunk down cash and get a Spanish colonial mansion in Trinidad or a mid-century modern apartment in Havana. But only if you were Cuban.

As a Cuban, this made sense to me. But I was not ready to repatriate. It felt risky. As much as I adored Cuba's architecture and people, I was alert to the danger of a place controlled by one man's will. Anyway, if I ever decided to repatriate, it would be to conserve buildings, not buy them. Though I had far more work than I could do in the United States, I remained tantalized by the prospect of working in Cuba. It felt like the proper endgame, the logical send-off to my long career in private practice.

Entrepreneurship was new to the island, and now there were private boutiques, hair salons, music venues, art galleries, nail parlors, piano tuners, computer geeks, graphic designers, barbers, and homegrown boutique hotels and restaurants that tourists vastly preferred to government-owned establishments. A paintings conservator colleague had opened a private practice tucked in the basement of a museum. Graduates of the Escuela Taller, a trade school set up by the Historian of Havana to train high school graduates in preservation trades like metalwork, masonry, plasterwork, and wood carving, had formed private construction brigades.

An architect I knew who taught at the university and had a side hustle renovating restaurants and private houses had approached me about opening a Havana office of my private practice. I had been helping her design a treatment plan for conserving the Moorish-style majolica tiles that covered the dining room of the Hotel Inglaterra, and I'd already been in contact with US-based manufacturers of conservation materials about importing them to Havana. Everyone was eager to get on the bandwagon. Once Obama lifted all restrictions, change would come quickly. Big hotel chains and American corporations were already circling. Would Hilton, Hyatt, Home Depot, Related Group, and Royal Caribbean understand the importance of Cuba's stone, terracotta, and terrazzo? Though government standards had been in place for decades, "money talks and shit walks," as my mother liked to say, and there were already rumors of bribes and slipshod standards replacing the long-standing restrictions against demolishing historic materials. Building conservation requires expertise that most architects and contractors don't

possess themselves, so, what can be repaired is often removed and replaced instead. This happens all the time in the United States, but in Cuba it felt doubly tragic simply because materials had remained preserved for so long.

THAT SPRING, my father went into the hospital with a urinary tract infection. The doctor performed a cystoscopy and diagnosed bladder cancer. "If I don't live through the surgery, make sure you take care of your mother," he made me promise.

I prayed silently: *Dear God, or universe, when it is time for one of them to go, please leave me with the one that will be easiest to deal with.* It was a childish yearning, but working in Miami had engulfed me in their needs, their arguments. I kept my time compartmentalized, but they were getting to the age when I realized there might not be that much time left. They were the hand I had been dealt. Our people, *nuestra gente*, Cuban and Jewish alike, did not abandon our parents.

My father had surgery and healed quickly. He came home from the hospital in time to see Donald Trump on the debate stage. "God help us if he wins," he announced, wincing from his catheter.

"No way that's going to happen," I said.

"Bill Maher thinks it is." My parents pronounced the comedian's name "macher," with a Yiddish intonation.

My father's face was pale and drawn. He had dropped the fentanyl and Ativan cold turkey and had stopped smoking, an addiction that began when he was fifteen. His cancer wasn't life-threatening, but the monthly treatments stung his urethra

and he dribbled urine, which embarrassed him and enraged my mother, who considered herself sorely alert to foul smells because of the years of sharing communal bathrooms in tenement houses. Unable to berate my father while he recovered, she developed stomach cramps. "Maybe I'm the one with cancer!" she flung at us. My father groaned, rolling his eyes.

"What, you think you're the only one who can be sick? The only difference between us is that I don't spend my days complaining. I can take the pain."

My parents lobbed the cancer diagnosis back and forth, aiming to score points at an imaginary goalpost over who merited more care, who had claims on the highest level of sympathy. At night, I lay on my Miami studio's sofabed, staring at the tropical garden Todd and I had planted—guava, avocado, papaya, banana, and mango trees, and birds of paradise and ginger plants with drooping tiers of red flowers. Nocturnal creatures croaked and screeched as if I were adrift aboard a steamer chugging down the Amazon. In some ways, I was riding on a current of similar danger and uncertainty. My parents were pushing eighty-five. One of them was going to be left. *Which one*, I wondered, *would be easiest to deal with?*

One day, out of the blue, my mother announced, "You better hope that he goes before me, because he's no picnic, no *señor.*"

When she said this, I recalled my father's bouts of sudden anger, the way he told me that I was belligerent and needed help when what I needed was for them to understand me. How one time he came home from work when I was playing kickball in the street with friends, and he yanked me indoors by my arm and yelled, "Girls and boys don't play those games together!" as if kicking a ball in the street with others was sordid. It made me wonder if there was truth to his being fired for harassment.

The bladder cancer diagnosis turned out to be wrong. "We should sue those fucking doctors!" my mother yelled. "Rosinke, don't you know a lawyer who would do it for free? One of your friends or clients?"

"I could ask around," I said, having no intention of involving anyone I knew in my family's histrionics.

IN BETWEEN WORK IN MIAMI and my trips to Cuba, Todd and I got married on an unseasonably cold February day at the Beverly Hills courthouse. Our only witnesses were Amy and our good friends Ed and Carolina. Amy brought cupcakes and I threw my bouquet on the Burton Way median, surrounded by sculptures that our firm cleaned annually. Our love was a quiet undercurrent, ballast that kept me appreciating what there was instead of what I thought was necessary. I relished his enigmatic manner, a force field of safety, especially because I could not push him around, no matter how hard I tried.

My firm soon embarked on the biggest project of my entire career—relocating a mosaic from the façade of Houston Methodist Hospital. I turned the management over to a pair of architectural conservators who worked for me—Kelly Ciociola and Christina Varvi, both trained conservators who oversaw our Miami and Los Angeles offices, respectively. These two women were a dream come true, but given my track record with staff, I hesitated to even think it. They were not only excellent practitioners, they were also eager to grow with the firm, to take on the constant juggling that comes with private practice, and they liked each other and treated each other as partners and colleagues.

Mosaics are composite artworks, made by close-setting small bits of stone, ceramics, or glass—called tesserae—in a bed of plaster, mortar, or, in modern times, concrete. No one tessera in a mosaic is of critical importance. But every piece comprises the visual narrative. Unlike smaller objects, or even large-scale sculptures that can move from place to place, mosaics are almost always intended to be site specific. They're like the opposite of immigrants—rooted firmly to walls and floors throughout the world, especially the ancient Mediterranean region.

In the bad old days when archaeologists would swoop into a country and pillage heritage objects with impunity, mosaics were habitually lifted from their ancient beddings, backed with concrete, and shipped off to European and American museums. That practice has now been abandoned except in cases of extreme danger—for example, the threat of a river being dammed or political violence. Instead, mosaics are conserved in situ and maintained by their host countries.

Modern mosaics, however, tend to be attached to buildings that might have fallen out of favor, or are about to be demolished, or have simply been altered so much that the artwork no longer has relevance in its location. At Houston Methodist Hospital, the 96-x-14-foot-long *Extending Arms of Christ* mosaic had been installed in 1963 over the main entrance, but later became hidden by a porte cochere and trees that blocked it from view. When a new building was added to the hospital, someone on the board thought they should consider moving the mosaic. Which is how we came to the project.

Projects of this magnitude require planning, inspections, and testing before protocols can be established. Before we could start, we needed to know how the mosaic was made, what held it in

place, the thickness of its concrete backing, whether it bonded directly to the building's exterior wall, and, most important, how would we put it back together when we took it apart. Kelly set off with a team to Houston to do the exploratory work. As chief technician, Ignacio should have been going with her, but he and I were headed to Havana to work on our first project in Cuba. Our client was the US State Department's Office of Cultural Heritage, the agency that manages the care of thousands of properties and artworks abroad. Though the department preferred to hire local conservators in host countries, no Cuban conservator was willing to endure the scrutiny of being on the US government payroll. Only my friend Javier, a professor of furniture conservation at the Instituto Superior de Arte, Cuba's national art schools, agreed to help us set down flaking paint on a chinoiserie buffet and dining chairs at the residence of the US ambassador.

One day during a lunch break in the garden, we happened to notice one of Havana's most infamous sculptures—the bronze eagle with spread wings that once stood atop a monument that commemorated the explosion and sinking of the USS *Maine* in 1898. Widely considered to have been self-imposed sabotage to allow the United States to enter what is known in Cuba as the War of Independence and in the United States as the Spanish–American War, the *Maine* monument was synonymous with US imperialism, and the eagle had been torn off the top by mobs during the 1959 revolution. Now the bronze bird glowered over ginger plants and bougainvillea, its wings outstretched over a fountain.

"The surface looks like shit," Ignacio noted, as he ran a finger through a soft and patchy wax coating. Having quickly become best buddies with the house manager, he found out that a

conservation firm from the United States had cleaned it several years earlier. "They probably used a wax that had too low a melting point," Ignacio said. "We can knock it out in an afternoon."

I LEFT IGNACIO AND JAVIER to finish setting the flaking paint and washing and waxing the eagle, then I headed to the Habana Riviera to meet an artist from Miami who had been commissioned to conserve his father's monumental concrete sculpture on the hotel's driveway. Though this iconic work should have been treated by a conservator, not an artist, I swallowed my professional pride and tried to offer helpful suggestions. I was wading in shallow water, wetting my feet, knowing that this artist had a direct line to the new developers of the hotel, and the entire façade was covered in gradated shades of aqua mosaics that would soon need conservation.

I had had my eye on Havana's 1940s and 1950s mosaics for a long time. There are dozens of these around the city, but by far the best of all hung on the façade of the Habana Libre Hotel, a former Hilton located on a busy corner of Vedado. Titled *Las Frutas Cubanas,* the giant mosaic had been designed by a Cuban avant-garde artist named Amelia Peláez, whose coveted still-life paintings hung in museums both in Havana and Miami. Her masterwork, however, was in sorry condition, sporting holes, cracks, falling tesserae, and bulges that I'd taken pains to photograph from the hotel's pool deck. Several Cuban colleagues had told me that the entire work had been refabricated in 1997 by a Mexican firm, an astonishingly short period of time for such a large work of art, especially because it now continued to

deteriorate. I had also learned recently that the Commission on Historic Buildings had already contracted with an Italian firm to refabricate the work yet again, even though that made no sense until somebody figured out what was causing the repeated failure of the artwork.

This poor mural, installed in 1958 onto a Hilton that was financed by the culinary workers union pension fund and run by a consortium of shrewd American gamblers (investigators in New York linked the 1957 murder of mafioso Albert Anastasia to his attempts to muscle in on the Hilton's casino concession), seemed to me an emblem of everything that had gone wrong in Cuba since the days of Batista. Within a year of its opening, tesserae started falling from the 225-x-33-feet-long mosaic. Around that time, Castro marched into Havana and made the Hilton his headquarters, changing the name to Habana Libre (Free Habana). Year after year, the tesserae continued to detach, the result of too little adhesive and grout. In 1997, when the hotel was hastily remodeled (the new design was roundly hated by Cuban preservationists for having altered original interiors designed by the Los Angeles architect responsible for the cylindrical Capitol Records tower) and the mosaic was refabricated, no one had studied the wall to determine if there were underlying causes to the repeated failures. Now that the process was to start again, I could not help but wonder whether anyone had actually considered why the damage kept recurring.

Back home, things weren't looking good for work in Cuba. Though representatives of the Trump organization traveled to Cuba seeking investment opportunities just months before the 2016 election, as soon as he took office, Trump vowed to reverse Obama's advances and ban all business with the island and most

travel. I was growing too exhausted anyway. No matter how Dinorah insisted that business was where my talents lay, I was weary of the clients and the staff and everything that went with running a practice. Recently one of the trained conservators in our employ had had a meltdown at the studio, flinging a box of conservation paints across a room because someone had put them on her desk. Another technician was reported saying that he liked to get under his fellow workers' skins, to make them insecure on purpose. Even Ignacio was growing testy; he took issue with me because he was hit with a high tax bill on funds he withdrew from his pension to buy a house, as if I controlled the tax laws. When our bookkeeper tried explaining the rules to him, he acted like we were trying to dupe him.

"Fire them all!" my mother said. "You're too soft with your staff."

"I can't fire them all. We need to get the work done." I did fire the woman who threw the paints across the room.

"You're like your father, too nice. And look where it got him."

Not long after the 2017 inauguration, my father's abdominal aneurysm, which had been growing slowly for more than a decade, jumped two centimeters. I wouldn't go so far as to say it was caused by the election, but he had been consuming MSNBC voraciously, muttering about the country going down the tubes. Although he loathed Trump, he also railed against Bernie Sanders, whom he called "another Fidel Castro." I tried explaining why that parallel was incorrect, but my father's mind had funneled into a dark cavern of pessimism. "The problem with

a guy like Trump," he said, "is what comes after he gets over-thrown. Look what happened to us in Cuba. Because we toler-ated Batista, we got sixty years of Castro."

My dad headed to surgery. Certain of a horrible outcome, he begged us all, "Don't let them let me suffer!"

"Relax, Lindy! Nothing is going to happen!" said my mother irately.

She left the room to talk to the nurses. My father whispered urgently, "Those documents I wrote, don't show them to anyone, not even your brother."

I had forgotten to read them. They were tucked into folders on my desktop: *My Father Alberto (Hungarian Nickname) "Bumi";* *First Florida Sunshine Review to Deregulate Opticianry: My Memoirs; Jack Barnes: My First Employer in America.* Twenty pages of straightforward memories about my grandparents in Transylvania, Bumi's journey to Cuba, about kindly Jack Barnes and the Florida Board of Opticianry. There was nothing out of line within those documents, except a mention in one sentence that my father's parents warned him that my mother would make him miserable. Meanwhile, there she sat beside him for twelve hours a day, leaving only to go home for a shower or a nap, bring-ing back his favorite homemade chicken soup with plantains and malanga that she said "*levanta un muerto*" (could raise the dead) and stopping at the Cuban bakery for syrupy yellow sponge cake cones called *borrachitas* that he loved. Despite the nervous stom-ach that would send her running to the bathroom without warn-ing, she spent a week in a Naugahyde hospital armchair, hopping up to fluff his pillows, ringing for the nurses when he needed medication, trimming his beard and toenails, mopping his face

with a washcloth doused in his favorite cologne. Every nurse who walked into the room said, "What a devoted wife you have, Mr. Lowinger."

"Yeah," he'd say, rolling his eyes. But God forbid she should go home for a shower or a nap. He would not stop asking, "Where is she? What time is it? When is she coming back?"

A new healthcare aide came into the picture. Zenaida was from Cuba's Pinar del Rio Province, where they grow the world's best tobacco. Full of sly energy and salacious humor, Zenaida entertained my father with dirty jokes and stories about Cuban realities during the *Periodo especial*. When Hurricane Irma veered toward Miami, the three of them, plus Todd and I, stayed at the Miccosukee Casino & Resort in the Everglades to ride out the storm and celebrate my mother's eighty-fifth birthday. That night, September 8, 2017, with the wind howling outside, we had a drink at the bar (my mother scowled, muttering "drinks for the drunks") while waiting for our table. A cha-cha-cha began to play. My parents stood up, canes in hand, and began dancing. They had the old rhythm, the sexiness. They laughed hard and held each other. My heart melted with love for them, my two dented and scratched *viejitos*. Then the storm turned westward, which sent crowds from the Gulf Coast to the hotel. Stragglers stretched out on the lobby floors in sleeping bags, with dogs on leashes, cats in cages. The generators gave out and the air inside became fetid from cigarette smoke and cat piss. "This is awful! Who let all these people in! What are we going to do when we get home if there's no air-conditioners!" my mother cried.

It was no small concern; it was ninety-five degrees outside. But still.

We left at daybreak, driving twenty miles per hour through the flooded streets. I deposited my parents with my brother and headed to the studio.

AN EVEN BIGGER HURRICANE, Harvey, halted our installation of the Houston mosaic when our staff had to evacuate. The project had been rife with problems and delays. We couldn't use a crane because it would have blocked the entrance to the emergency room. The only way to get the sections down was with a gantry, which meant that pieces had to be less than four hundred pounds, resulting in ninety-six sections, far more destruction than we had intended. Our repairs looked good, but they were taking twice as long as we'd expected. The staff was exhausted. Ignacio complained about having to wear a heavy double harness the contractor insisted upon.

I was tired also. Though Kelly and Christina were entirely managing the Houston project, and now Christina was handling the refabrication of tesserae for the 1940s four-story tubular sheath of gold tesserae that graced the facade of a shuttered department store at the corner of Wilshire and Fairfax Boulevards that was being transformed into the Academy Museum of Motion Pictures, during those same years I'd been traveling non-stop. I went to Maui to repatinate a giant bronze Buddha, to Seattle to clean a federal building paint-bombed by protesters, to Spokane, Washington, to fix a mosaic floor in a 1906 post office in subzero weather at night, to Tucson for a sculpture survey, and, of course, Miami every four to six weeks to check on the practice there, visit my parents, and help Kelly conduct graffiti cleaning

tests at the Marine Stadium, the astonishingly daring Cuban building that remained preposterously in danger of the wrecking ball. The stadium, a modern wonder, sculpture as architecture, with a living architect who reminded me of what my father might have been like had he been allowed to follow his dreams, sometimes kept me up at night. I worried for its future, which was in the hands of politicians who refused to see that it was not only an architectural marvel, but the imprint of an immigrant community on a region of this country. When I walked along its concrete ramps, I wanted to be nowhere else but here, Miami, in view of its aqua watercourse shaped like the Circus Maximus. But I did not live in Miami; I lived in Los Angeles, a stone's throw from a gold mosaic that was equally marvelous. I could not wrap my mind around the fact that I was now almost sixty years old, and no place felt like home for me. Maybe that's why I was always on the move. Or maybe I was just too ambitious for my own good.

I was in Tucson one spring evening, having just given a lecture on the maintenance of the city's public art collection, when the phone rang. My mother calmly said: "Your father had a heart attack. He's in the hospital." I changed my ticket, drove to Phoenix the following morning, and flew to Miami. My brother and sister-in-law canceled a twenty-fifth-anniversary trip.

My father had a stent put in, but he suffered a second heart attack and bled internally. "Don't let me suffer!" he cried each time his painkillers wore off. Kidney failure, a dialysis fiasco. Lungs and heart affected by too many cigarettes, too many sorrows.

My mother sat beside him fourteen hours a day, hounding and cajoling him. "Think positive, Lindy!"

Tanked up on morphine, my father pointed to a little blue light on a piece of equipment and said, "That machine knows that you and I don't get along." Everyone laughed, but I could tell my mother was stung by the joke. She had been doing everything she could to combat his indifference to life. What a waste of love, I thought. Their marriage was as contentious as any I had ever seen, but they clung to each other like tesserae locked onto a wall.

"I am afraid to be alone," my mother whispered to me while he slept.

Three days into this crisis, Zenaida took my mother home to shower. My father woke up suddenly and made eye contact with me. Frantically, he tried to pull off his oxygen mask. The weekend caretaker, an Ecuadorian named Nancy, and I both heard him yelling, "*Fruta, fruta!*"

"What is it, Papi?"

"*Fruta, fruta!*" he insisted.

"Do you want some fruit? Are you hungry?" I asked, Amelia's mosaic *La Fruta Cubana* coming to mind.

"He's saying *disfruta*, not *fruta*," Nancy said.

I looked at him, nodding agitatedly. His eyes seeped tears. "*Fruta, fruta!*" he cried again, his last words to me.

Disfruta means "enjoy."

Chapter Fifteen

PAINT

Beyond the velvet mountains, Los Angeles emerges in a jewel-like sparkle of ruby freeway lights, emerald tennis courts, and sapphire swimming pools. I press my nose against the airplane window, gazing at the pale ribbon of light that hangs over the miles of twinkling habitation in a land once sparsely punctuated by the earthen structures, bullrush huts, and willow reed constructions of the Gabrielino, Tongva, and Chumash peoples. I am flying in from Mexico City, where I went to an art fair called Zona Maco. A week ago, I was home at my apartment in Miami. I have come to terms with living in two places, along two oceans, swimming in the Atlantic and hiking in the Santa Monica Mountains. Here 40 percent, there 40 percent, and 20 percent everywhere else, as I tell people when they ask me how I manage my time.

The engines of the Boeing 777 wheeze as we descend over a dark brushstroke of oil fields. A massive, half-built, quartz-white

football stadium appears below us. As we brace for landing, I remember that I have to finish writing a maintenance plan for the stadium's sculpture park. The next fair, Frieze Los Angeles, is just two weeks away. We need to clear space on the schedule, prepare kits of materials so we can be ready to rush off to fix what gets broken. Shit happens at art fairs. Items get bumped, scratched, smudged, and our collectors regularly ask us to inspect the condition of pieces they're considering for purchase. I like to sleuth around the booths and see what's being hyped, what artists and trends are hot. I'm a subversive prowler, asking questions surreptitiously wherever people do not recognize me, cataloging claims of magic coatings, gleaming surfaces that "don't need maintenance," tarnish that's "supposed to happen," plastics that will never crack or yellow unless they're "displayed in direct sunlight." I know I sound cynical, but it's mostly tongue in cheek. Contemporary art can be a chimera, full of bombast, but I am always struck in the heart by at least one item at these art fair paloozas. The chattering crowds go silent. *What would it take to repair this?* floats through my mind, but I let that thought go and focus, instead, on the magic of a moment where a visual art object takes me into its thrall.

The plane touches down. I switch my phone on and call my mother. It's almost midnight in Miami. "*Hola*, Mami. We just landed. You can go to sleep now."

She yawns and sighs. "Sleep? What sleep? I was awake all night last night."

My mother pours out the sorrows of her widowhood as we taxi to the gate. It's been eight months since we buried my father. She spends each day with Nancy, her caretaker, visits friends, and goes to the beauty parlor and to play mah-jongg. At night she

wanders her apartment, crying, feeling scared and lonely. I call her every evening between eight and nine o'clock Eastern time. She tells me all of her stomach ailments, how she got into a vicious argument with the board president of her condo over the decoration of the lobby. She is "done with" La Colonia because almost no one came to my father's funeral. I've tried explaining that we messed up the announcement in the paper, that even Zenaida, the Cuban caretaker who was once my father's favorite, did not hear of it in time.

"Zenaida! Who can believe a word she says. She called to give me her condolence and all she did was go on and on about Cuba. As if I cared. Cuba, Cuba, Cuba! I never got a chance to go back when your father was alive. Now I'll never see my mother's grave."

As it so happens, just a few weeks before I went to Mexico City, I was in Havana with a small group of preservation architects. We stayed in a privately owned hotel, as is now required by US law. Flights are down to one or two a day. Cubans can send only the smallest remittances to their families. Our group was not allowed to spend money in hotels and restaurants owned by the Cuban military, which made no sense considering that Cuba is a country where the military *is* the government.

During the visit, I noticed that the Amelia Peláez mosaic was covered by a scrim printed with its exact design, in preparation for refabrication by the Italians. In the company of a conservator named Anita who was one of Eusebio Leal's closest confidantes, I visited the Historian at his Vedado home. He was frail from battling cancer, but glad to see me. He offered me coffee, which

Anita brewed. Though Leal was never known as a devotee of modern era buildings, I figured he might know what was happening with the prominent mosaic, but he seemed in no mood to talk about difficulties. His voice was reedy and dark circles ringed his eyes. Realizing that I might be seeing him for the last time, I offered, "Eusebio, many Cubans on both sides of the Straits of Florida will continue fighting the good fight you dedicated your life to."

He smiled, noting the flourish of my language, which echoed his own oratory predilections. "We're at a critical point, Rosita," he said.

He is right; deferred maintenance has taken its irreparable toll, especially on concrete structures. When people now say, "I want to see Cuba before it changes," my mind fills with terrible scenarios of bulldozers and wrecking balls.

"Stop already with the worry about Cuban buildings!" scoffs my mother one day when she's feeling especially angry that I don't live nearby. She unleashes a diatribe about what *really* matters in the world: "Having enough to eat, a roof over your head, your family nearby! I. Am. Alone!" It's hard to argue with that sentiment, but buildings whose materials tell the story of a country and a hemisphere matter also. Of course, saving our planet is more urgent now than anything. However, study after study on building preservation shows that renovation is much more environmentally sound than demolition and reconstruction. As Carl Elefante, former president of the American Institute of Architects, famously said, "The greenest building is the one that already exists."

My FATHER'S LAST WORDS often float into my head. I need to *disfrutar*, enjoy life. I've asked Kelly, Christina, and Ignacio to take over our practice. They can buy me out slowly, over time, without a penny out of pocket. To me, it's a no-brainer. We're a thriving business, with an international reputation. They could work for themselves, never have to worry about being fired or laid off. But they don't see it that way. "I want to practice conservation, not manage people," says Christina sheepishly. Kelly is more blunt. "I need a better work/life balance as it is." Ignacio claims he's interested, but he has bought a house in Homestead, an hour and a half south of the office, and he's always leaving work early to beat the traffic. The business is clearly not what's on his mind.

In September 2019, I was approached by a Canadian restoration contractor about buying me out. I've been seriously considering the offer, though it makes me sad to see it go this way. But I'm ready to move on. I've been in private practice for thirty-five years, with this last iteration now more than a decade old. According to both JPMorgan Chase & Co. and the Bureau of Labor Statistics, more than 50 percent of US-based small businesses last only five years; I've beaten those odds a few times. No entrepreneur wants to close their doors and leave two dozen people unemployed, but if no one wants to take over, maybe it's time to say *hasta la vista* and throw in the towel.

Like Zona Maco, Frieze Los Angeles is packed with art collectors from around the world. It's February 14, 2020, and half a dozen California counties have declared health emergencies due to a novel virus. Cruise ships are stranded at sea due to outbreaks (confirming my aversion to the very thought of being packed at

sea with thousands of others). You wouldn't know any of this is happening from the throngs at Paramount Studios, where the fair is held amid the false frontages of the back lot. Everyone is shoulder to shoulder on the VIP opening morning, gawking at the art and at one another, sipping champagne and trying to make small talk with a museum director, influencer, or celebrity. People are not kissing each other as much as usual, but I welcome that, since I'm always getting colds at art fairs.

Three weeks later, I head to a private Santa Barbara residence to work on painted outdoor sculptures by Mark di Suvero, Tony Smith, and Yayoi Kusama. The Kusama only needs a surface cleaning. The di Suvero is faded, but the paint is thick enough that we can compound the surface to remove the chalking and get another few years out of the coating. The Tony Smith has been repainted several times and looks waxy and lumpy, which means it will need repainting, a difficult thing to do on-site.

Whenever I work on painted outdoor sculptures, I remember a joke my father used to tell about a new Cuban immigrant who is walking around Miami, looking for work. The man starts up a street where he sees "*un americano*" sitting in front of his house. *El cubano* asks the guy for a job and *el americano* says, "Sure, go out back and paint my back porch." Eager and grateful, *el cubano* grabs the can of paint and heads back to do as asked. An hour later he returns and says, "I'm finished."

The American is incredulous. "So fast?"

"*Si*," proclaims the Cuban proudly. "But just so you know, it's not a porch. It's a Ferrari."

My dad's joke is about an immigrant's misunderstanding of a word. But what makes it funny is the idea of using a water-based house paint on a precision sports car. Similarly, outdoor sculpture

requires specific industrial coatings that are *not* automotive coatings, even though many people think they are the same thing. But car paints are almost always clear and glossy, whereas painted outdoor sculptures can be matte, like the Tony Smith, or semi-glossy like the di Suvero, and the surface can be smoothly spray-painted, brushed, applied with a textured roller, or topped with a clear coating, like the Kusama. Conservators have to know the aesthetic the artist wanted and what materials and methods will get us there before embarking on a treatment. Though sculptures are best painted indoors in a spray booth, it's not always feasible or cost effective to move a giant artwork to a studio. On the other hand, when you paint a sculpture on-site, you're beholden to the weather, which can't be too hot, too cold, or too humid, and there can't be any rain at all or wind that will blow dirt and insects onto the coating. Painting a work outdoors is the ultimate balancing act.

On Monday morning, March 9, 2020, everything in Santa Barbara is ticking along perfectly. The weather is cool and dry, the paint arrived on time, the compressor is humming without sputtering. Normal life is sliding toward a precipice, but everything we do to clean the Kusama, compound the di Suvero, and strip and paint the Tony Smith works like magic. On March 12, what would have been my parents' sixty-second anniversary, we spray the final topcoat on the Tony Smith. During my evening phone call to my mother, she tells me, "The world is going into lockdown!"

Todd spends the evening glued to the television. The two Democratic presidential contenders have held press conferences about what is now called a global pandemic. In the middle of the night, I wake up coughing, my chest tight with asthma. I'm

afraid. Todd assures me that I'm most likely having a psychoso-matic reaction to the news cycle. We head home to Los Angeles.

The world changes on a dime. We pay people for three weeks of work, then furlough half the staff, and lay off all the others. We assure everyone that we'll bring them back to work as quickly as possible. It feels like failure anyway. I lay awake at night, coughing. We ship our reserves of N-95 masks and gloves to local hospitals. I don't get very sick. Todd doesn't catch anything. The case numbers climb. Todd's son, a medical resident, is mobilized to the ER. Nancy fills my mother's hall closet with toilet paper and Lysol. My cough disappears after three weeks. People are scared to breathe.

In May, a man's breath is taken from his body by a knee, not a virus. The world watches in horror as George Floyd strug-gles on the ground in Minneapolis, begging for his life, for Mama. The eyes of the policeman who pins his neck against the concrete are as cold as marble.

"I can't breathe," says Floyd as he is suffocated by an officer of the law.

These last words were coined in 2014 by Eric Garner, an African American man choked to death by police for selling sin-gle cigarettes in Staten Island. And echoed by Javier Ambler II, a forty-year-old African American tasered to death at a traffic stop in Tacoma, Washington. Breonna Taylor, an African American medical technician gunned down in her Louisville bed by cops the day the world went into COVID-19 lockdown, did not have time to make a similar plea.

The world is coming apart. Corrosion lies beneath the surface of our everyday activities. There is no mystery here. No need for diagnostics. The evidence is as obvious as the reason paint fades in sunlight. Racism. It's in the air we breathe, like mold. It's like salt in the coastal wind, unseen by some of us; felt radically and daily by those whom it impacts directly.

From the safety of my Los Angeles living room, aware that as a white Cuban immigrant I am unlikely to ever deal with being shot in bed or have my treasured son tasered and choked to death for a traffic violation, I watch the world erupt. Led by the cry of "Black Lives Matter," Americans take to the streets to topple, tag, and damage sculptures that glorify oppression and the racist past. It starts with monuments to the Confederacy. Across the South, these heinous bronzes, installed during the Jim Crow era for the express purpose of degrading and threatening people of color, are yanked down by ropes, torn off of pedestals, tagged from top to bottom. Attention soon shifts toward monuments whose depictions of Black, indigenous, and people of color are demeaning, and those that commemorate slave traders and Spanish conquistadors. Statues of Christopher Columbus, whose arrival in Cuba on October 27, 1492, initiated the systematic brutalization of the continent's First Nations and peoples, are splattered with red paint to protest their glorification of genocide. In California, bronzes of Father Junipero Serra, a Spanish Franciscan priest who founded the Spanish Mission system in the mid-1700s and was known to have presided over the torture and enslavement of native Californians (despite this, he was beatified by Pope John Paul II in 1988 and canonized in 2015 by Pope Francis), are beheaded or removed in ritualistic ceremonies complete with chanting in indigenous languages.

WHEN THE FIRST CALLS COME IN about vandalized public art, our team gathers over Zoom to decide what we want to do. Under the rules of the lockdown, maintenance and outdoor landscaping businesses are allowed to remain open, and conservation of outdoor works falls into several of these categories.

One of us says, "I don't want to remove graffiti from offensive sculptures."

We can easily agree to that. Anyway, our studios are in Los Angeles and Miami, where there are few, if any, Confederate monuments and most sculptures we work on are abstract.

"What about a 'Black Lives Matter' tag?" someone else asks.

This is a tough call. Who wants to erase that critically urgent phrase? On the other hand, isn't our job to protect artworks and serve our clients? (Sounds like the police's job.)

"We'll cross that bridge when we have to," I say.

Fortunately, the sculptures we are called to clean in Los Angeles, Miami Beach, and Beverly Hills are tagged only with obscenities, not "Black Lives Matter." But what would we have done had it been different? What is our role as conservators in this urgent moment? Dialogues erupt on the American Institute for Conservation community message boards over our profession's statement on Confederate statues, on cultural appropriation, on repatriating stolen artworks, the overwhelming whiteness of most conservation studios, the culture of internships that makes it hard for people without money to meet the requirements to get into graduate school. To some, these are more urgent matters than grappling with certification. To me, they're both

necessary. But then, I am in my sunset years as a professional—
the past, not the future, of our field.

MAY 2020 IS THE FIRST ANNIVERSARY of my father's death,
what Jews refer to as his *yahrzeit*. My mother and brother mask
up and head to the cemetery to say the Kaddish at his newly
placed headstone. My brother sends me pictures of the inscrip-
tion on the granite: There's a pair of eyeglasses and the phrase
"*Siempre con una sonrisa*" (always smiling). It isn't quite a true
description of my father's countenance, but he loved to tell jokes
and laugh. I sat with him after retirement, listening to his
drug-fueled recollections of his youth in Camagüey, and how
later he pored through architecture magazines looking for a
design to copy. The thing about him that sticks with me the most
was his capacity to love. He burned with love; it tethered him to
us. Had he walked out on our family, I am certain I would never
have gone off to college or found my way to conservation. One
evening on the phone, I say something along those lines to my
mother.

"Walk out on *me*? Are you nuts?" There is a strange ring to that
statement.

"What? Anyone can walk out on a marriage," I say.

She falters, then says, "Trust me, that was never going to
happen. But it doesn't matter. He left me anyway and now I'm
alone."

THE LOCKDOWN GRINDS INTO my mother's innards. She relives her early years of being abandoned. She'll say, *This is worse than when I lived at the orphanage. At least there I wasn't alone.* The venal condo board president ups the ante in their quarrel, purposely refusing to repair the elevator on her side of the building, or wear a mask in the lobby. When she lodges a formal complaint, he screams at her in public, an eighty-seven-year-old widow. Surrounded by such rancor, and alone at night, my mother's stomach cramps. Our phone calls become catalogs of overflowing toilet bowls, diapers that don't hold her excrement, and not being able to make it in time to the bathroom. Masked and wearing latex gloves, she visits one gastroenterologist after another, certain she has colon cancer, but all tests for cancer, colitis, Crohn's, and celiac disease are negative. She takes a pill for a blood condition that might be the culprit.

"Try eating a gluten-free diet," I suggest.

My mother detonates: "I! Don't! Have! Gluten! Allergies! You think you always have the answers. You and your brother don't know how hard I am struggling. I hate this building. You both are with someone. I. Am. Alone!"

I find myself grateful for the pandemic's isolation. It's like that so-called miracle coating for bronzes, shielding me from having to get on an airplane. Before the pandemic, I was visiting my mother and Miami studio every four weeks. Why, one might ask. Because she is a cracked mosaic, a marble with iron inclusions, a ceramic whose glaze does not bond well to the substrate. An object of sublime beauty and value fabricated with inherent vice. Distance has given me perspective. How she is, is not her fault.

It's not my fault either. But I have a tool kit of compassion and determination. I've spent years in therapy.

Is it my responsibility to mend her troubles?

Isn't that the question all of us are asking now about our nation? None of us is singly responsible for the state of world affairs, but everyone can take a bit of action.

In lockdown in Los Angeles, I spend a lot of time ruminating about how my career can serve as a path toward repair of the world. I want to repair on a global scale, like my colleagues at the Getty Conservation Institute, but I also just want to quit and *disfrutar*, as my father exhorted me to do. Let the next generation move us forward to the next level. I grow to love the lazy days of working from my couch, making notes, taking walks with Todd on leafy streets, where the air is clearer than usual because there are so few cars on the streets. My son and his girlfriend lock down in our guest house. We eat dinners outside, by the light of solar lanterns, aware that this is the new mark of privilege. It is a time to ponder differences between those who have and those who don't. My private clients are at one extreme of the equation, the moneyed plutocrats, the one-percenters. At the other end of the spectrum are the unhoused that crowd the streets of cities like Los Angeles, the day workers, those who pack groceries, deliver boxes to our houses. The pandemic is like a peeling coating that reveals a network of insect cavities. What can be done about this? What part of my work offers a fix?

Each evening, when I call my mother, I think about my makeshift prayer of being left with the one that's easiest to deal with. It's a rock to push uphill. I'm guilty, a bad daughter. She needs me but I'm like my grandfather Samuel, standing at the orphanage's gate, offering love but with strict boundaries that she can't

understand. Maybe all I can do is offer this love, insufficient though it is. *I don't forget, but I forgive.* Or *I can forgive only because I won't forget.*

IN EARLY SUMMER, our firm gets a PPP loan that allows us to bring everyone back to work. No one has been traveling except Christina, who gamely flies to Seattle to do mock-up cleaning tests on the limestone façade of a federal courthouse. When I question this, she says: "We have no choice. It's government construction work, required." I worry for her safety. She assures me that airplanes and hotels are almost empty and that she orders room service, rents cars to avoid public transportation, and carries packs of Clorox wipes and masks.

Ignacio says, "Thanks for the offer, but I've decided to sit this out. Los Santos say that everything is just going to get worse."

I don't believe that this is just about his religion.

"Do you want to take a leave of absence?" I offer.

"Nah," he says. "Consider this my resignation."

"What happened? Are you angry? Did I do anything that upset you?"

He says no, but hesitates just enough that I know it isn't true. I prod, but he eludes my questions. I hear my mother: *Your employees are not your friends.* Maybe. But he *was* my cherished colleague. The way Robin was, before we grew apart. But the damage appears to be done. There's no way to fix what I don't understand

Four other staff members also decide not to come back to work. Our firm dwindles to sixteen employees. Work is picking

up again, especially outdoor sculpture. Christina and Kelly hunker down and craft elaborate schedules to keep a maximum of four people in our studios at a time. Everyone has to be masked and take their temperature before walking in the door. We write up policies for clients: We won't work where people are unmasked, we need social distance, access to a bathroom that is not used by other contractors. Like everyone, we're stabbing in the dark, trying to dodge what we don't comprehend.

WE ARE JUST GETTING USED TO these working conditions when I get a call about an arson fire at Mission San Gabriel Arcángel, a Roman Catholic church founded by the infamous Father Junipero Serra in 1771. A large adobe church that sits against the rugged San Gabriel Mountains in northern Los Angeles County, the mission was built by enslaved laborers from nearby Tongva villages and features capped buttresses, a soaring interior wooden ceiling, and an outdoor *campanario* with six bronze bells. In the early nineteenth century, the sanctuary was fitted with a painted wooden altarpiece, called a reredos, that holds sculptures of the Virgin Mary and Saints Gabriel, Dominic, Joachim, Francis, and Anthony.

It takes several days to get fire department approval to enter the building. When I do, I am hit by a wet acrid scent even behind my KN95 mask. The sanctuary's roof has collapsed. To get close to the reredos, I have to skirt a jumble of charred wood pews, terracotta shingles, and waterlogged canvas paintings. The walls are streaked with black rivulets, and smoky sunlight coming through the open roof provides the only illumination. A

contractor is already there, rigging the painted sculptures for removal. It would have been far better to wait for me to take a look, to have a conservator devise the best method for the rigging, but I get the urgency. Roof beams teeter overhead. The power of the rising flames is evident over the surface of the reredos: below the midpoint, the painted surfaces are merely covered in soot. Above, everything looks like it's been dipped in tar.

Destruction of this sort is nothing new for me. Haiti was far worse. But this was not a neutral act of nature. This was a slash of human anger, a burst of rage akin to Isis's destruction of ancient Palmyra. I suddenly feel stupid for thinking that vandalism was interesting or cool. Though it will turn out that the person who lit the fire was a lone wolf arsonist, with a history of clashes with the church, and not an activist protesting indigenous enslavement, it is mid-2020 when this happens, and therefore hard not to associate this blaze of anger with the cries of communities of color in the wake of George Floyd's murder. Something has to give. People are simply fed up with business as usual.

A torched house of worship is a terrible sight. You feel the broken prayers, the lingering smoky scent a vestige of the biblical scapegoat. I can't stop thinking about Kristallnacht, the bombing of the Cluj synagogue, the arson and shootings that African American churchgoers across our nation endure on a regular, alarming basis. One can argue back and forth about whether religion is good or bad, but I, for one, remember the graceful power of those shabbat dinners at the rabbi's daughter's house. That need for sacred solace and spiritual transcendence at a time when my family's world was upside down and my mother was terrifying. Call it childish, but I get the visceral impact of belief. It is part of our conservator's credo. We are a scientific profession, but

we are true believers in the possibility of repair. We face a deto-
nated Buddha, a slashed painting, or an Eva Hesse whose once
pliable plastic artworks have become dark and hard over time and
visualize redemption. We can't fix everything, but we approach
our work with hope. We hope, we look, and we repair.

THE SCULPTURES ARRIVE AT OUR studio in the fall. The fig-
ures that were on the lower registers yield to cleaning with vacu-
uming, dry sponges, water, and a simple solvent mix. The charred
surfaces of Gabriel, Francis, and Anthony are tougher to treat.
Like most mission churches, San Gabriel Arcángel had been
restored many times in the past, and the last time, in the early
1990s, the sculptures were overpainted with acrylics that melted
in the fire, fusing to the oil paint and gilding on the sculptures
that were situated on the upper registers. The only thing that
removes this blackened plasticity are solvent gels, part of a clean-
ing system developed in the 1980s by a brilliant conservation
scientist named Richard Wolbers, who was later convicted of
sexual assault, causing some conservators to refuse to use the cre-
ator's name to describe his system. But no matter what you call
them, the Wolbers gels are revolutionary game changers that
have allowed conservators to manage the potentially harmful
effects of strong cleaning agents by slowing them with weaker
solvents and extending their dwell times. Chris Stavroudis, a Los
Angeles colleague who is an expert in this modular cleaning sys-
tem, comes to our studio to help us mix a bespoke cleaning gel
that removes the char without touching the original surface. The
red and turquoise colors of San Gabriel's cloak emerge, the brown

and gilding of San Joaquim's garment. It is all science, but it feels like sorcery.

Like the char on the San Gabriel sculptures, my mother is also dissolving. Not in a good way. It's been six months since I've seen her—the longest hiatus since I had the Rome Prize. As her eighty-eighth birthday approaches, she says: "Every night I pray to God to take me, but he isn't listening. So, I've decided to take matters into my own hands."

"Don't start with the threats."

"I'm not threatening. I'm going to do it. And I don't mean killing myself, though I could if I felt like it by taking all of my pills at the same time, or stopping the ones that lower my platelets and get a stroke. No. What I've decided to do is move out of the Jockey Club. This building is going down the drain. Our seawall needs repair, but that fucking asshole board president, that elder abuser, who I plan to report—"

"Mami," I interrupt, "you can't move in the middle of a pandemic."

"Oh, yes, I can!" she says, her voice growing shrill. "Maybe *that* will kill me once and for all. And don't you worry. I can manage by myself. I can find a room and live there. I was born poor and I don't mind being poor again."

Case numbers, hospitalizations, and deaths are rising every day. Florida is a disaster. I don't want to get on a plane.

"Nancy is helping me clean out the drawers and closets. I've started throwing out papers, letters—"

"Mami, please, please don't throw anything out before I see it."

"If you want them so much, come and get them."

GLASS

s far back as I can remember, my mother has had a cut crystal candy basket on her coffee table. Filled with individually wrapped caramels and Hershey's miniature chocolates, it is a fragile, gaudy object with a useless handle, the last thing I would imagine someone bringing when fleeing their country. But the basket had been a wedding present from her step-uncle Morris, the diamond cutter, so my mother brought it with her from Cuba.

When I was eight years old, I almost knocked that candy basket to the floor while dancing around our living room. Miraculously, it skidded only to the edge of the table, some angel watching over me. My mother went nuts anyway, predictably screaming, telling me I was careless and stupid, and all the rest that went along with that. She forgot about it quickly and went about her business. Small tornado, all things considered. I can

only imagine the explosion of both shards and fury had that candy basket hit the terrazzo floor. The glass would have sledded into every corner of the room. My mother would have been mopping splinters up for days, lashing out at me every time she found another one stuck to the bottom of her slippers.

I dread having to mend broken glass. I'm not alone in this among conservators. Glass fights back, the slick fragments repeatedly slipping out of alignment while the slow catalyzing epoxy that we prefer dries. Unless the glass is opaque, or within the matrix of a mosaic, joins are hardly ever invisible. It's practically a magic trick to get the color mixed correctly into a fill. A chip on the rim of a vase? That is the bane of the objects conservators' existence. I'm always in awe of those colleagues who are good at glass repairs.

The crystal candy basket now sits on the coffee table of my mother's new apartment in a vibrant senior independent living facility in her beloved Aventura. We toured it when I flew down to Miami for her eighty-eighth birthday, smack dab in the middle of the pandemic. "The salespeople from the place are calling me constantly," she told me. "They're offering a free lunch, no commitments."

The clever marketing ploy worked. After a lunch of pasta and salmon salad, a perky sales associate handed me a glossy pitch book. I looked it over, did the math.

"We can't afford this," muttered my mother, hope nonetheless vibrating in her voice.

I said, "Let's see," and conferred with Todd, my brother, and my sister-in-law. Two days after Christmas, in the year when people were scared to leave their homes to go to the supermarket, my mother moved into a renovated one-bedroom a stone's throw

from the Aventura mall and with a view of the golf course—the two landmarks of the town she loves to call home.

I was unable to return for the move. Rather, I was unwilling to get back on a plane a second time during the height of the pandemic. This, coupled with the fact that my brother and I insisted that she give up her car, led to repeated bouts of crying and shouting, "You don't control me! I can still drive! I am not too old; I don't even want to go there anymore!" in the days leading up to the move. To be fair, neither my brother nor I really took into account that losing the freedom to drive is a difficult milestone in the last decades of one's life, but ultimately my mother was willing to trade the car in for mah-jongg games galore, senior yoga twice a week, concerts every Thursday night, shabbat services streamed directly from the Aventura Jewish center, and a posse of widows to sit with at dinner—"We don't mingle with the couples, because the wives always think you're after their husbands," as she tells me.

Now ninety-one years old, my mother is popular among her new friends. She has managed to avoid the scorched-earth quarrels that were once her trademark. She is careful not to talk about politics except with residents she identifies as non-Republican, and, of course, with my father, whose photos she addresses every night, alternately admonishing him for dying and leaving her alone, and begging him for forgiveness: "I shouldn't have been so hard on you. You were good, so good to me. I just couldn't control myself," she tells me that she says to him.

My mother never says that to me. She doesn't have to. I try to keep things light between us. I've done the repair work on my own, using the tools she and my father let me discover when they did not get in my way of leaving them. I guess my prayers have

been answered. I've been left with the one that has allowed me to mend the fraught past of our family. The joins are visible, but that's the way I want them to remain, like Japanese *kintsugi* or mended archaeological ceramics.

Her mind is razor sharp. She regales me with stories about scammers targeting the elderly, and how recently a hospital collections agency called her about bills related to my father's last hospital stay. After ascertaining that only he was responsible for payment, she told them, "He and I don't live together anymore; his new address is . . ." and she gave them the name of the cemetery, section, and plot number where my father is buried.

Every now and again my mother asks me, "How's your book going?" She knows I'm writing this because I've spent many evenings recording her stories. Some days she calls me out of the blue with a memory she thinks might be useful to me. Yet, I'm still wondering how to present this in a way that will let her see it for the gift I intend it to be. Love injected beneath flaking surface paint, discolored old joins pulled out, the fragments realigned. I can't reverse all of our family's damage, any more than any of us can, but as Primo Levi wrote of his harrowing life experiences, "Paradoxically, my baggage of atrocious memories became a wealth, a seed; it seemed to me that, by writing, I was growing like a plant."

Growing means accepting, not forgetting. Once, when I sounded impatient on the phone with her, she said: "I know what you really think of me. I've still got that letter."

The "letter" is the poison pen missive I wrote her and my father after I lost my twins.

"Come on, Mami, that was years ago. Get rid of it."

"That's a good one, coming from you, who wouldn't let me throw anything out. You spend your life restoring antiques."

Try as I might, I can never get my mother to understand that conservation is not about repairing what is old. It's about sustaining all fabric of human endeavor, what people treasure, where we live, and what we honor, no matter when it was made. The documents I rescued from her lockdown cleaning frenzy held a treasure trove of information. My grandfather Samuel's naturalization document when he arrived in Havana. Alberto and Blanca's marriage license in Santiago de Cuba. Letters from my grandparents that told of how they'd traded their apartment in Vedado for a beach house in seaside Guanabo, photos of my father and his brother arm in arm in front of the Capitolio, stacks of sepia images of Slavic-looking Jews with Hungarian inscriptions on the back and cards jotted with chess moves from my Uncle Felix's friend Fernando, finishing a game they were playing when Felix abruptly left. Also, my father's bank book, with his five- and ten-dollar deposits noted in his architect's handwriting, and a palm-sized Spanish-English dictionary in which my grandfather Alberto transliterated English words in ballpoint pen to help him learn the new, guttural language of his second exile.

While I was poring through the documents, my mother left the room. She came back with a coconut shell wrapped in cotton and gauze. "I had this made when your father was having his affair with Felix's girlfriend," she said proudly.

"By a santera?" I asked, alarmed. Such *trabajos* are considered potent and dangerous.

"Absolutely," she said defiantly. "You're not the only one who knows about the santos!"

She offered it to me, but I refused to even touch it. All the other items and letters I sorted and stored in archival sleeves and boxes. Everything except my father's orange hammer. That sits in my glove compartment, in case I accidentally drive into a canal.

IN MAY 2020, a week after the anniversary of my father's death, Linda went into the hospital in Philadelphia. She had been having memory loss. A brain tumor was found on her pituitary gland. I called the day before the emergency surgery. "It's not malignant," she said nonchalantly. "The doctors say it should be easy to remove."

It wasn't.

That day, the last time that we spoke, Linda asked after my mother. She often told me I was lucky to be making peace with my parents. She had penned an essay for the Jewish *Forward* titled "Seeking Forgiveness" that is full of regrets and self-recrimination at her own inability to do the same before her parents died. The essay is also an exhortation to act in the name of restoration, even when you don't feel the feelings. In other words, sometimes we need to do the right thing even if it doesn't totally make sense to us or others. We repair and make reparations by taking the risk of going past our own immediate emotions. Acting is its own salvation. You take the harsh decision or material, blend it into a gel, and watch the magic happen. The content of this book is like one of those solvent gels. That's my hope, anyway.

THE WORK OF ART CONSERVATORS is at a crossroads. Young professionals are clamoring for different modes of practice, to raise our equity and inclusion as much as our profile. The future will bring inconceivable challenges. Collections in the path of ferocious wildfires. Coastal sites engulfed by oceans. Senseless wars with their accompanying gratuitous cultural destruction. And now works threatened by climate activists throwing soup and gluing themselves to artworks. But who can really blame these young people? The planet's temperature is rising and we are sipping champagne in the Paramount studios back lot. Meanwhile, the limestone of the US Capitol has been scuffed and gouged by a mob egged on by a sitting president, the paintings and marble sculptures in the Rotunda doused with tear gas. Cuba remains in the choke hold of a repressive hard-line government that will not yield to change, and the US government clings to the embargo. In response, 250,000 Cubans, a number that comprises 2 percent of the island's population, left the country in 2022—a number bigger than the Mariel boatlift and the Balseros Crisis combined.

It's hard not to be pessimistic. But if conservation has taught me anything, it's that damage is a prelude to redemption. You can't repair what has never been broken. The key is to be mindful of decay before the glaze is completely lost, before the bones turn to powder in the sun. When glass breaks, it does so violently, leaving jagged shards that never quite go back together perfectly. But most other deterioration is gradual and unobservable, unless you're paying attention. That's the key, paying attention. Conservators know that it's better to keep that Lalique vase secured with sticky

wax so it won't topple, but at a human level this is tricky business. As Elizabeth Spelman writes, "To think about repair requires us to recognize our own failures and imperfections and those of the world we live in. . . . It means attending to properties in things . . . and capacities in individuals."

IN THE LAST DAYS OF 2021, as I was getting ready to close the deal with the Canadian firm, three members of our staff, led by Christina Varvi and Nelson Hallonquist, asked me to reconsider. Exhausted by the pandemic and the hemorrhaging of staff, Kelly had already left us to become Vizcaya's in-house conservator. Christina said to me, "If you'll stick around and help us through the first few years, we can keep this going."

So, here I sit, at long last someone's employee. Treating artworks, but knowing that the best use of my time is to pass along as much knowledge as I can and then get out of the way. My demons are dwindling alongside my mother's, and I recognize that her amazing strength lives within me also. I still call her every night and spend a third of my time in Miami. I buck the monstrous traffic up to Aventura and take her to the mall or to the nearby jewelry exchange where she gawks at the giant diamond rings and occasionally sells a pair of earrings she no longer wears. We eat at bagel joints and Cuban restaurants, but mostly at home, where her aide Nancy helps her cook me chicken, picadillo, rice, and stewed plantains. Still beautiful and put together, her hair crimson red, her nails perfectly French manicured, her sweat suits and her slip-on sneakers color-matched, my mother never lets me forget that a woman needs to take care of her

appearance. "Restoration starts at home, with your nails, your clothes, making sure your hair has a nice cut and color. I only say this because I want the best for you. That's all I've ever cared about, you know."

I believe that she feels this from the bottom of her heart. And I have tried to avoid a similar "I couldn't help it" fallback in my own life—have tried to learn from the many mistakes I made— but it would be impossible to know whether or not this has had anything to do with my finding peace about most of my past while she remains haunted. And yet, for a haunted woman, Hilda Peresechensky has, in the end, not lacked for love. Amulet or not, my father devoted himself to her. Now that he's gone, my brother and I try to fill the gap as best as possible.

"What does God want from me?" my mother regularly asks. "I'm ninety-one years old! The oldest person who ever lived in my family. Enough is enough."

I shrug, feigning a nonchalance we both know I don't possess, and reach for a caramel in the crystal candy basket. Garish as Graceland, that thing should go straight to an estate sale, when the time comes. But that won't happen. It's destined to go home with me and live on a shelf, if not on a coffee table. If I accidentally knock it over dancing, I'll know what to do with the shards.

ACKNOWLEDGMENTS

The active writing of this book began in 2020, when the world appeared frightening and broken in so many ways, but this story of repair has been coming together for decades. I owe thanks to many people, first and foremost my parents for their courage, resilience, fierce, if sometimes fraught love, humor, and acceptance that I had to exile myself from their lives in order to find my own path in the world. My mother's willingness to divulge things that people tend to keep secret, even knowing that it might be difficult to see them in print, defines her bigheartedness. She is truly one of a kind.

This is a love story to conservation, a profession that honors change over time and the beauty within damaged things. My earliest mentors, Lawrence Majewski, Virginia Greene, and Andrew Lins, taught me that humility is the root of our work. After four decades in practice, I have dozens of colleagues to thank, but my deepest gratitude goes to Christina Varvi and Nelson Hallonquist for recognizing that the great private practice we built together deserves a next chapter and to the entire staff of RLA Conservation, especially Pat Oblak, Lydia Garcia Puente, Anjelica Russell, Caroline Dickensheets, Elena Bowen, Sonia Jerez Fraj, and Salomé García for protecting my writing

time over the last year. Cherished colleagues Irena Calinescu, Kyle Normandin, and Sarah Nunberg invested their time and expertise to read the manuscript in its entirety, bolstering my confidence with their enthusiasm for the story. Longtime friends Michele Marincola, Paul Himmelstein, and Pamela Hatchfield supported my application for a Samuel H. Kress Foundation of the American Institute for Conservation Publication Fellowship. I am indebted also to Jeanne Marie Teutonico for her wise counsel and friendship, to Amy Green for beach walks and for suggesting that *Dwell Time* might make a good title for a book, and to John Fidler, Frank Matero, Abigail Mack, Glenn Wharton, Will Shank, Judith Levinson, Ellen Pearlstein, Julia Betancor, Isabel Rigol, Holly Hotchner, Nancy Odegaard, Kelly Ciociola, Paul Gaudette, Linnaea Dawson, Mary Jablonski, Suzanne Siano, Emily Macdonald-Korth, and the entire ArtCare Conservation family for years of camaraderie and inspiration.

I am honored that this book received a 2023 Kress Publication grant from the American Institute for Conservation and hope that I have done right by our field within its pages. To AIC and the Association for Preservation Technology, I give thanks for maintaining robust communities where us fixers of the material world gather to exchange ideas. To both organizations, as well as the Los Angeles Conservancy, the council of the Getty Conservation Institute, and dozens of museums around the country, I offer gratitude for choosing me to lead their travels to Cuba. I owe my understanding of Cuban architecture to the inimitable scholarship of my dear friend Eduardo Luis Rodriguez and the resources of the Wolfsonian Museum Library and the Cuban Heritage Collection at the University of Miami. I also thank the American Academy in Rome, where the idea for this

book first arose, and where I made friends who continue to be part of my creative community.

It feels like a minor miracle to have landed at Row House, a publisher whose values dovetail with this book's themes of repair and justice. I am grateful to Kristen McGuinness for urging me to write this proposal and helping shepherd the writing of the manuscript. To the Row House team: Rebekah Borucki, V. Ruiz, and Kelly Taylor, thank you for your unwavering commitment to writers whose voices might not otherwise be heard and for assigning me a dream editor, Gina Frangello, who shaped this narrative into one that focused, first and foremost, on restoring that most delicate of objects—the human heart.

Without my lifelong posse—my sister of the heart Carol Davis, who was the first reader of these pages; Roselyn Sands, who has been by my side since our crib days in Havana; and my sage high school accomplice Melodye Feldman—this book would not exist. To my dear Judy White, who pored through a draft and offered profound observations, Ruth Askren, who sustains me with friendship and painting sessions in her studio, and Dana Spiotta, whose steadfast encouragement of my writing has been a treasured gift since we met in Rome: thank you. *A mis sócios esenciales*—Alexandre Arrechea, Nereida Garcia Ferraz, Elizabeth Cerejido, Beatriz Bustamante, and Carolina Miranda—*mil gracias por ser mis conspiradores.* I also thank Elissa Zimmerman for spurring the growth needed to tackle the difficult family material, Barry Michels for teaching me to tussle with the lurking shadow, and Robert Bosnak for shredding my dreams into an engine of creativity. My wonderful writer's group, Christine Kerr and Daria Sommers, and our mentor, Marcia Bradley, offered ongoing support and excellent insights. I am also

beholden to Rabbi David Kasher of Ikar Los Angeles for conversations on Refu'ah; Linda Kriger and Hilario Candela, both of whom passed away suddenly while I began the writing, and whose spirits permeate these pages; Ruth Behar for decades of Cuban-Jewish creative fellowship; Wendy Kaplan, for her generosity and comments on chapters; Fred Brandfon, for his steadfast friendship; and Israel Sands, Misha Askren, Joel Marcus, Joel Hoffman, John Stuart, Lesley Elwood, Raquel Carreras, Vicki Gold Levi, Frank Luca, Nancy Benitez, Universo Garcia, Lucila Sosa, Ceferina Garcia, Nancy Cárdenas, Jason Lloyd Clement, Jorge Hernandez, JC Hidalgo, the Vives-Figueroas, the Freimans, the Storks, the Cutiños, the Kranises, Tracy Kramer, Darien Donner, Geo Darder, Vic and Tony, Ed Taheny, Darrell Couturier, Marlene Barrios, Nigel Sampson, and many, many others whose names may be escaping me but who have made a place for me in their hearts and homes.

This book is about family, and though my father, Lindy, uncles Felix and Enrique, and all five of my grandparents are long gone now, their intrepid spirits permeate these pages. To my wise and wisecracking brother, Steven, who became a dear friend against all odds, my sister-in-law, Kathleen, *sobrinos* Adam and Elaine Lowinger, cousins Sam and Marah Peresechensky, my son's partner, Felicia Folkes, godsons, Dan and Ezra Solway, and my Kessler-Shipp-Wiese adoptees, Bridget, Rene, Bryan, Mandy, Fenn, Remy, and Io, I offer all my love and appreciation.

Finally, and above all, there is my son, Ben, and husband, Todd. For everything you are, everything you do, for how you always see the best in me and fill my days with love and raucous joy—this book is for you.

BIBLIOGRAPHY

"Abstracts of Reports of the Immigration Commission, Vol II" (Washington Government Printing Office, 1911).

Ariza, Mario Alejandro. *Disposable City: Miami's Future on the Shores of Climate Catastrophe* (New York: Bold Type Books, 2020).

Augustin, Ed and Frances Robles. "Cuba is Depopulating: Largest Exodus Yet Threatens Country's Future," *New York Times*, December 10, 2022, https://www.nytimes.com/2022/12/10/world/americas/cuba-us-migration.html?searchResultPosition=1.

Barger, Michelle. "Thoughts on Replication and the Work of Eva Hesse," *Tate Papers* 8, https://www.tate.org.uk/research/tate-papers/08/thoughts-on-replication-and-the-work-of-eva-hesse, accessed June 20, 2022.

Bellis, Mary. "The History of Aerosol Spray Cans," *ThoughtCo*, August 28, 2020, thoughtco.com/history-of-aerosol-spray-cans-1991231.

Bouton, Katherine. "A Reporter at Large: The Dig at Cnidus." *New Yorker*, July 17, 1978.

Bowman, Bryan and Kathy Roberts Forde. "How slave labor built the state of Florida—decades after the Civil War," *Washington Post*, May 17, 2018.

Brandi, Cesare. *Teoria del Restauro* (Rome: Edizioni di storia e letteratura, 1963).

Cassman, Vicki and Nancy Odegaard, "Human Remains and the Conservator's Role," *Studies in Conservation* 49, no. 4 (2004): 271–82, doi: 10.1179/sic.2004.49.4.271.

Cassman, Vicki, Nancy Odegaard, and Joseph Powell, eds. *Human Remains: Guide for Museums and Academic Institutions* (Altamira Press, 2008).

Dayton, J.E. "The problem of tin in the ancient world (part 2)," in *The Problem of Early Tin*, eds. A. Giumlia-Mair and F. Lo Schiavo (Oxford: Archaeopress, 2003), 165–170.

Ferrer, Ada. *Cuba: An American History* (New York: Scribner, 2021).

Freinkel, Susan. *Plastic: A Toxic Love Story* (New York: Houghton Mifflin Harcourt, 2011).

Gálvez, William. *Camilo, señor de la vanguardia* (Editorial de Ciencias Sociales, 1988).

Gamboni, Dario. *The Destruction of Art: Iconoclasm and Vandalism since the French Revolution* (Reaktion Books, 1997).

Gardner, Howard and Lee S. Shulman. "The Professions in America Today: Crucial but Fragile," *Daedalus* 134, no. 3 (summer 2005): 13–18.

Gradwohl, David M., Joe B. Thomson, and Michael J. Perry. *Still Running: A Tribute to Maria Pearson, Yankton Sioux*, special issue of the *Journal of the Iowa Archeological Society* 52 (2005).

Hall, Lauren Reynolds. "Preemptive Strategies and Collaboration for Emergency Planning: Lessons Learned at Vizcaya in Miami," *APT BULLETIN: The Journal of Preservation Technology* 52 (2021): 2–3.

Hassan, Russell. *On Forgiveness* (independently published, 2020).

Johnson, J.S. "Consolidation of Archaeological Bone: A Conservation Perspective," *Journal of Field Archaeology* 21, no. 2 (1994): 221–33.

Kaufman, Burton I. and Scott Kaufman. *The Presidency of James Earl Carter, Jr.* (American Presidency Series, September 21, 2006).

Koob, S.P. "The use of Paraloid B-72 as an adhesive: its application for archaeological ceramics and other materials," *Studies in Conservation* 31 (1986): 7–14.

Kriger, Linda. "Seeking Forgiveness," *The Forward*, September 24, 2008, https://forward.com/news/14255/seeking-forgiveness-02569.

Lazzari, M. and D. Reggio. "What Fate for Plastics in Artworks? An Overview of Their Identification and Degradative Behaviour," *Polymers* 13 (2021): 883, https://doi.org/10.3390/polym13060883.

Levin, Jeffrey. "Preventive Conservation," the Getty Conservation Institute, https://www.getty.edu/conservation/publications_resources/newsletters/7_1/preventive.html.

Lippincott, Jonathan D. *Large Scale: Fabricating Sculpture in the 1960s and 1970s* (New York: Princeton Architectural Press, 2010).

Lowinger, Rosa. "In Defense of Decorative Finishes: Cuban Architectural Conservation in the Twenty-First Century," *Conservation Perspectives* (Getty Conservation Institute, fall 2017), https://www.getty.edu/conservation/publications_resources/newsletters/32_2/decorative_finishes.html.

Lowinger, Rosa. "In Haiti, Rescuing Art Amid the Rubble," WNYC.com, July 26, 2010, https://www.wnyc.org/story/88453-haiti-art/.

Lowinger, Rosa, Christina Varvi, and Kelly Ciociola. "Logistical Challenges in the Relocation of Monumental Modern Architectural Artworks," *Studies in Conservation* 65 (2020): 19–98, doi: 10.1080/00393630.2020.1780855, https://www.flgov.com/wp-content/uploads/orders/2020/EO_20-91-compressed.pdf.

Maekawa, Shin and Kristen Elert. *The Use of Oxygen-Free Environments in the Control of Museum Insect Pests* (Getty Conservation Institute, 2003).

Marincola, Michele and Lucretia Kargère. *The Conservation of Medieval Polychrome Wood Sculpture: History, Theory, Practice* (Getty Conservation Institute, 2020).

Miranda, Carolina. "Ysrael Seinuk: The Master Builder," *Time*, August 22, 2005.

"Over the Decades, American Public Generally Hasn't Welcome Refugees" (Pew Research Center, November 18, 2015), https://www.pewresearch.org/fact -tank/2015/11/19/u-s-public-seldom-has-welcomed-refugees-into-country/ft _15-11-18_refugeepublicopinion/.

Reyes, Paul. "Letter from Florida: Paradise Swamped: the boom and bust of the middle-class cream," *Harper's*, 39–40.

Rodriguez, Eduardo Luis. *The Havana Guide: Modern Architecture, 1925–1965*. Princeton, NJ: Princeton Architectural Press, 2000.

Scott, David. *Copper and Bronze in Art* (Los Angeles: Getty Publications, 2002).

Sease, Catherine. "The Case Against Using Soluble Nylon in Conservation Work," *Studies in Conservation* 26, no. 3 (1981): 102–10.

Smith, Abby. "What Can We Afford to Lose?" *Journal of Library Administration* 38 (2003): 3–4, 175–82.

Stavroudis, Chris and Sharon Blank. "Solvents and Sensibility," *Western Association of Art Conservators Newsletter* 11, no. 2 (May 1989): 2–10, https:// cool.culturalheritage.org/waac/wn/wn11/wn11-2/wn11-202.html.

Stevens, Elizabeth. "An Archeological Find Named Iris Love," *New York Times*, March 7, 1971, https://www.nytimes.com/1971/03/07/archives/an -archeological-find-named-iris-love-archeological-find.html.

Teutonico, Jeanne Marie, ed. *Architectural Ceramics. Their History, Manufacture, and Conservation* (London: James & James, 1996).

Teutonico, Jeanne Marie, Leslie Friedman, Aïcha Ben Abed, and Roberto Nardi. *The Conservation and Presentation of Mosaics: At What Cost? Proceedings of the 12th Conference of the International Committee for the Conservation of Mosaics, Sardinia, October 27–31, 2014* (Getty Publications, 2014).

UNESCO Declaration concerning the Intentional Destruction of Cultural Heritage (2003), https://link.springer.com/referenceworkentry/10.1007/978 -3-319-51726-1_3260-1.

Wertime, Theodore A. and James D. Muhly, eds. *The Coming of the Age of Iron* (New Haven , CT: Yale University Press, 1980).

Wharton, Glenn, Susan Lansing Maish, and William S. Ginell. "A Comparative Study of Silver Cleaning Abrasives," *Journal of the American Institute for Conservation* 1 (1990): 13–31.

Williams, Donna and Rosa Lowinger. "Quiet Collaboration: The Special Relationship Between Artists and their Fabricators," in *From Marble to Chocolate: The Conservation of Modern Sculpture*, ed. Jackie Heuman (London: Archetype Press, 1995), 30.

ABOUT THE AUTHOR

ROSA LOWINGER is a Cuban-born American writer and art conservator. The author of *Tropicana Nights: The Life and Times of the Legendary Cuban Nightclub* (Harcourt, 2005) and *Promising Paradise: Cuban Allure, American Seduction* (Wolfsonian Museum, 2016), she is the founder and current vice president of RLA Conservation, LLC, one of the United States' largest woman-owned art and architectural conservation firms. A fellow of the American Institute for Conservation, the Association for Preservation Technology, and the American Academy in Rome, Lowinger writes regularly for popular and academic media about conservation, historic preservation, the visual arts, and Cuba.